3,000
DECORATIVE
PATTERNS
OF THE
ANCIENT WORLD

3,000 DECORATIVE PATTERNS OF THE ANCIENT WORLD

BY
FLINDERS PETRIE

DOVER PUBLICATIONS, INC.
Mineola, New York

This Dover edition, first published in 1986, is an unabridged republication of the work originally published, under the title *Decorative Patterns of the Ancient World*, by the British School of Archaeology in Egypt and Bernard Quaritch, London, in 1930.

DOVER *Pictorial Archive* SERIES

Manufactured in the United States of America
Dover Publications, Inc., 31 East 2nd Street,
Mineola, N.Y. 11501

Library of Congress Cataloging-in-Publication Data
Petrie, W. M. Flinders (William Matthew Flinders),
 Sir, 1853-1942.
 Decorative symbols and motifs for artists and
craftspeople.

 Reprint. Originally published: Decorative patterns of the ancient world. London: British School of Archeology in Egypt, 1930.
 1. Decoration and ornament, Ancient—Themes, motives. I. Title.

NK1180.P4 1986 745.4'41 85-46072
ISBN 0-486-22986-6

DECORATIVE PATTERNS

OF THE

ANCIENT WORLD

The purpose of this collection is historical, and any interests that it may claim by racial characters or charms of form are only by the way. It stands as a first outline of an index to all the decorative imaginings of man. The subject is boundless, and to wait for completion would bar any useful result. This beginning of an arrangement of the matter will serve for sorting new material into a form in which it can be compared, registered and consulted.

The limitations of the subject in this volume are where it would trench on ground which is sufficiently known already. The course of civilizations since A.D. 1000 are so far familiar that the artistic connections would not add to our history of events; the architectural studies of capitals and mouldings are so many that they form an entire subject, well-worked, which would overbalance the general history of decoration if included here; the whole theory of interlacing (ACM) or the enormous mass of mosaics in the Roman world seldom add a new form; the many long trails of degradation of forms, human, animal, and vegetable, are usually of little value, as such subjects may equally well be adopted by any people, and simplification usually follows. Geographically this series is limited to Europe and Western Asia, with their links to other lands, but ignoring designs which are special to Siberia, China, or India.

The value of decoration, historically, is due to its having no stimulus of necessity. Where an invention is obviously needed, man will repeatedly invent on much the same lines, to meet his wants. But there is no general need fulfilled by drawing a spiral, rather than a triangle or an octopus. There is great diversity of fertility in different peoples; some abound in fresh ideas—like the Cretans or Apulians, others are limited to two or three stock devices—as the Babylonians or Chinese. The historic connections of design that can be traced, with due regard to place and period, give a strong presumption of a real connection between the designers. This may be due to descent, which will revive a forgotten style after it has been overlaid—like Late Celtic, under Louis Quinze (see LY 96); or it may be a racial movement, like the spread of Hellenism in Asia; or by trade connections—as the Mykenaean style in Egypt, or Chinese in England; or it may be owing to the labour of captives, like the foreign motives in Roman work (see LY 66, 68; WZ 2), or the plait borders unknown at Pompeii, which appear after the Dacian war.

In selecting examples, it seems best to avoid mere intricacy of overloading a basic motive, where no additional idea is added; where such were brought in, it is better to simplify them if too elaborate, as the real motive may be hidden by irrelevant complication. We do not look for hyperboles in an index.

The material subject of a design is only incidental to the quest for motives, whether it be drawn from utility, such as basketry or netting, or from beauty as in plant forms, or from religious symbols as the cross or swastika, or from art and man's device. The scale is immaterial to the nature of the form, and only convenience of size and of detail is followed here. In selection, the earliest examples are always taken, after them the most widely spread, and variants which may be found elsewhere, also any unusually late examples. The mere repetitions of common types in a country are needless for our purpose.

The numbering is designed to allow of the largest amount of expansion without irregularity; thus between 3 and 4 can come 31 to 39.

The first entry in the reference, beneath each drawing, is that of date; if known, in years, it is stated as + for A.D. or − for B.C. If the century alone is known, the middle date is entered. When no definite date is found, a guess has been made from the general circumstances, as being better

4

than nothing, and is marked with a query. The wider divisions are by Egyptian dynasties in Roman numerals, or by the Minoan series, or by the ages of Neolithic, Bronze, and Iron. The nearest equivalents are stated in a table, on the first page of plates.

The second entry is the name of the place, when it is recorded; if obscure, the region is quoted, as the detail can be seen in the original work.

The third entry is that of the source, extracted from over two hundred and fifty works, including many long series. The abbreviations are given in a list. Commoner publications have been preferred, as being easier for verification. Arabic numerals are those of figures, if in a single book, as a translation will retain those numbers; they denote pages, if in a serial. Roman numerals are for volumes (capitals) and plates (small).

It is needless to write obvious conclusions which are seen on looking at the classified examples. Necessary notes of new conclusions and ideas are sometimes put on the plates or, if long, are

in print. A plate should explain itself as far as possible, and not be issued in the dignity of silence.

I have looked forward to doing this work for the last thirty years, and prepared for it. The selection and pencilling are on my own responsibility, and most of the inking in; some inking was done by other hands, and the shields and natural plants are mostly due to Miss Phyllis Gardner's brush work. Any spare space in a plate is left as a blank for making additions.

Those whose purpose is not historical, but artistic, will be aided by the references to the original sources which they require; the sketches here are merely an index.

I hope that every twenty years or so, supplementary plates will be issued by other workers after me, and that a flood of new connections will result from discoveries so much needed in the Middle East. This corpus is a preparation for the co-ordinating of all the new material.

NOTES.

Pls. I–III. *Hero subduing Animals.* The general idea of the A class is that of a controlling deity, which dominates the strongest powers of Nature, represented by lions, bulls, or horses. This symbolism originated in Elam or Iraq, and thence penetrated westward, mainly through Assyrian influence. The Gilgamesh series, AD, is a special form of this idea, but was linked with the rest. The female type is Ishtar, AN, passing into Astarte, AR, mixed with the Mother type of Cybele, AP 8, and the Earth goddess, AP 3, 6. In the West this passes into a deity dominating wolves, AU, or birds, AV, the most intractable creatures.

Pl. IV. *Animals.* The type of two sphinxes, or animals, with a middle column seems to start from Greece, and was continued late there, BA 8. With a middle tree it begins in Egypt, F 1, under Elamite influence; it is early in Iraq, BF 2; from Asia it came into Egypt, BC 8. Pairs of lions without a pillar appear early in Elam, BJ; and sphinxes in the West, BG.

Pl. V. *Animals.* The two snake-headed monsters, BK 2, 4, certainly passed from Sumer to Egypt. The dugong, BM 3, was the figure of Ea the god of wisdom, who rose from the Persian Gulf; it was corrupted in Assyria, as BM 5; thence it passed, under Assyrian influence in the north, to Denmark, M 8. The Glutton head, BN 2, is the main figure in Chinese decoration, where it degraded until formalised as N 4. The twisted snakes type is earliest in Egypt, BP 2, 3, but strangely survives along with rosettes in India, P 5. The form of about 2000 B.C., P 1, has a central staff which brings it nearer to the Caduceus. The two swords with guarded grips are the earliest that we know, P 1.

Pl. VI. *Vase and Animals.* This type originated in a Bacchic group, BT 2, with it a vase and plant became associated, V 2 to 5. Next a vase of fruit appears with birds of any kind, W 2, 4. The peacock was placed in decoration in China before this age, W 3, and first appears in western sculpture, on the porphyry sarcophagus of

Constantia, A.D. 330. At 560 it became usually placed with the vase and plant.

Pl. VII. *Animal Forms*. The triskele appears first about —1500, CB 12; this plain geometrical form, CB 60-75, precedes the development as human legs, CD. A Roman version was the development as dragons' heads, CF. The Chinese dragon seems to be copied from a bird, about —1000, CH 2; it passed under Norse influence, CH 6 (see MQ 3, 6, 84), and became denaturalised, CH 8. The Nautilus passed through various stages since —1800, CN 2. The shell is reduced, the arms formal, by —1300. Later the shell was the main object, with three arms, CO 2, and came down to —500, CO 7. Various other marine animals are difficult to identify.

Pl. VIII. *Octopus*. The naturalistic type, CR 2, of —1800 became regularised by —1600, CR 3, and formal soon after, CR 5. The eight-armed form was revived in the Dipylon ware, CR 8, and seems to have penetrated to the back of China, CR 9, where it is less likely to have been re-invented from the coast. The four-armed type soon arose, about —1400, CT 2, 4, 5. Then the two-armed which lasted to —1300. The period of transfer of the type abroad is thus indicated by the stage of simplifying: to Spain by —1500, to Brittany by perhaps —1200, CU 9. Other forms are of doubtful origin, CX.

Pl. IX. *Naturalistic Plants*. Plant forms are the earliest types of decoration, in France, DM 1, 2, and in Egypt, DM 30-66, at the beginning of prehistoric art. As no magic powers can be supposed to be gained by this variety of species, they warn us against seeing magic intent in the frequent forms of animals; the taste for beauty will produce one as well as the other.

Pl. X. *Lotus*. The lotus was but little varied in Egypt, and it spread mostly from the Assyrian form, DR 4; from this it entered Cyprus and the West, also passing into Scythia, DR 9.

Pls. XI, XII. *Lily*. The lily was adopted in Crete about —2000; EA 2, 5. It became formalised by —1400, EC 3 (see FH 1, 2), and lost to nature, EC 7. In Syria it passed to a different type, BC 8, which was fully treated, as a botanical exposition at Amarna, in —1370. There the parts were clearly set out, ED 2, the pistils (marked P), the anthers (A), the calyx (C), and the spathe with a withered tip (S). These parts continued to be distinguished when the form was borrowed in other lands, down to the Hittite form, EK 7. At this stage it underwent a formalising by the Assyrians,

who did not understand it, EM 3, which may be called-the bowl type. This went through western stages till it became ES 4, 5, 6, and then grew into a third form, ET 2, 3. Then this ran through a thousand years of classical varieties until it disappeared as EY 7, 8, 9. A detailed account of the development was issued in *Ancient Egypt*, 1929, p. 65.

Pl. XIII. *Palmetto*. The palmetto was brought into Egypt by 2800 B.C., FA 1, and *Emblems* 20, pl. LXXXV. It was greatly developed in Assyria, inserted in volute capitals, FB 2, 4, 5, 6, and adapted to running borders, FC. The Greek types combine the acanthus leaf, FD, with the lotus standing on a degraded form of the lily, FD 5, three subjects in one. Pl. XV. *Formal Flowers*. The fleur-de-lis form is in Japan, FG 3, almost as early as among the Franks, see QK 4. It did not enter Italy in decoration till the Papal Alliance with the Franks against the Lombards in +776, and probably vanished from architecture after Charlemagne. The development of the lily with curled and spiral petals, FH 1, 2, is important for dating this form to 1500 B.C., when it was removed on the way to Britain, 23, 56. Pl. XVIII. The foliage forms seem to pass from acanthus to wild geranium in FU 3, 4. The development of foliage, FV 6, 7, in +800, was growing into a skirl in +750, FV 1, and +825, FV 3, and became disconnected from the branch by +840, FV 8.

Pl. XIX. *Arabesques*. These start in —300, developing a bract at the fork of a branch, GB 12, into a calix form, GB 16, 2. In the Praetextatus catacomb, +180, there was a real reversion to Nature, unique in such work, GB 4, 5. The arabesque became standardised for all apse mosaics of the IV-XII centuries. The Dacian form in GB 9 may have started the Chinese Han type, GC 3 to 8. Pl. XX. *Syrian*. Another strong design was the Syrian vine border, GE 2, 3, which grew into the fine school of the IInd century, GE 7, 8. This was taken up by Rome, GE 5, where it is found by A.D. 130, and passed thus in the Ist century to the Lower Rhine, GE 4, 6. There naturalised, it was carried by the Anglian invasion into England, and it is found upon the Northumbrian crosses, GG 2, 3, 4. The strength of the northern connection appears by the type of the natural interlacing of +750, as seen at Otley, being copied unnaturally in Russia by +1234. With this design in use on the Lower Rhine, there is no need to look to Syrian monks as bringing it to the Anglians.

Pl. XXI. *Symmetric*. The translation of formal plant design, GJ 3, 4, to Persia, GJ 5, and China, GJ 6, is probably due to Roman influence. But the Han style, GK 5, must be due to Assyro-Persian influence earlier, as in GK 4, which entered Russia. Pl. XXII. *Foliage Borders*. For the Persian affinity of the Moselle work, GQ 6, and pl. LXXXVI, 70, 83, and LN 71, 75, see Notes LXXXVI.

Pl. XXV. *Rosettes*. The pattern on this Pompeian potter's stamp, HC 2, so closely resembled the Egyptian rosette, HC 3, as to suggest that a piece of old Egyptian design had been brought over in a grain ship to Puteoli, and copied.

Pl. XXVII. *Inanimate*. The hills with plants and flowers, JB 1-7, are an interesting development of scenery in 1400 B.C. The radiate pattern, JE 6, is an extraordinary union of 7 and 13 points. Pl. XXVIII. *Radiate*. The most glorious radiate form is the sun on JQ 6, a yellow disc, with red centre, shining yellow rays and spangles of light on a blue ground.

Pl. XXIX. *Spirals*. The spiral begins before the Neolithic age in the Pyrenees, at the Azilian period, LA 8, LB 6, 10. Perhaps of the same age is that in Egypt of the prehistoric (Amratian) period, LA 13, which suggests a coil of thorny climbing plant, see LXXXV, 32, 33. On the neolithic Danubian pottery, the crossing bands on the spiral suggest that it represented a bundle of grass stems, tied at intervals to make it stiff for construction, LA 26, 28. In either case, it was of flexible vegetable origin, before it became formalised. The full grasp of it was in the aenolithic, with the noble types, LA 58, 63. The S spiral was as early as the whorl, LB 6, 10. Pl. XXX. *The Looped S S* is also aenolithic, LC 16, 18, 20.

Pl. XXXI. *S Continuous*. The multiple band was favoured in Russia and Scandinavia, LC 60, 68, 70, 74, 94, 95, 96: while the spotted band belongs to the south, LC 62, 64, 66; LM 2. In Egypt, the circular spiral, C 86, 87, is of the XI and early XII dynasty, the oval, C 88, 89, is later in the XII, but was started in Ur at an earlier date, LJ 5; it was secondary in Egypt. The S with two sprigs, LD 14, or flowers, D 41, 28, 49, 56, began in —2500, and extended to —1500, LD 56. It was carried west and modified at New Grange, dated on the Irish side between —2000 and —1500. This accords with the Cretan dating. Pl. XXXII. *Band*. The band winding round centres, LE 3, similarly passed to the west and reached Denmark, LE 7, 9, in the same age,

LM 11. Pl. XXXIV. *The C Spiral* begins with LM 19, and seems to rise later than the S form. It is the earliest in Egyptian history, or M 7, about —3400. Pl. XXXVII. *Late Forms*. Spirals became fragmentary in Scythia and the north, LQ. A peculiar decoration with parallel lines of curve, LR, spread from south Russia, just reached Mykenae about 1600, but was otherwise all northern, and spread to China. R 9 and 95 are examples of false spirals, merely circles.

Pls. XXXVIII, XXXIX. *British*. The C spiral was settled in the British Isles, and the form of it, united with the lily with curved petals (extracted at the side of LS 56), comes from the flower, FH 1, 2, of —1500. The trumpet spiral was started in Crete, LV 4, about —1500 or earlier; it had passed to Britain by about +100, LX 4, and was eagerly developed later in Britain, LX 5, 7, and Ireland, LX 8, 9. The use in Britain was long before the period of Irish missions, and its arrival must have been in the Bronze Age, before it vanished from the south, probably about —1500 when other spiral patterns were transmitted. These spirals were here a thousand years before the Celts, who adopted what they found here already. The inflated style, LW, may be due to Celtic taste in each case, as it does not appear before that people. How usual spirals were for common purposes is seen in LX 98, 99, on objects in use.

Pl. XL. *Spiral Blobs*. The blob form, LY belongs to the North, a later growth of the bulbous, LV, and inflated, LW. It entirely disappeared after the Roman age, but revived by racial taste under Louis Quinze, LY 96, and infected the jewellery and furniture of that time. It appears on Roman lamps, Y 67, 68, probably due to the employment of the Gaulish captives of Caesar in the Roman potteries. The joining of spirals with a circle (often with double centres) in Britain is pre-Roman, LZ; then of Roman age in LX 4, and it continued into the Lindisfarne work, LX 5.

Pl. XLVI. *Interlacing Designs* belong originally to Norway, MN 2, 3; thence they were brought by the Anglian invasion into north England, N 4, 5, 54, 6, 66. They do not appear in Ireland till a later date, and they have no relation to the Celts, as plaits enter the British Isles a thousand years later than the Celts. Similar angular interlacing, as in rush work, entered Italy with the Lombards, and not earlier (MN 7, 73, 76, 79). It was combined with circular curves, partly by +700, MN 54, and completely by +825, MO 2. From Milan, O 4, +880, it passed to Ireland +924. It

continued in more complex forms in Italy till +1132, MO 8. It is distinguished from interlacing of the Goths, for that was not angular, but curved, as in osier work, see MH 65, 68, 69. The origin of all such interlacing is probably for the screens used to subdivide tents.

Pl. XLVII. *Animal Interlacing.* Interlacing was elaborated by the Norse with animal figures and dragons, MP. The complex dragon plaiting, MQ 8 (one animal shaded to show the form), gave rise to a figure of 8 pattern, MQ 84. Wire work was developed in the north, MU 2 to 5, by +680, and copied after the Norse invasion of Ireland, MU 7, B, of +850 onward. Wire threading on a chain was also imitated, MR 4.

Pl. L. The divisions of a circle are by 4 in Egypt and early Crete, where compass-struck patterns were unknown; but by 6 in Assyria, Syria, Greece and Italy, owing to facility of division by compasses. Pls. LI, LII. *The Skirl* seems to be intended to indicate circular motion, as in PT 9, the drawing of a chariot wheel.

Pls. LIII, LIV. *Shields.* The shields of northern races yield much of the decoration which has otherwise all perished in their woodwork. The Daci, on the column of Trajan, used vegetative forms, QC, D, and the crescent QE. Torques were worn by Daci, QF, and by Celts, QG; one was on the left arm, as in the story of Tarpeia, and two or four for higher ranks. On the column of Aurelius, the enemy in chain armour were the Marcomanni, as such armour was used in Holstein, QH. The Quadi used scale armour of horn (Ammianus), and this identifies the type, QK 1. The fleur-de-lis, K 4, is probably of the Franci, who were in the war of A.D. 417. The shields, QR 2, 3, 4, may be of Roman legions. The circular shield belonged to Greece and Gaul, QT, V. The Scythian type is identified by QX 2, but became so fashionable in art, that it is hard to draw conclusions from its presence in Gaul, X 5, and Etruria, X 6, 7. For the signs on Scottish gravestones, which appear to be shields and broken spears, see Pl. LXXXVII: as this origin has not yet been discussed, they are left in the miscellaneous class.

Pl. LV. *Band of Balls.* This pattern seems poor as a design, but it was very popular in the north. It touched the south at Mykenae, RN 4, and north Italy under the Lombards, RP 84, Q 4, RR 1, 2, 4, 5, 6, but never rooted there. It entered England, Q 2, 3, with the Jutes, and is found rarely on early fonts. Pl. LVI. *Architecture.* A

surprising feature, which has been overlooked, is the early use of the arch. In the neolithic age in Germany there were pillars and arches, RX 2, apparently of brickwork, with stone capitals. In Cappadocia very early arches are figured, RX 3; and in Mykenae by —1700 there were actually pointed arches, RX 4. After these, it seems likely that the later figures, X 5, 6, 7 were also of arched buildings. The spiral column, which was early in Mykenae, BC 6, was in Italy by —500, RY 3, and in India by +200, Y 5.

Pl. LVII. *The Cross* was an early emblem, in Susa by about —3000, and in India, SA 4, distinguished by a double border, SA 1 to 4. This gives reason for regarding the sign in Egypt at the same time, A 6, 7, as being an emblem, and not merely a mechanical piece of line-work. It was equally known between these two countries, in Cilicia and Aleppo, A 8, 9. The more ornate barred ends, B 5 were added not later than —2000. The sign is also bordered in Egypt, C 7, and Melos, C 8. By —2600 the cross began to be elaborated in Crete, SD, and D 2 is an astonishingly early example, not far from the primitive figure, A 2. It fell into a coarser treatment on the mainland, SE. This pure equilateral form, without any ornament, SF 4, was that in the shrine at Knossos, dating about 2300 B.C., and is exactly the same as the well-known Greek cross of Christian times. It was also used in the north, by the example F 3, from Laibach. It was adapted to woven stuff for clothing, SF 7, 8, and by —1400 in a fanciful form, G 7, 8, it was probably made in Crete, and imported to Egypt for hangings. After that, it became degraded, SJ. In Assyria, SK 5 to 9, the terminals were emphasized, and copied thus in the north, SK 2.

Pl. LIX. *Christian Age.* On reaching Christian times, it is clear that the pagan forms were retained, M 3 continued as N 1, 12; M 1, continued as N 15; N 4 continued as N 45. None of the pagan ornate forms were used religiously till the Vth century, A.D. (O9, O97). Pl. LX. In the Christian monuments, the XP monogram begins in +331, and lasts till +470. The variant with the P made with Horus' lock of hair, begins +440, and continued to +560, but is common in Egypt later. The plain figure of the cross first appears in +380, and the jewelled cross in +425. The expanded terminals begin about +450. The Arian cross has discs at the terminals, SX 1, 12. The adored cross at Palenque, in Central America, has terminals of the type of +600. Such a cross may well have been taken by the Nestorian mission in +638

to China, and within the next five centuries there may have been Chinese communication with America.

A very important movement was the reforming activity of Leo the Isaurian, who tried to bring the Byzantine empire and law into a more modern condition. Part of the change was the iconoclast movement in A.D. 730, to which we must ascribe the removal of the arms from the great crosses at Constantinople, on the west doors of Hagia Sofia; and this reformation was reflected in 820, when the Archbishop of Turin abolished crosses and images in his diocese. To the same movement is due the erasure of the cross arms at the church of S. Prassede in Rome, SY 6. In 830 the cross received the addition of a second bar higher up; this short cross-piece may have represented the label, INRI, SZ 2, 6.

Pl. LXIII. *Triangle*. Among triangles should be noticed the peculiar half rhombs, TR 7, 8, 9. On the last named the circles contain two small circles, as in late Celtic work elsewhere, LX 1, 4, 5; Z 4, 5, 6. Some meaning may have been attached to the sign. The curious type of the triangle with a disc on the point is as early as —1100 (TS 1), and appears again at —400 (TS 56). The main example of it on the tomb of Theodoric, TS 6, is too late in date to give a clue to understanding it. Rhombs subdivided were the favourite type about —600 (TZ).

Pl. LXVI. *Textiles*. Among weaving patterns, there is a large variety copied in the brickwork of mediaeval Iraq, UP. The reason for this is that matting is often placed over mud brick walls to preserve them from weather, and so the patterns of matting were naturally associated with such building. The net-work patterns, UN, in Britain are copied from the string nets in which pots were carried, as they were in Egypt. Hanging drapery, UR, was often in use on walls, and is one of the commonest painted subjects. The great example of imitation is in the marble stripes lining the cathedral of Monreale, marked out by the red borders of each width represented, and striped marble was selected for the apse, which simulated hangings.

Pls. LXIX, LXX. *The Swastika* is more commonly pointing backward (V; E, F, G), than forward (V; A, B). The groups here are of the simple form, then with one extra bend, and others up to 5 bends. Each group is arranged geographically from west to east, to show the distribution. The eastern is the earlier source. On the Indian form, see *Ancient Egypt*, 1922, 56.

Pl. LXXI. *Grooves and Steps*. The origin of the " strigil " pattern, WB 6, on Roman sarcophagi is traced back here to wide fluting, W, A and B. The step pattern, W, G to K, is purely northern, and only touches the Mediterranean at one corner. It is very persistent, and is now in general use from Scotland to China. It took possession of the gold and garnet work, which originally (WJ 2), was free from it, and ruled all the Jutish and Saxon jewellery work in England, WK 2, 3. Pls. LXXIII-IV. *Mosaics* are classed by the obliquity of the angles formed, 1:1 up to 1:3. The long hexagon embroidery in Assyria, Z 6, is evidently derived from two hexagons, one above the other, as in Z 5. The Solomon's Seal pattern, WZ 2 was probably due to Jewish captives employed.

Pl. LXXV. *Key*. The simple key patterns abound in Italy, the more interesting are the reciprocal forms, where the inter-spaces are of the same form as the solid between them, as in XA 8, and XD. The maze pattern XE 2 is the oldest known. XE 6 is not perfect, as the upper left-hand quarter does not open. Pl. LXXX. *Squares*. The expanded cross of Hartlepool, YN 7, is derived from the Ravenna type, N 5, and that obviously came from an Etruscan origin, N 4. Pl. LXXXII. The curious pattern YW 5 seems to have been copied from a grating above a doorway. The squares of varied content, YY and YZ, show what the Celt did before he acquired the spiral or interlaced forms.

Pl. LXXXIII. *The Metopic* series, ZA to E, was developed to separate squares of design around vases. In this form it precedes by a thousand years the architectural use of parallel lines between metopic groups. There is no meaning in grooving the ends of the roof beams in a building; but when that device of parallel lines to separate groups was well fixed in vase painting, it naturally was transferred to a similar duty in architecture.

Pl. LXXXV. *Emblems*. Over the head of Hittite deities is placed the sign 10 A, B, C, 11, which is recognised as the sign of divinity. It may represent a double shrine of the Mother and Son deities. A modification of this, 12, is placed beneath each of five divine figures, on a gold ring from Tiryns. The same is developed as 15 at Knossos, and this passed on to the types 16, 18 and 19; the last-named still retains the double bar of 10 A to C. Whether the Cretans recognised the original sense is quite unknown; apparently, it is merely used as ornament. Another emblem is that of the Hittite

royal mark, which is found on pottery and elsewhere, 21-2-3. It appears as an amulet at Amarna, 27; also as a mould for making such amulets, No. 28; this suggests that the Egyptians traded pendants or amulets with the Hittites. A gold amulet of this type is also known, Z 9.

On the dress of the Kefti people, about the north-east of the Mediterranean, in 1600 B.C., there is placed an emblem, 36; this belonged to a previous age, as examples occur in Egypt at 2700 B.C., 32, 33; we cannot say from where they were introduced. In Asia it passed to Kashgar (37), to a reliquary of Persian (?) sources (38), and up to Lithuania, 39.

Pl. LXXXVI. Some groups are hardly assignable to any of the main classes. Fresh connections may appear in future. The wave group, 61-69, links on to some in the spiral group, LP 37, 56, of the same period and regions: but the wave forms could not all go among spirals; in order to separate these classes, far earlier examples would be needed. The strange divergent droops, 70 to 79, are un-explained: in 75 they seem to show a structure which recalls Persian or Central Asian design. The Persian affinity of 70 and 83 is puzzling in the Franco-German region; the rest of the group is in GQ 6, 7, and LN 71. In 83 the flower at the top, the droops on each side, the two commas below, and the droops at the base, are all of the fashion of Persian work, as on the dress of Khusrau, 84. Was it due to a stray party from Xerxes' expedition at 480 B.C., lost in Thrace, and pushing west to the Rhine? Their superior civilisation might well take a lead in that region. In Hagia Sofia, 85, the middle figure is almost Turkish, and is duplicated in the very foreign group in Britain, 82. Below in group 91 to 95 is the series of boss designs from China; this is an Asiatic idea which crops up in the large oval boss from the Caucasus, WJ 8, and in Asiatic-Gothic elsewhere.

Pl. LXXXVII. The Scottish emblems on tomb-stones have been supposed to represent a fibula and pin; but no pin could have a widening at each end, nor be bent. It seems rather that the group represents some form of shield reversed, and the broken spear, of a warrior. Such a long, round-ended, shield as QZ 3, 4 appears QP 4, 6, and accords with the style of Celtic shields, as seen in the example from the Thames, QZ, 46. The lunate form, QZ 6 may be the Scythian shield, QX, QY; the deeper form QZ 5 is parallel to the deeper forms QX 8, 9. The squared forms QZ 66-77 may be a square basket-work breastplate,

like the square front and back pieces on Gaulish figures at Marseilles. In the sides are circular hollows to allow freedom for the arms and, below, it descends in two cuisses over the thighs. The spear points remain in Z 2, 3, 6, 62, 64, 66. The whole idea seems to have been originally the reversing of the shield, laid longways or upside down, and the breaking of the spear, like the heralds breaking their wands at a funeral, as symbols of the end of the career. On one stone a helmet is also figured, see ACM 99. This custom would have arisen in the Bronze Age, and in the post-Christian period of these monuments the originals were probably forgotten, more or less, and the forms were confused. It may be mentioned that the animal on these tombstones, sometimes called an elephant, is probably a walrus.

Pl. LXXXVIII contains mysterious forms which may some day find a place in the series when we have much more material before us.

To sum up some of the results that we can already gain from this study: there is the great influence of Assyria on the North, in Hungary (SK 2, 5) on the Lower Dnieper (DR 9, FA 9, GK 4, 5), and extending to Denmark (BM 8); there is the movement at 1500 B.C. from Crete and Mykenae to Britain, which was probably by the Atlantic, and not from Northern lands where such designs are unknown (FH 1=LS 56, LD 56=LD 97, LE 3=LE 7, 9, LN 63=LN 67, CU 3=CU 9); there is the Syrian vine copied on the Lower Rhine, and thence brought to Northumbria by the Anglians; there is the interlaced work coming from Norway, brought by the Anglians to England, and by the Danes to Ireland; there is the Han style in China due to Assyro-Persian work; there is the Hittite divine emblem planted in Crete, and the royal emblem in Egypt; and there is the rise of arched brickwork in neolithic Germany, in Cappadocia, and with pointed arches in Mykenae. Lastly, there is a strong evidence of a wandering body from the army of Xerxes reaching the Lower Rhine.

These are some of the more definite conclusions which may already be drawn from a study of these decorative patterns; when more material is available one may expect to find many more links in the earlier ages. From these we shall view the past as a network of civilisations, peculiar to each land, and interacting on each other. We may then dis-criminate the original source of each of the devices which belonged to different areas before they were spread by intercourse.

ABBREVIATIONS.

APPROXIMATE RELATIONS OF PERIODS.

EGYPT Dynasty.	B.C.	CRETE.	Bronze. Iron.		BRITAIN	IRELAND	CHINA
IV	3784	EM II					
VI							
	3084						
VII		EM III					
XI		MM I					
	2588					2500 Br. I	
XII		MM II	E-B				2203 Hia
	2375						
XIII,XV		MM III	M-B				
XIV,XVI						1900	
XVII		LM I				Br. II	1764 Sheng
	1589						
XVIII		LM II					
A'mhtp. III	1400			Montel. III Br.		1400	
	1328					Br. III	
XIX		LM III	L-B	M. IV Br.			
	1202						
XX				M. V Br.	Beaker A		
	1102						1120
XXI			E-I			1000 Br. IV	Chow
	950			Hallstatt			
XXII			M-I	I	B	800	
XXV						Br. V	
	664			II			
XXVI			L-I	500	C		
XXX				Tène		388	
	320			250		Celts	
Ptolemaic		Hellenistic		II			206
				100			Han
				III			

For the dating in years, see the recent results in *Ancient Egypt*, 1929, June.

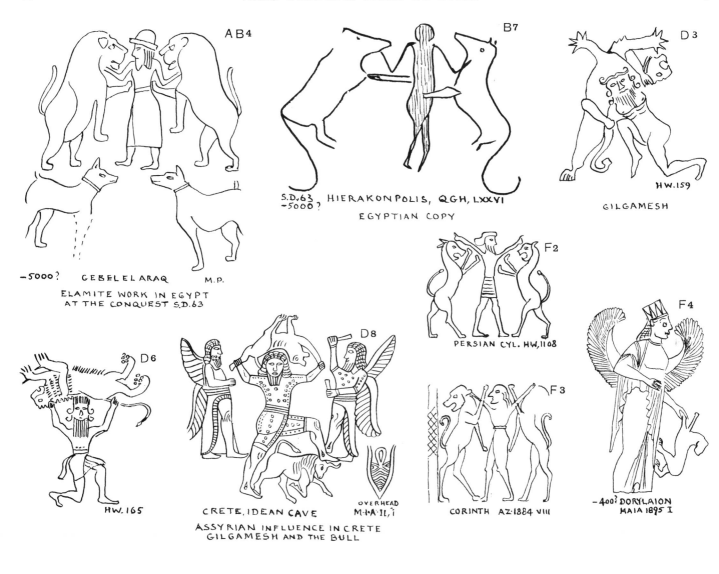

AB4

−5000? GEBEL EL ARAQ M.P.
ELAMITE WORK IN EGYPT
AT THE CONQUEST S.D.63

S.D.63 HIERAKONPOLIS, QGH, LXXVI
−5000?
EGYPTIAN COPY B7

D3
HW.159
GILGAMESH

F2
PERSIAN CYL. HW,1108

D6
HW.165

D8
CRETE, IDEAN CAVE
ASSYRIAN INFLUENCE IN CRETE
GILGAMESH AND THE BULL
OVERHEAD
M·I·A·II,1

F3
CORINTH AZ·1884·VIII

F4
−400? DORYLAION
MAIA 1895 I

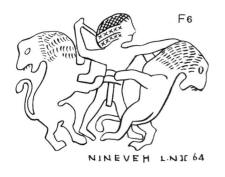

F6
NINEVEH L.NII 64

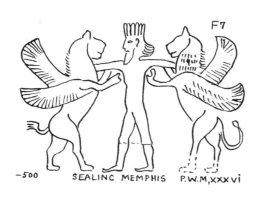

F7
−500 SEALING MEMPHIS P.W.M,XXXVI

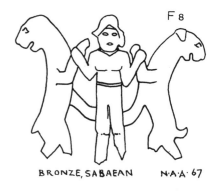

F8
BRONZE, SABAEAN N.A.A·67

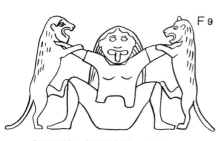

F9
BRONZE, PERUGIA, M.I.252.17

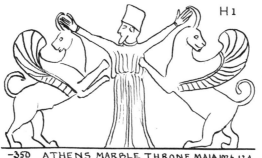

H1
−350 ATHENS, MARBLE THRONE, MAIA,1926,124

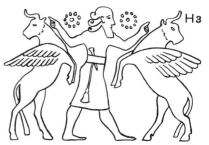

H3
−730 NIMRUD L·N·XLViii

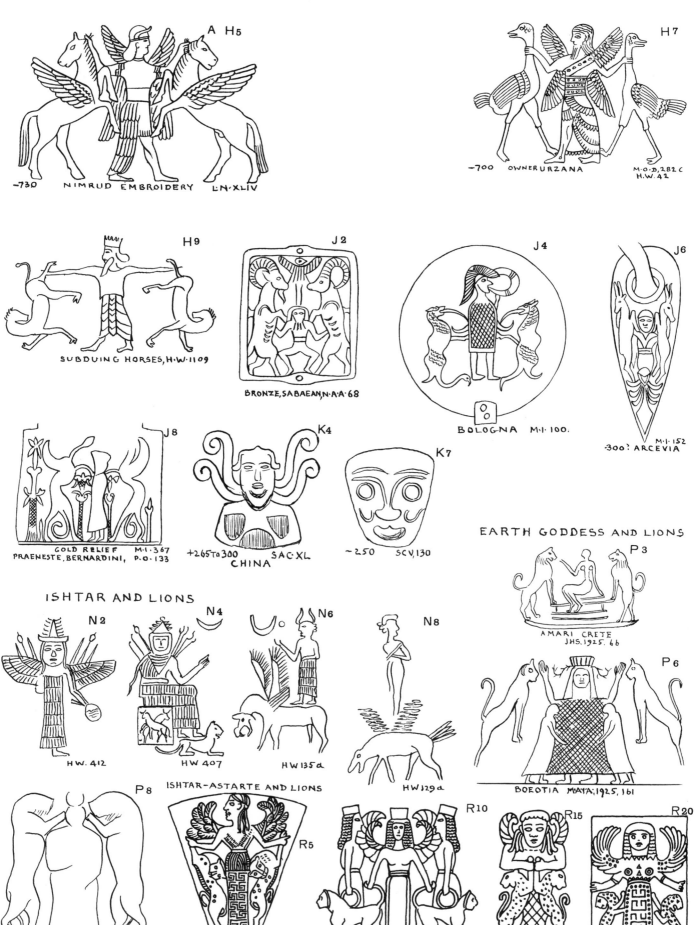

A H5
-730 NIMRUD EMBROIDERY L·N·XLIV

H7
-700 OWNER·URZANA M·O·D·282 C
H·W·42

H9
SUBDUING HORSES, H·W·1109

J2
BRONZE, SABAEAN, N·A·A·68

J4
BOLOGNA M·I·100.

J6
-300? ARCEVIA M·I·152

J8
GOLD RELIEF M·I·367
PRAENESTE, BERNARDINI, P·O·133

K4
+265 TO 300 SAC·XL
CHINA

K7
~250 SCV,130

EARTH GODDESS AND LIONS

P3
AMARI CRETE
JHS.1925. 66

P6
BOEOTIA MAYA; 1925, 161

ISHTAR AND LIONS

N2
HW. 412

N4
HW 407

N6
HW 135a

N8
HW 129a

P8
PHRYGIA HOC 39

ISHTAR-ASTARTE AND LIONS

R5
-550 KUBAN R·I·G·VI

R10
SPARTA J·H·S.

R15
MOD·281a

R20
RHODES, B·M

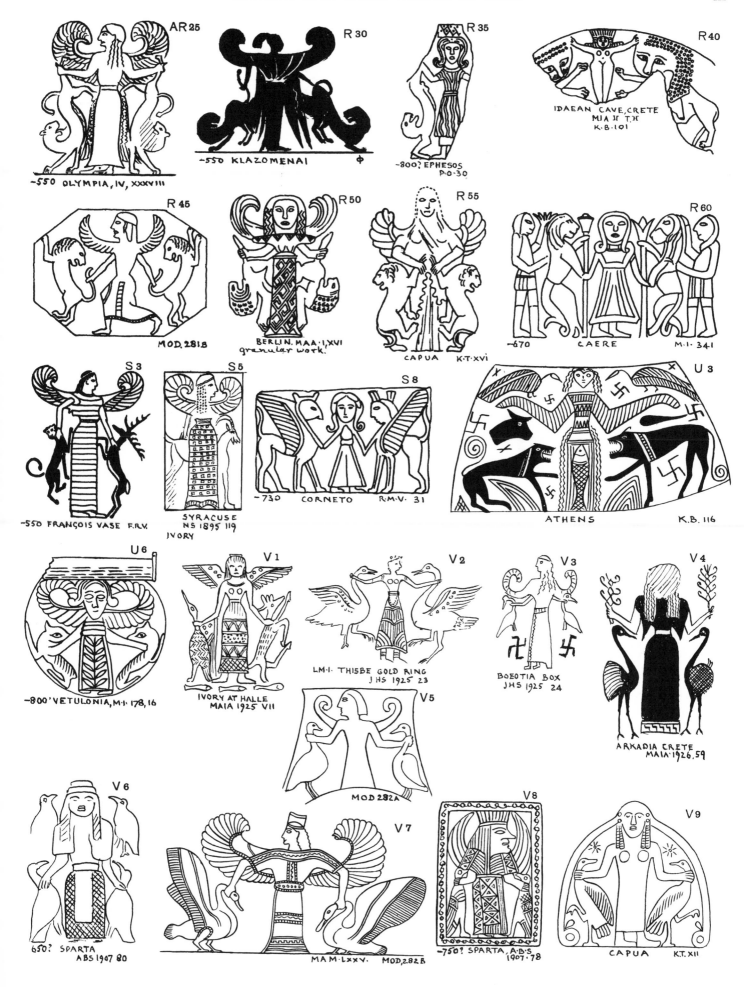

AR 25

R 30

R 35

R 40

-550 OLYMPIA, IV, XXXVIII

-550 KLAZOMENAI

-800? EPHESOS P.O.30

IDAEAN CAVE, CRETE MIA II T.H K.B.101

R 45

R 50

R 55

R 60

MOD. 2818

BERLIN. MAA·1,XVI granular work.

CAPUA K.T·XVI

-670 CAERE M.I. 341

S 3

S 5

S 8

U 3

-550 FRANÇOIS VASE F.R.V.

SYRACUSE NS 1895 119 IVORY

-730 CORNETO R.M.V. 31

ATHENS K.B. 116

U 6

V 1

V 2

V 3

V 4

-800? VETULONIA, M.I. 178,16

IVORY AT HALLE MAIA 1925 VII

LM·I· THISBE GOLD RING JHS 1925 23

BOEOTIA BOX JHS 1925 24

V 5

MOD 282A

ARKADIA CRETE MAIA·1926.59

V 6

V 7

V 8

V 9

650? SPARTA ABS 1907 80

MAM·LXXV. MOD,282B

-750? SPARTA, A.B.S 1907·78

CAPUA K.T. XII

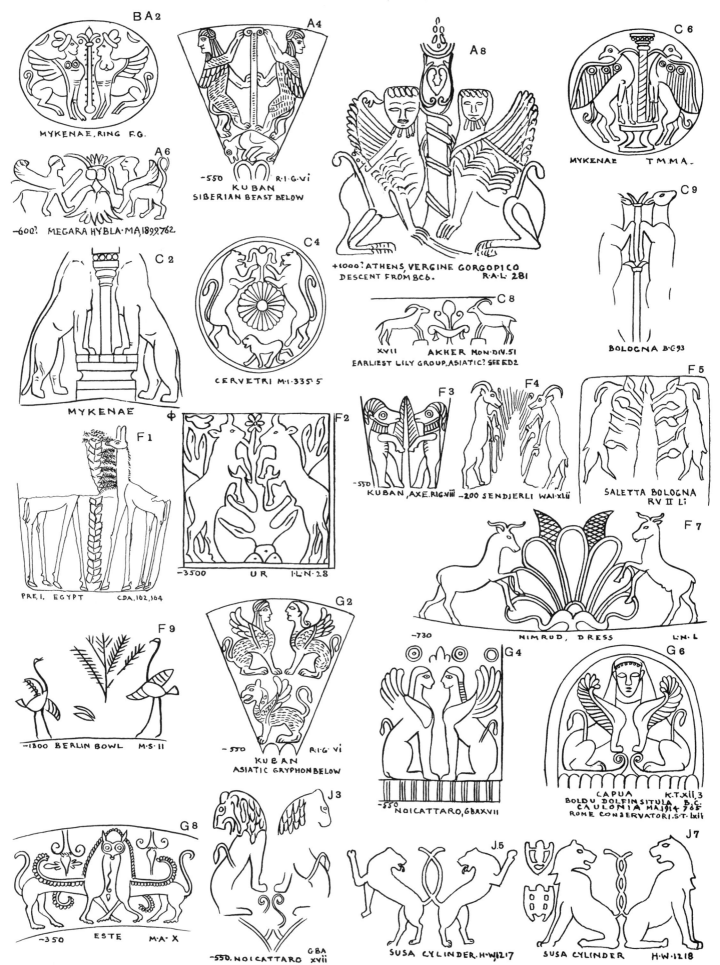

BA2
MYKENAE, RING F.G.

A4
−550 R·I·G·VI
KUBAN
SIBERIAN BEAST BELOW

A8
+1000? ATHENS, VERGINE GORGOPICO
DESCENT FROM BC6. R·A·L 281

C6
MYKENAE TMMA.

A6
−600? MEGARA HYBLA·MA1899,762

C2
MYKENAE φ

C4
CERVETRI M·I·335·5

C8
XVII AKHER MON·DIV·51
EARLIEST LILY GROUP, ASIATIC? SEE ED2

C9
BOLOGNA B·G·93

F1
PRE·I. EGYPT CDA,162,164

F2
−3500 UR I·L·N·28

F3
−550
KUBAN, AXE·RIG·VIII

F4
−200 SENDJERLI WAI·XLü

F5
SALETTA BOLOGNA
RV II Li

F7
−730 NIMRUD, DRESS L·N·L

F9
−1800 BERLIN BOWL M·S·II

G2
−550 R·I·G·VI
KUBAN
ASIATIC GRYPHON BELOW

G4
−550 NOICATTARO, GBAXVII

G6
CAPUA K·T·XII·3
BOLD·U·DOLFINSITULA B·C.
CAULONIA MA1914 765
ROME CONSERVATORI·ST·LxII

G8
−350 ESTE M·A·X

J3
−550. NOICATTARO GBA
XVII

J5
SUSA CYLINDER·H·W1217

J7
SUSA CYLINDER H·W·1218

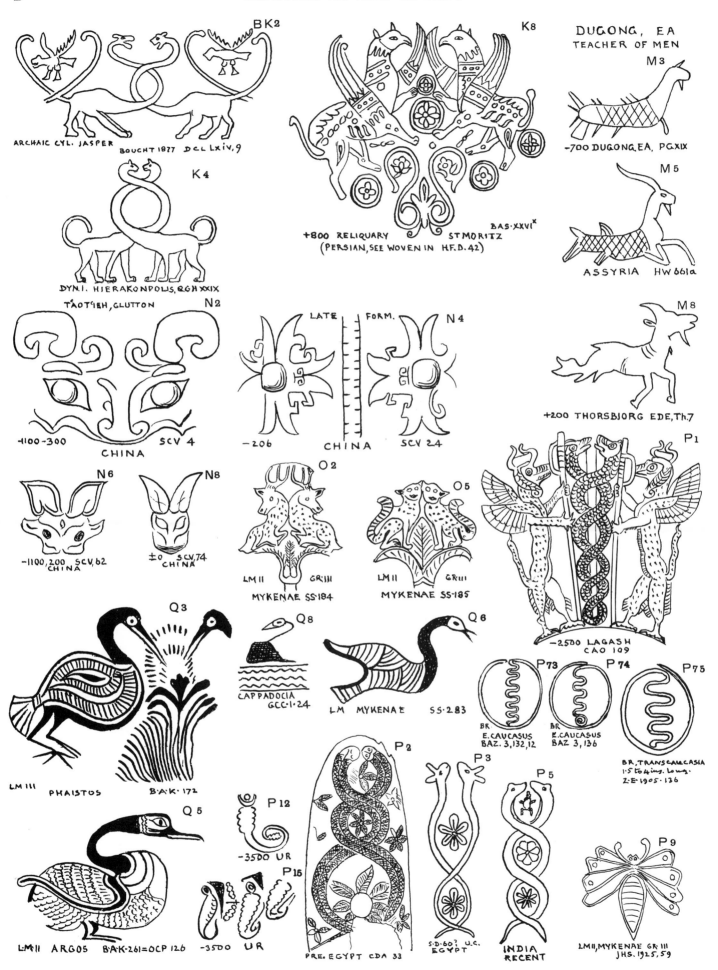

BK2

ARCHAIC CYL. JASPER BOUCHT 1877 D.C.L. LXIV, 9

K8

DUGONG, EA
TEACHER OF MEN
M3

−700 DUGONG, EA, PG.XIX

K4

DYN.I. HIERAKONPOLIS, RGH XXIX

BAS.XXVI×
+800 RELIQUARY ST.MORITZ
(PERSIAN, SEE WOVEN IN H.F.D. 42)

M5

ASSYRIA HW 661a

TÁOTᵀIEH, GLUTTON N2

−1100−300 SCV 4
CHINA

LATE FORM. N4

−206 CHINA SCV 24

M8

+200 THORSBJORG EDE, Th.7

N6

−1100, 200 SCV, 62
CHINA

N8

±0 SCV, 74
CHINA

O2

LM II GR III
MYKENAE SS 184

O5

LM II GR III
MYKENAE SS 185

P1

−2500 LAGASH
CAO 109

Q3

LM III PHAISTOS B·A·K· 172

Q8

CAPPADOCIA
GCC·I·24

Q6

LM MYKENAE SS·283

P73 P74 P75

BR
E. CAUCASUS
BAZ. 3,132,12

BR
E. CAUCASUS
BAZ 3,136

BR, TRANSCAUCASIA
1·5 to 4 ins. Long.
Z·E·1905·136

Q5

LM II ARGOS B·A·K·261=OCP 126

P12

−3500 UR

P15

−3500 UR

P2

PRE. EGYPT CDA 33

P3

S·D·60? U.C.
EGYPT

P5

INDIA
RECENT

P9

LM II, MYKENAE GR III
JHS. 1925, 59

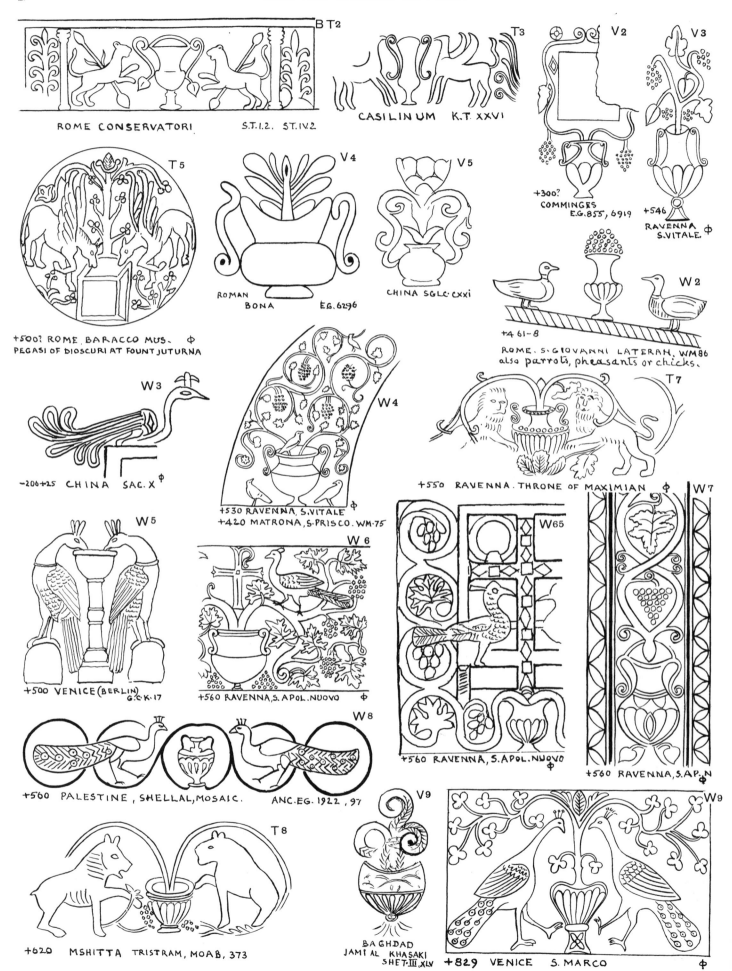

B T2
ROME CONSERVATORI S.T.I.2. ST.IV.2

CASILINUM K.T. XXVI

T3

V2

V3

+300? COMMINGES E.G. 855, 6919

+546 RAVENNA S. VITALE ϕ

T5

V4
ROMAN BONA E.G. 6296

V5
CHINA SGLC. CXXI

+500? ROME. BARACCO MUS. ϕ
PEGASI OF DIOSCURI AT FOUNT JUTURNA

W2
+4 61-8
ROME. S. GIOVANNI LATERAN. WM86
also parrots, pheasants or chicks.

W3
-206 +25 CHINA SAC. X ϕ

W4
+530 RAVENNA, S. VITALE
+420 MATRONA, S. PRISCO. WM. 75

T7
+550 RAVENNA. THRONE OF MAXIMIAN ϕ

W65

W7

W5
+500 VENICE (BERLIN) G.C.K. 17

W6
+560 RAVENNA, S. APOL. NUOVO ϕ

+560 RAVENNA, S. APOL. NUOVO ϕ

+560 RAVENNA, S. AP. N

W8
+560 PALESTINE, SHELLAL, MOSAIC. ANC. EG. 1922, 97

T8
+620 MSHITTA TRISTRAM, MOAB, 373

V9
BAGHDAD
JAMI AL KHASAKI
SHET. III, XLV

W9
+829 VENICE S. MARCO ϕ

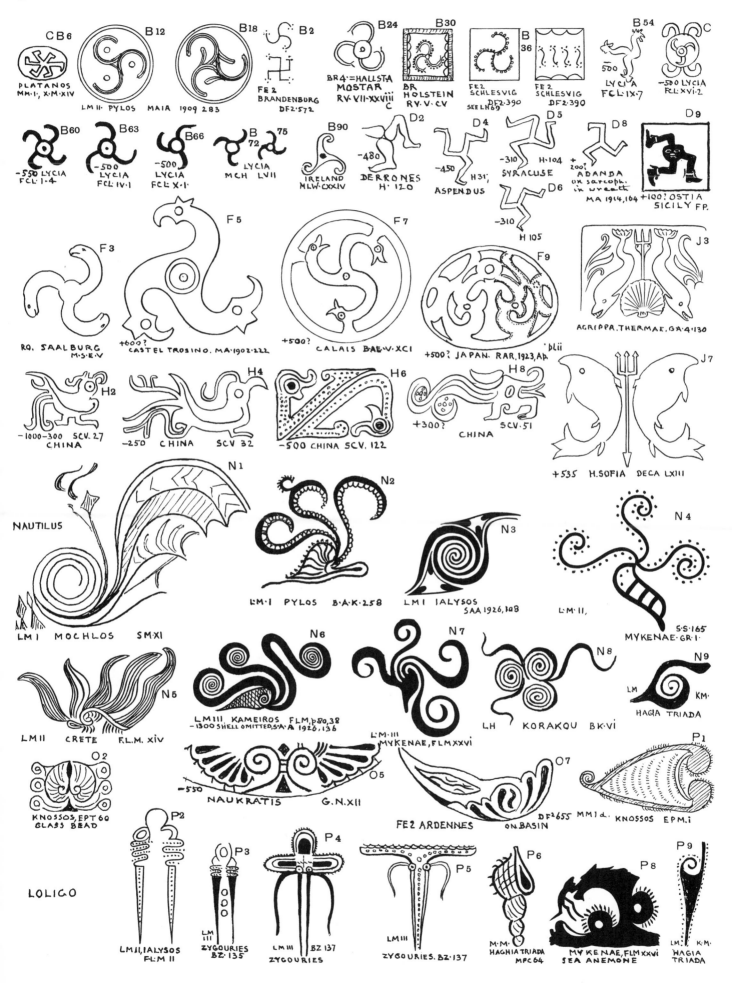

CB6
PLATANOS
MM·I·, X·M·XIV

B12
LM II· PYLOS

B18
MAIA 1909 283

B2
FE2
BRANDENBURG
DF2·572

B24
BR4'=HALLSTA
MOSTAR
RV·VII·XXVIII
C

B30
BR
HOLSTEIN
RV·V·CV

B
36
FE2
SCHLESVIG
DF2·390
SEE LH69

B
36
FE2
SCHLESVIG
DF2·390

B54
500
LYCIA
FCL·IX·7

C
-500 LYCIA
FCL·XVI·2

B60
-550 LYCIA
FCL·I·4

B63
-500
LYCIA
FCL·IV·1

B66
-500
LYCIA
FCL·X·1·

B
72 75
LYCIA
MCH·LVII

B90
IRELAND
MLW·CXXIV

D2
-480
DERRONES
H·120

D4
-450
ASPENDUS
H31,

D5
-310
SYRACUSE
H·104

D6
-310
H 105

D8
+200?
ADANDA
ON SARCOPH.
IN WREATH
MA 1914,164

D9
+100? OSTIA
SICILY FP.

F3
RO. SAALBURG
M·S·E·V

F5
+600?
CASTEL TROSINO. MA·1902·222

F7
+500?
CALAIS BAE·V·XCI

F9
+500? JAPAN. RAR.1923, AA
·plii

J3
AGRIPPA. THERMAE. GA·4·130

H2
-1000-300 SCV·27
CHINA

H4
-250 CHINA SCV 32

H6
-500 CHINA SCV·122

H8
+300?
CHINA
SCV·51

J7
+535 H.SOFIA DECA LXIII

N1
NAUTILUS
LM I MOCHLOS SM·XI

N2
LM·I PYLOS B·A·K·258

N3
LM I IALYSOS
SAA 1926,108

N4
L·M·II,
S·S·165
MYKENAE·GR·I·

N5
LM II CRETE F.L.M. XIV

N6
LM III KAMEIROS FLM.p80,38
-1300 SHELL OMITTED,S·A·A 1926,136

N7
L·M·III
MYKENAE, FLM XXVI

N8
LH KORAKOU BK·VI

N9
LM KM.
HAGIA TRIADA

O2
KNOSSOS, EPT 60
GLASS BEAD

O5
-550
NAUKRATIS G·N·XII

O7
FE2 ARDENNES
ON BASIN
DF 2655

P1
MM I d. KNOSSOS EPM·i

LOLIGO

P2
LM II, IALYSOS
FLM II

P3
LM III
ZYGOURIES
BZ·135

P4
LM III BZ 137
ZYGOURIES

P5
LM III
ZYGOURIES. BZ·137

P6
M·M·
HAGHIA TRIADA
MPC 64

P8
MYKENAE, FLM XXVI
SEA ANEMONE

P9
LM· KM·
HAGIA
TRIADA

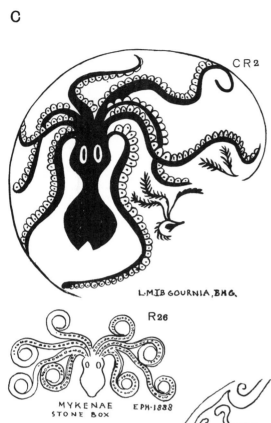

CR 2

L.M.IB GOURNIA, B.H.G.

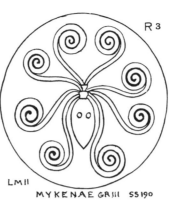

R 3

LM II
MYKENAE GR III SS 190

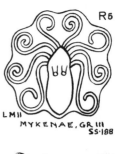

R 5

LM II MYKENAE, GR III
SS·188

R 6

KUPHONISIA MGP 307
AMORGOS

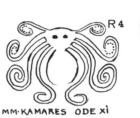

R 4

MM·KAMARES ODE XI

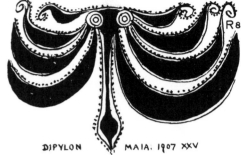

R 8

DIPYLON MAIA. 1907 XXV

R 26

MYKENAE EPH·1888
STONE BOX

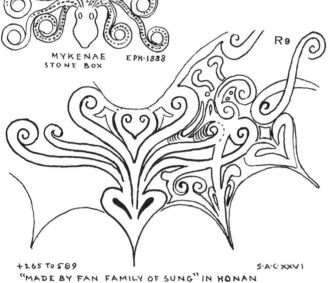

R 9

+ 265 TO 589 S·A·C XXVI
"MADE BY FAN FAMILY OF SUNG" IN HONAN

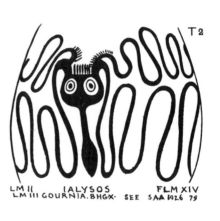

T 2

LM II IALYSOS FLM XIV
LM III GOURNIA. B.H.G.X. SEE SAA 1926 79

S 2

·M III MPC.127

U 1

~1350 MYKENAE
ABS 1923 107

T 4

LM II IALYSOS F.L·M·VIII

T 5

LM II IALYSOS FLM ii

T 6

LOS
MILLARES
SPAIN S·O·O·iii

U 2

LM II IALYSOS, FLM ii

U 3

LM·HAGIA TRIADA. K·M·

U 6

LH III KORAKOU BK 91

U 9

MEGALITH C·D·133
PERIOD
CUP
BRETON

U 7

LH III
=1150 PALEST·

KORAKOU BK·85

U 8

S·A·A 1926, 43

X 2

CRETE
M·S·X

X 3

HITTITE
H.H. 135

X 5

ORSOVA
M·B·H 1912,15,16

X 6

X 8

KNOSSOS
INLAY
E·P·T·40

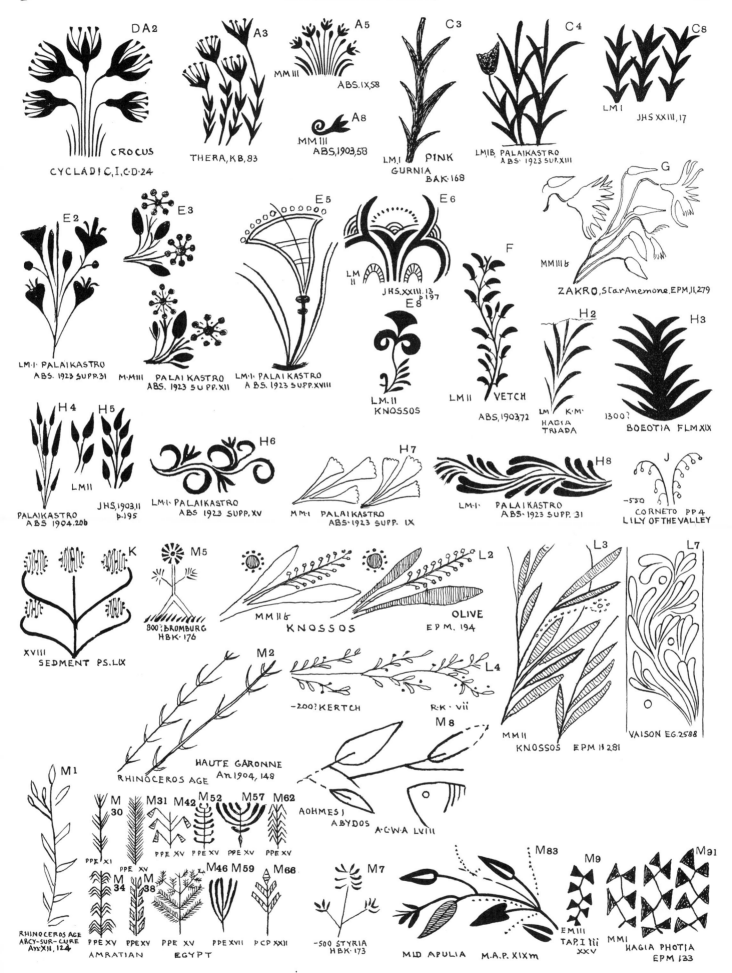

DA2 CROCUS CYCLADIC, I, C·D·24

A3 THERA, K.B, 83

A5 MM III ABS.IX,58

A8 MM III ABS,1903,58

C3 PINK LM.I GURNIA BAK·168

C4 LMIB, PALAIKASTRO ABS· 1923 SUP.XIII

C8 LM I JHS XXIII, 17

E2 LM·I· PALAIKASTRO ABS. 1923 SUPR.31

E3 M·MIII PALAIKASTRO ABS. 1923 5UPP.XII

E5 LM·I· PALAIKASTRO A.B.S. 1923 SUPP.XVIII

E6 LM II JHS.XXIII.13 p 197

E8 L.M. II KNOSSOS

F LM II VETCH ABS, 190372

G MM III b ZAKRO, Star Anemone. EPM,II,279

H2 LM K·M· HAGIA TRIADA

H3 1300? BOEOTIA FLM XIX

H4 H5 LM II PALAIKASTRO ABS 1904.20b JHS,1903,11 p·195

H6 LM·I· PALAIKASTRO ABS 1923 SUPP. XV

H7 MM·I PALAIKASTRO ABS·1923 SUPP. IX

H8 LM·I· PALAIKASTRO ABS·1923 SUPP. 31

J −550 CORNETO PP 4 LILY OF THE VALLEY

K XVIII SEDMENT PS.LIX

M5 800? BROMBURG HBK·176

L2 MM II b KNOSSOS OLIVE EPM. 194

L3

L7 VAISON EG.2588

M2 HAUTE GARONNE An 1904, 148 RHINOCEROS AGE

L4 −200? KERTCH R·K· vii

M8 MM II KNOSSOS EPM II 281

M1 RHINOCEROS AGE ARCY-SUR-CURE An XII, 124

M 30 M31 M42 M52 M57 M62 PPE XI PPE XV PPE XV PPE XV PPE XV

M 34 M 38 M46 M59 M66 PPE XV PPE XV PPE XV PPE XVII P CP XXII AMRATIAN EGYPT

AOHMES I ABYDOS A·G·W·A LVIII

M7 −500 STYRIA HBK·173

M83 MID APULIA M.A.P. XIX m

M9 EM III TAP.I IiI XXV

M91 MMI HAGIA PHOTIA EPM 133

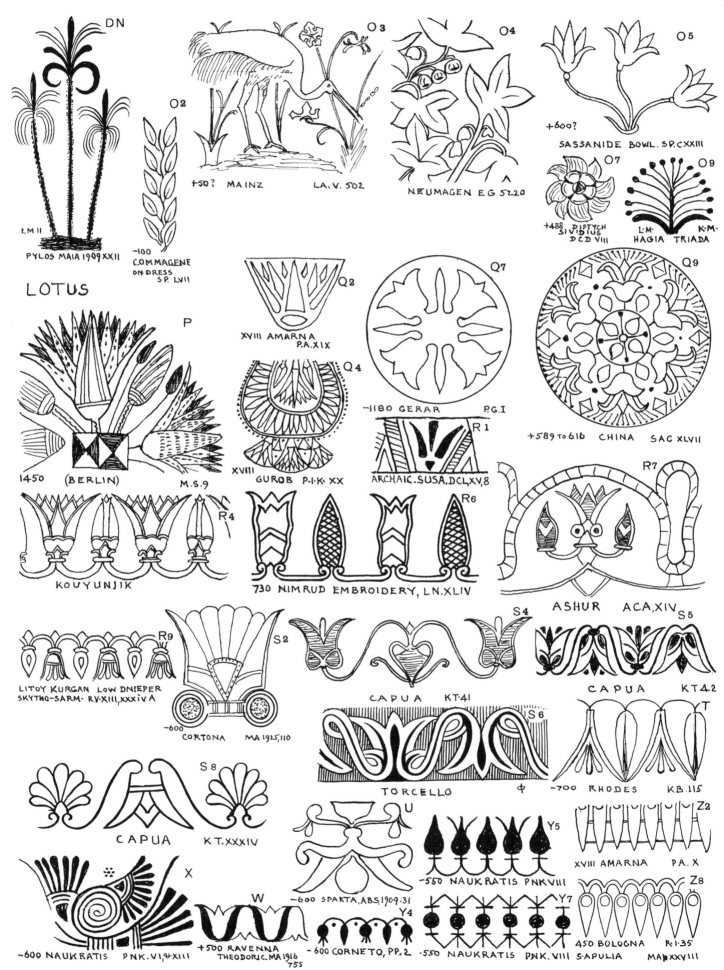

DN

O 2

+50? MAINZ

O 3

LA. V. 502

O 4

NEUMAGEN EG 5220

O 5

+600?

SASSANIDE BOWL. SP. CXXIII

O 7

+488 DIPTYCH
SIVIDIUS
DCD VIII

O 9

L·M·　　　K·M·
HAGIA TRIADA

LM II

PYLOS MAIA 1909 XXII

-100
COMMAGENE
ON DRESS
SP. LVII

LOTUS

P

1450　(BERLIN)　M.S.9

Q 2

XVIII AMARNA
P.A.XIX

Q 4

XVIII
GUROB P.I.K· XX

Q 7

-1180 GERAR　　P.G.I

R 1

ARCHAIC. SUSA. DCLXV.8

Q 9

+589 TO 616　CHINA　SAC XLVII

R 4

KOUYUNJIK

R 6

730 NIMRUD EMBROIDERY, LN.XLIV

R 7

ASHUR　ACA.XIV

R 9

LITOY KURGAN LOW DNIEPER
SKYTHO-SARM· RV·XIII, XXXIV A

S 2

-600
CORTONA　MA 1925,110

S 4

CAPUA　KT·41

S 5

CAPUA　KT·42

S 6

TORCELLO

T

-700 RHODES　KB.115

S 8

CAPUA　KT.XXXIV

U

-600 SPARTA, ABS 1909·31

X

-600 NAUKRATIS　PNK.VI, & XIII

W

+500 RAVENNA
THEODORIC. MA 1916
755

Y 4

-600 CORNETO, PP.2

Y 5

-550 NAUKRATIS PNKVIII

Y 7

-550 NAUKRATIS　PNK. VIII
S·APULIA

Z 2

XVIII AMARNA　PA. X

Z 8

450 BOLOGNA　R·I·35
MA XXVIII

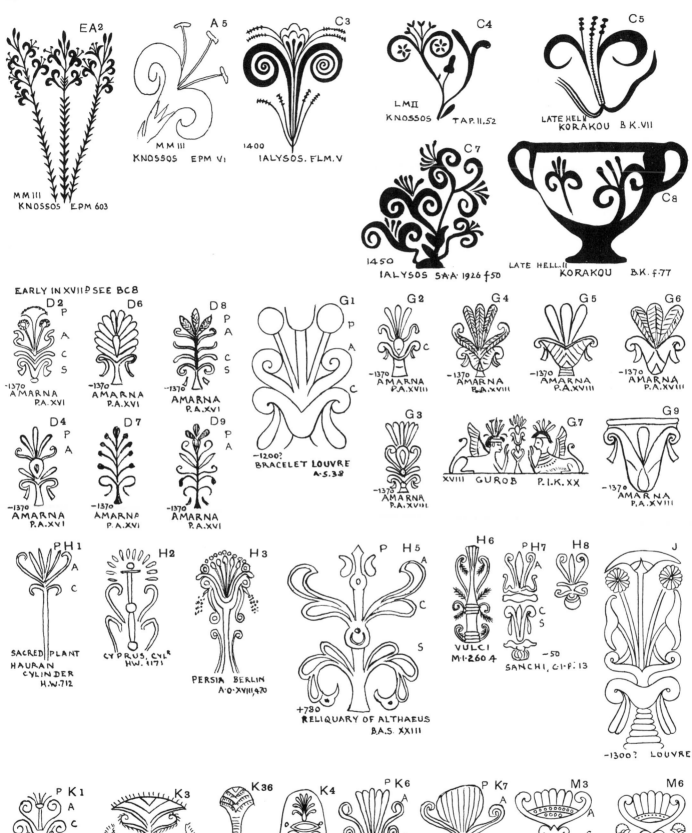

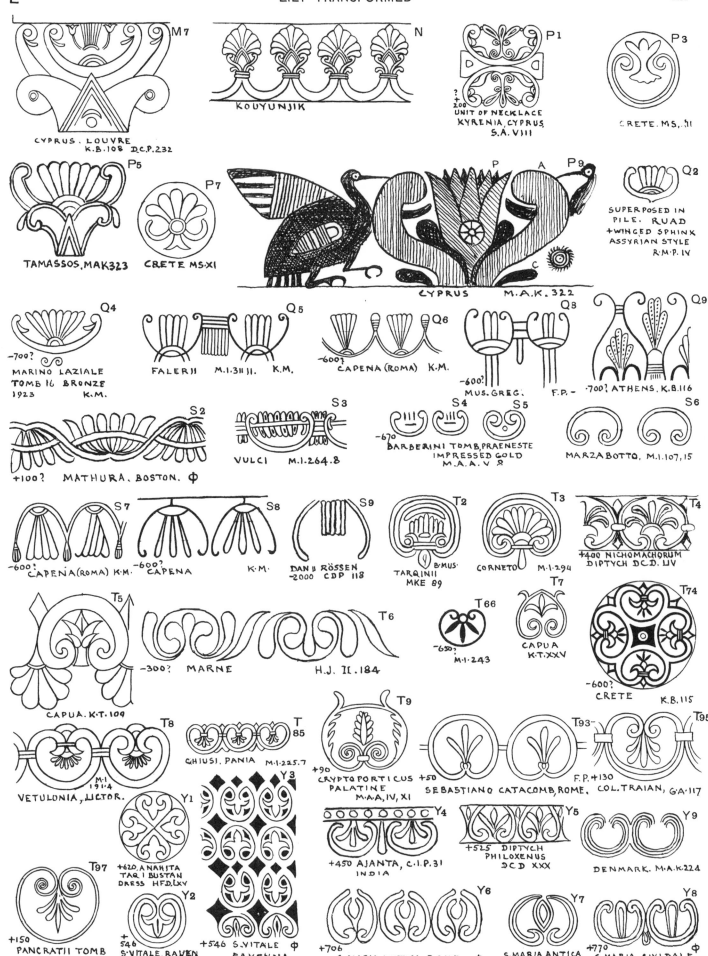

CYPRUS. LOUVRE
K.B.108 D.C.P.232

KOUYUNJIK

UNIT OF NECKLACE
KYRENIA, CYPRUS
S.A. VIII

P1

? +
200

P3

CRETE. MS. XI

P5

TAMASSOS. MAK323

P7

CRETE MS. XI

CYPRUS M.A.K. 322

Q2

SUPERPOSED IN
PILE. RUAD
+WINGED SPHINX
ASSYRIAN STYLE
R.M.P. IV

Q4

-700?

MARINO LAZIALE
TOMB 16 BRONZE
1923 K.M.

Q5

FALERII M.I.311 II. K.M.

Q6

-600?
CAPENA (ROMA) K.M.

Q8

-600?
MUS.GREG.
F.P. -

Q9

-700? ATHENS. K.B.116

S2

+100? MATHURA. BOSTON. Φ

S3

VULCI M.I.264.8

S4 S5

-670
BARBERINI TOMB, PRAENESTE
IMPRESSED GOLD
M.A.A. V 8

S6

MARZABOTTO. M.I.107,15

S7

-600? CAPENA(ROMA) K.M.

S8

-600? CAPENA

S9

K.M.

DAN II RÖSSEN
-2000 CDP 118

T2

TARQINII
MKE 89

B.MUS.

T3

CORNETO M.I.294

T4

+400 NICHOMACHORUM
DIPTYCH D.C.D. LIV

T5

CAPUA. K.T.109

T6

-300? MARNE H.J. II.184

T66

-650?
M.I.243

T7

CAPUA
K.T.XXV

T74

-600?
CRETE K.B.115

T8

M.I
1914
VETULONIA, LICTOR.

T85

GHIUSI. PANIA M.I.225.7

T9

+90
CRYPTOPORTICUS
PALATINE
M.A.A. IV. XI

+50
SEBASTIANO CATACOMB, ROME.

T93

F.P. +130

T95

COL.TRAIAN. G.A.117

Y1

Y3

Y4

+450 AJANTA. C.I.P.31
INDIA

Y5

+525 DIPTYCH
PHILOXENUS
D.C.D. XXX

Y9

DENMARK. M.A.K.224

T97

+150
PANCRATII TOMB
M.A.A. IV.XXXIII

+620. ANAHITA
TAQ I BUSTAN
DRESS H.F.D. LXV

Y2

+
546
S.VITALE, RAVEN.
R.S.79

+546 S. VITALE Φ
RAVENNA

Y6

+706
S.MARIA, ANTICA. ROME Φ

Y7

+770
S.MARIA, ANTICA
ROME F.P.

Y8

+770
S.MARIA CIVIDALE Φ

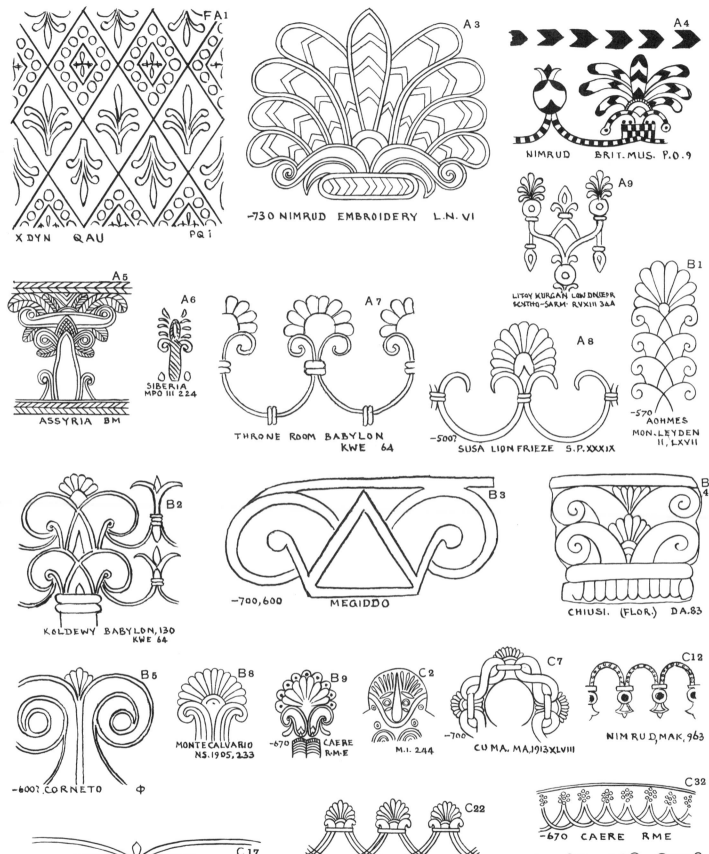

FA1

X DYN QAU PQi

-730 NIMRUD EMBROIDERY L.N. VI

A3

A4

NIMRUD BRIT. MUS. P.0.9

A9

LITOY KURGAN LOW DNIEPR
SCYTHO-SARM. RVXIII 3AA

A5

ASSYRIA BM

A6

SIBERIA
MPO III 224

A7

THRONE ROOM BABYLON
KWE 64

A8

-500? SUSA LION FRIEZE S.P. XXXIX

B1

-570 AOHMES
MON. LEYDEN
II, LXVII

B2

KOLDEWY BABYLON, 130
KWE 64

B3

-700,600 MEGIDDO

B4

CHIUSI. (FLOR.) DA.83

B5

-600? CORNETO Φ

B8

MONTE CALVARIO
NS.1905,233

B9

-670 CAERE
R·M·E

C2

M.I. 244

C7

-700 CUMA. MA,1913 XLVIII

C12

NIMRUD, MAK, 963

C32

-670 CAERE RME

C22

FALERII M.I. 327.13

C37

C17

-600?
CERVETRI SEDIA CORSINI
MA 1916, 458, V

C27

CHIUSI, PANIA M.I. 225.7.

PRAENESTE, BARBERINI TOMB
ROUGH IVORY. M·A·A·V.10

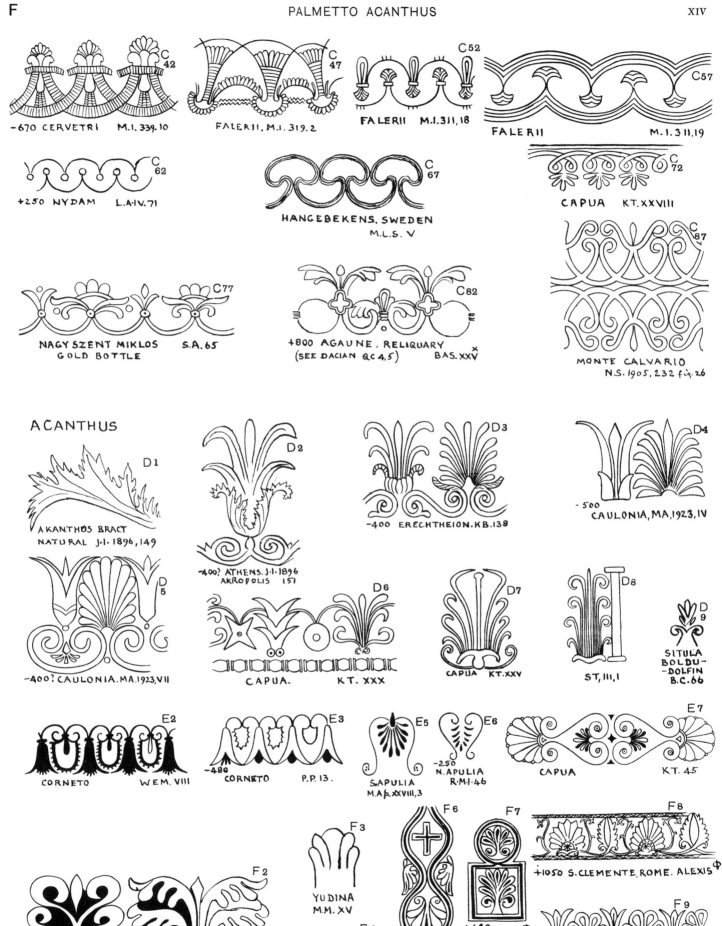

-670 CERVETRI M.I.339.10 C42

FALERII, M.I.319.2 C47

FALERII M.I.311,18 C52

FALERII M.I.311.19 C57

+250 NYDAM L.A·IV·71 C62

HANGEBEKENS, SWEDEN
M.L.S. V C67

CAPUA KT.XXVIII C72

NAGY SZENT MIKLOS S.A.65
GOLD BOTTLE C77

+800 AGAUNE, RELIQUARY
(SEE DACIAN QC 4,5) BAS. XXV C82

MONTE CALVARIO
N.S.1905,232 fig.26 C87

ACANTHUS

AKANTHÓS BRACT
NATURAL J·I·1896,149 D1

-400? ATHENS. J·I·1896
AKROPOLIS 151 D2

-400 ERECHTHEION.KB.138 D3

-500
CAULONIA, MA,1923, IV D4

-400? CAULONIA.MA.1923,VII D5

CAPUA. KT. XXX D6

CAPUA KT.XXV D7

ST, III,1 D8

SITULA
BOLDU-
DOLFIN
B.C.66 D9

CORNETO W.E.M. VIII E2

CORNETO P.P. 13. E3

S.APULIA
M.A.β.XXVIII,3 E5

-250
N.APULIA
R.M.I.46 E6

CAPUA KT. 45 E7

YUDINA
M.M. XV F3

F6

F7

+1050 S.CLEMENTE, ROME. ALEXIS Φ F8

+160 BAALBEK, ALTAR COURT. F2

S.B.I,103 +200 COTTAEUM
J.R.S 1925 XXIII F4

+640 Φ
SYRACUSE
JAMB

+640 Φ
SYRACUSE
JAMB

FOSCHERARI BOLOGNA Φ F9

FLEUR-DE-LIS

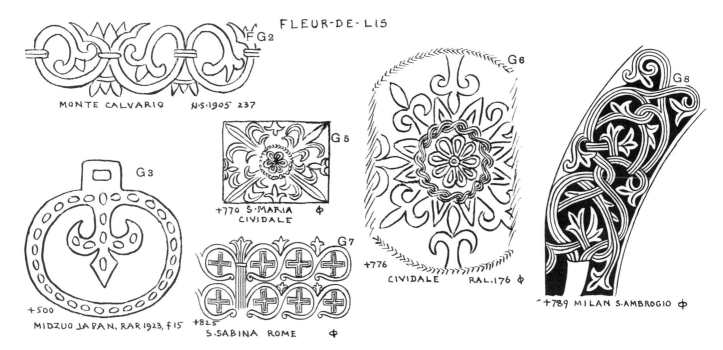

FG2

MONTE CALVARIO N·S·1905 237

G3

+500
MIDZUO JAPAN, RAR 1923, f 15

G5
+770 S·MARIA
CIVIDALE φ

G7
+825
S·SABINA ROME φ

G6

+776
CIVIDALE RAL·176 φ

G8

+789 MILAN S·AMBROGIO φ

FORMAL FLOWERS

H1
LM II
KNOSSOS EPM II 285

H2
SEE LS56
LM II
KNOSSOS, A, 1914 66

H3
LATE
HEL. II
KORAKOU, BK· VII

H4
MYKENAE, JHS, XXIV

H5
CRETE
MOSSO KB. 84

H6
MMII PALAIKASTRO
ABS. 1923 SUPP. 26

H7
LM·III·PALAIKASTRO

H8
ABS, 1923 SUPP·XXIII

H9
−1200
SPATA FLM·XVII

J3
−670
CUMA R·M·I· 53

J6
−400 ARCHENA, MURCIA RV·I xlii

J4
J5
−670
CUMA M·A·1913,30; R·M·I·pl.36

J73
XVII KAMES SPEAR
ESB 30

J74
MYKENAE

J7
MMIII KNOSSOS FAIENCE
ABS 1903 67

J8
LM II
BSA1903
p311, 9.

J9
LM II· PYLOS, MAIA 1909 290

J95
1450 IALYSOS, SAA 1926, 53

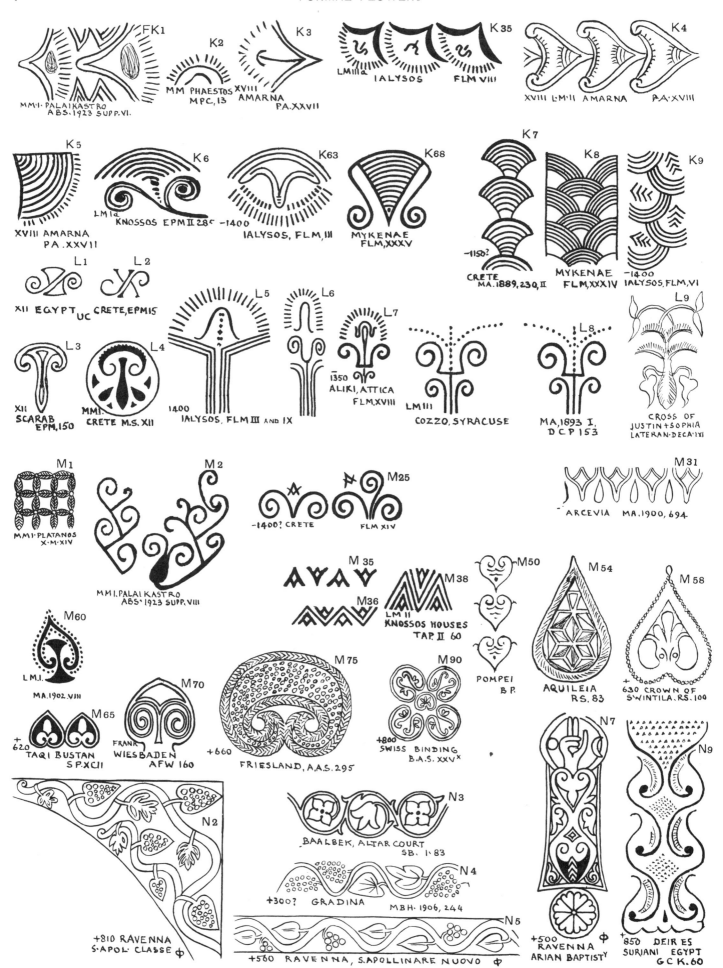

FK1 — MM·I. PALAIKASTRO A.B.S.1923 SUPP.VI.

K2 — MM PHAESTOS XVIII MPC.13

K3 — AMARNA P.A.XXVII

K35 — LMIIIa IALYSOS FLM VIII

K4 — XVIII L·M·II AMARNA P.A.XVIII

K5 — XVIII AMARNA P.A.XXVII

K6 — LMI a KNOSSOS EPM II 285 ~1400

K63 — IALYSOS, FLM, III

K68 — MYKENAE FLM,XXXV

K7 — ~1150? CRETE MA.1889,230,II

K8 — MYKENAE FLM,XXXIV

K9 — ~1400 IALYSOS,FLM,VI

L1 — XII EGYPT UC

L2 — CRETE,EPM15

L3 — XII SCARAB EPM,150

L4 — MM·I. CRETE M.S.XII

L5 — 1400 IALYSOS, FLM III AND IX

L6 —

L7 — 1350 ALIKI, ATTICA FLM.XVIII

L8 — LM III COZZO, SYRACUSE

L8 — MA,1893 I, D C P 153

L9 — CROSS OF JUSTIN+SOPHIA LATERAN·DECA·IXI

M1 — MM·I·PLATANOS X·M·XIV

M2 — MM I. PALAIKASTRO ABS· 1923 SUPP.VIII

M25 — ~1400? CRETE FLM XIV

M31 — ARCEVIA MA.1900,694.

M35 — M36 —

M38 — LM II KNOSSOS HOUSES TAP.II 60

M50 — POMPEI B P.

M54 — AQUILEIA RS. 83

M58 — 630 CROWN OF SWINTILA.RS.100

M60 — LM·I. MA.1902.VIII

M65 — 620 TAQI BUSTAN S.P.XCII

M70 — FRANK WIESBADEN AFW 160

M75 — +660 FRIESLAND, A.A.S.295

M90 — +800 SWISS BINDING B.A.S.XXVX

N2 — +810 RAVENNA S.APOL·CLASSE Φ

N3 — BAALBEK, ALTAR COURT SB. I. 83

N4 — +300? GRADINA MBH·1906, 244

N5 — +560 RAVENNA, S.APOLLINARE NUOVO Φ

N7 — +500 RAVENNA ARIAN BAPTISTY Φ

N9 — 850 DEIR ES SURIANI EGYPT G C K. 60

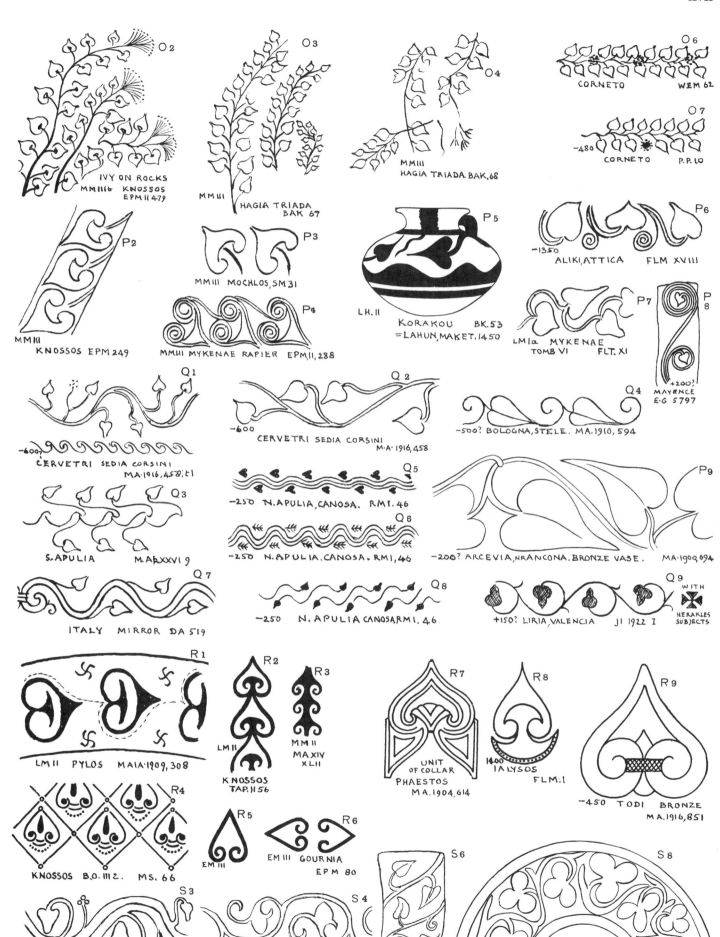

O 2 — IVY ON ROCKS MM III6 KNOSSOS EPM II 479

O 3 — MM III HAGIA TRIADA BAK 67

O 4 — MM III HAGIA TRIADA BAK. 68

O 6 — CORNETO W.EM 62

O 7 — −480 CORNETO P.P. 10

P 2 — MM III KNOSSOS EPM 249

P 3 — MM III MOCHLOS, SM 31

P 4 — MM III MYKENAE RAPIER EPM, II, 288

P 5 — LH. II KORAKOU BK. 53 = LAHUN, MAKET. 1450

P 6 — −1350 ALIKI, ATTICA FLM XVIII

P 7 — LM Iα MYKENAE TOMB VI FLT. XI

P 8 — +200? MAYENCE E·G 5797

Q 1 — −600? CERVETRI SEDIA CORSINI MA.1916,458, b1

Q 2 — −600 CERVETRI SEDIA CORSINI M·A·1916,458

Q 4 — −500? BOLOGNA, STELE. MA.1910, 594

Q 3 — S. APULIA M. AP.XXVI 9

Q 5 — −250 N. APULIA, CANOSA. RM I. 46

Q 6 — −250 N. APULIA. CANOSA. RM I, 46

P 9 — −200? ARCEVIA, nr ANCONA. BRONZE VASE. MA.1909,694

Q 7 — ITALY MIRROR DA 519

Q 8 — −250 N. APULIA CANOSA RM I. 46

Q 9 — +150? LIRIA, VALENCIA JI 1922 I WITH HERAKLES SUBJECTS

R 1 — LM II PYLOS MA IA·1909, 308

R 2 — LM II KNOSSOS TAP. J 56

R 3 — MM II MA XIV XLII

R 7 — UNIT OF COLLAR PHAESTOS MA.1904,614

R 8 — 1400 IALYSOS FLM: I

R 9 — −450 TODI BRONZE MA.1916,851

R 4 — KNOSSOS B.O. III 2. MS. 66

R 5 — EM III

R 6 — EM III GOURNIA EPM 80

S 6

S 8 — COPTIC MOSCOW GC. LXIV. 5

S 3 — +50 SIYA GATE BSA. 6, III 340

S 4 — +220 TO 241 CHINA SAC XII

+506 TRIPTYCH AREOBINDUS DCD XV

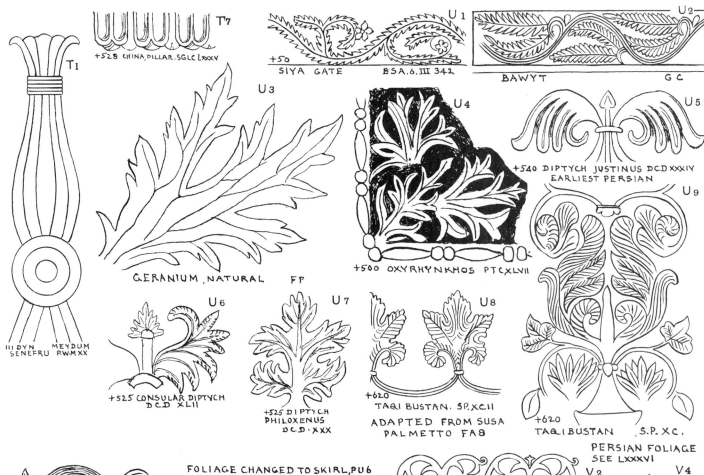

T7
+528 CHINA, PILLAR. SGLC LXXXV

U1
+50
SIYA GATE B.SA.6.III 342

U2
BAWYT G C

T1
III DYN MEYDUM
SENEFRU P.W.M XX

U3
GERANIUM, NATURAL FP

U4
+500 OXYRHYNKHOS PT CXLVII

U5
+540 DIPTYCH JUSTINUS DCD XXXIV
EARLIEST PERSIAN

U9

U6
+525 CONSULAR DIPTYCH
DCD XLII

U7
+525 DIPTYCH
PHILOXENUS
DCD · XXX

U8
+620
TAQI BUSTAN. SP.XCII
ADAPTED FROM SUSA
PALMETTO FA8

+620
TAQI BUSTAN S.P. XC.

PERSIAN FOLIAGE
SEE LXXXVI

FOLIAGE CHANGED TO SKIRL, PU6

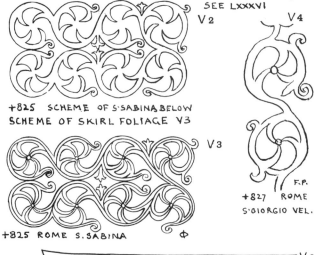

V2 **V4**

+825 SCHEME OF S·SABINA BELOW
SCHEME OF SKIRL FOLIAGE V3

V1
+650 OR 750
S.MARIA
ANTIQUA
ROME F.P.

V5

V3
+825 ROME S.SABINA Φ

F.P.
+827 ROME
S·GIORGIO VEL.

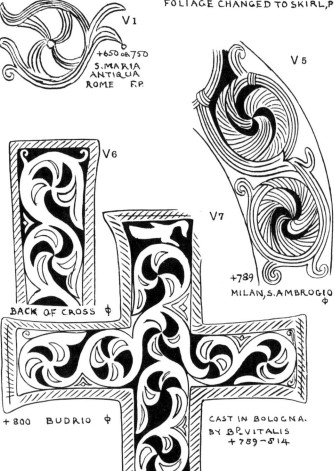

V6
BACK OF CROSS Φ

V7
+789
MILAN, S.AMBROGIO
Φ

+800 BUDRIO Φ

CAST IN BOLOGNA.
BY BP. VITALIS
+789 - 814

V8
+840 CROSS OF LUDOVICUS + LOTHARIUS, BOLOGNA Φ
SKIRL BROKEN LOOSE

PETALS GROUPED
TO SKIRL

V9
BOLOGNA
REUSED IN FOSCHERARI TOMB. Φ

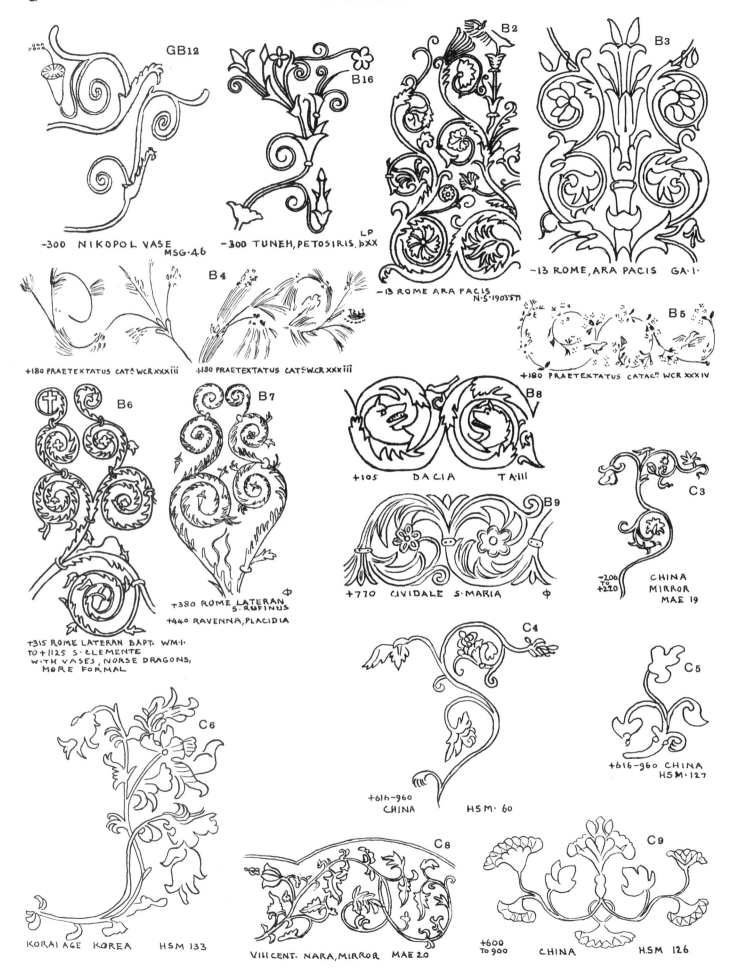

GB12

-300 NIKOPOL VASE
MSG·46

B16

-300 TUNEH, PETOSIRIS. bXX
LP

B2

-13 ROME ARA PACIS
N·S·1903·571

B3

-13 ROME, ARA PACIS GA·1·

B4

+180 PRAETEXTATUS CAT⁰ WCR XXXiii

+180 PRAETEXTATUS CAT^W.CR XXXiii

B5

+180 PRAETEXTATUS CATAC^ WCR XXXIV

B6

B7

+380 ROME LATERAN
S. RUFINUS
+440 RAVENNA, PLACIDIA

+315 ROME LATERAN BAPT. WM·1·
TO +1125 S· CLEMENTE
WITH VASES, NORSE DRAGONS,
MORE FORMAL

B8

+105 DACIA TA·III

B9

+770 CIVIDALE S·MARIA

C3

-206
TO
+220 CHINA
MIRROR
MAE 19

C4

+616-960
CHINA HSM· 60

C5

+616-960 CHINA
HSM·127

C6

KORAI AGE KOREA HSM 133

C8

VIII CENT. NARA, MIRROR MAE 20

C9

+600
TO 900 CHINA H.SM 126

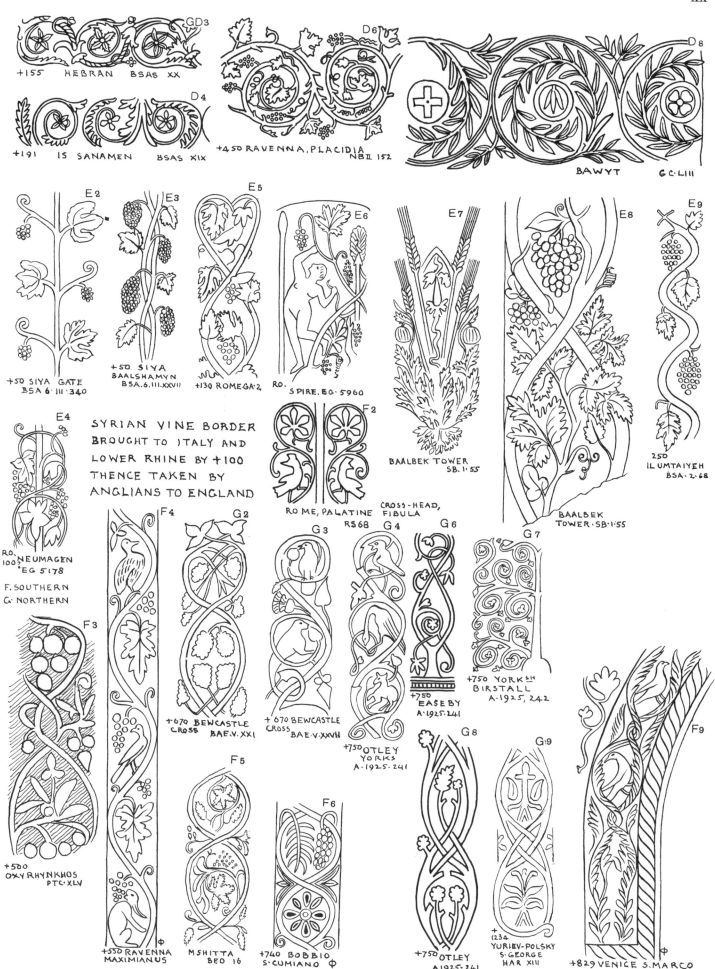

GD3
+155 HEBRAN BSAS XX

D4
+191 IS SANAMEN BSAS XIX

D6
+450 RAVENNA, PLACIDIA
NBII 152

D8
BAWYT G C·LIII

E2
+50 SIYA GATE
BSA 6·III·340

E3
+50· SIYA
BAALSHAMYN
BSA.6.III.XXVII

E5
+130 ROMEGA·2

E6
RO.
SPIRE. EG. 5960

E7
BAALBEK TOWER
SB. I· 55

E8
BAALBEK
TOWER·SB·I·55

E9
250
IL UMTAIYEH
BSA·2·68

E4
RO.
100· NEUMAGEN
·EG 5178

F. SOUTHERN
G· NORTHERN

SYRIAN VINE BORDER
BROUGHT TO ITALY AND
LOWER RHINE BY +100
THENCE TAKEN BY
ANGLIANS TO ENGLAND

F2
ROME, PALATINE
RS68

CROSS-HEAD,
FIBULA

F3
+500
OXYRHYNKHOS
PTC·XLV

F4
+670 BEWCASTLE
CROSS BAE·V·XXI

G2
G3
+670 BEWCASTLE
CROSS BAE·V·XXVII

G4
+750 OTLEY
YORKS
A·1925·241

G6
+750
EASEBY
A·1925·241

G7
+750 YORKᵉʰ
BIRSTALL
A·1925, 242

F5
+550 RAVENNA
MAXIMIANUS

M.SHITTA
BEO 16

F6
+740 BOBBIO
S·CUMIANO

G8
+750 OTLEY
A 1925·241

G9
+
1234
YURIEV-POLSKY
S·GEORGE
HAR XIII

F9
+829 VENICE S.MARCO

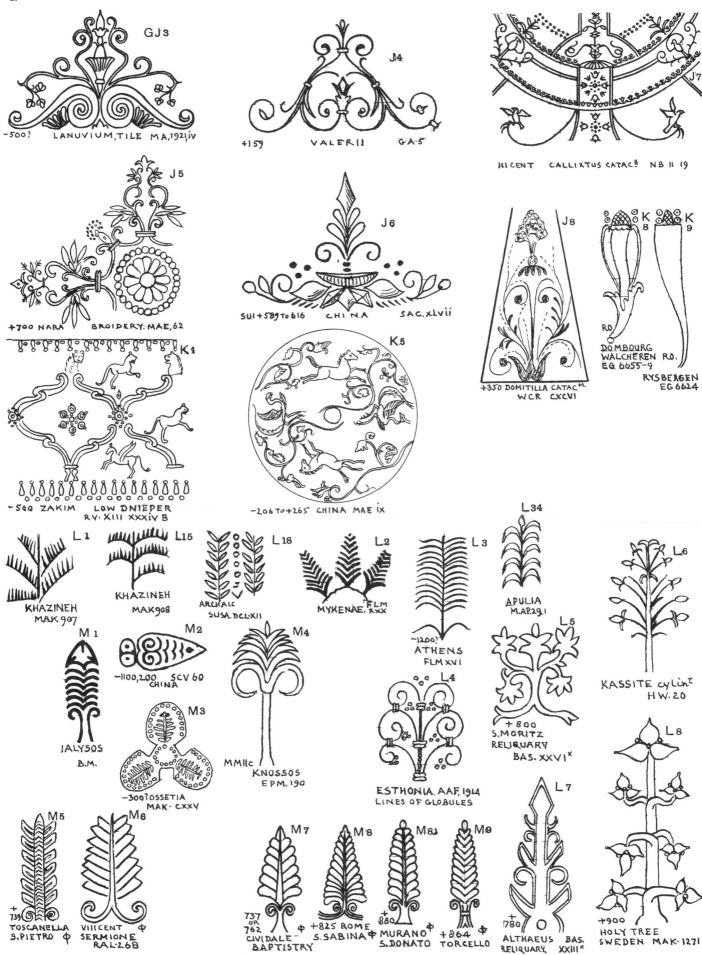

GJ3

-500? LANUVIUM, TILE MA,1921,iv

J4

+159 VALERII G.A.5

J7

HI CENT CALLIXTUS CATAC.B NB II 19

J5

+700 NARA BROIDERY. MAE, 62

J6

SUI +589 To 616 CHINA SAC. XLVII

J8

+350 DOMITILLA CATAC M. WCR CXCVI

K8 K9

RO. DOMBOURG WALCHEREN RO. EG 6655-9

RYSBERGEN EG 6624

K1

-500 ZAKIM LOW DNIEPER RV. XIII XXXIV B

K5

-206 To +265 CHINA MAE ix

L1 KHAZINEH MAK 907

L15 KHAZINEH MAK 908

L18 ARCHAIC SUSA. DCLXII

L2 MYKENAE. XXX FLM

L3 -1200? ATHENS FLM XVI

L34 APULIA M. AP.29.1

L6 KASSITE cylin.r H.W. 20

M1 JALYSOS B.M.

M2 -1100,200 SCV 60 CHINA

M3 -300? OSSETIA MAK. CXXV

M4 MMIIc KNOSSOS EPM. 19a

L4 ESTHONIA. AAF, 1914 LINES OF GLOBULES

L5 +800 S. MORITZ RELIQUARY BAS. XXVI x

L8 +900 HOLY TREE SWEDEN MAK. 1271

L7 +780 ALTHAEUS RELIQUARY BAS. XXIII x

M5 +739 TOSCANELLA S. PIETRO φ

M6 VII CENT SERMIONE RAL.268 φ

M7 737 OR 762 CIVIDALE BAPTISTRY φ

M8 +825 ROME S. SABINA φ

M81 +880 MURANO S. DONATO φ

M9 +864 TORCELLO φ

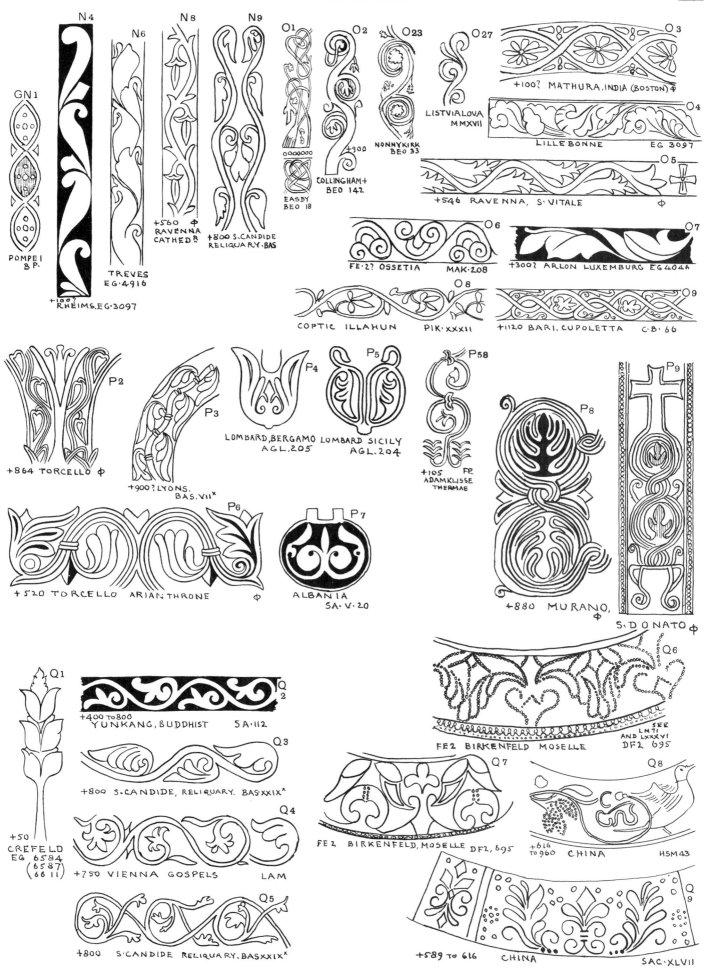

GN1

POMPEI
B.P.

N4

+100?
RHEIMS. EG·3097

N6

TREVES
EG·4916

N8

+560 Φ
RAVENNA
CATHED.

N9

+800 S.CANDIDE
RELIQUARY·BAS

O1

EASBY
BEO·18

O2

COLLINGHAM+
BEO·142

+900

O23

NONNYKIRK
BEO·33

O27

LISTVIALOVA
MMXVII

O3

+100? MATHURA, INDIA (BOSTON) Φ

O4

LILLEBONNE EG·3097

O5

+546 RAVENNA, S·VITALE Φ

O6

FE·2? OSSETIA MAK·208

O7

+300? ARLON LUXEMBURG EG·404A

O8

COPTIC ILLAHUN PIK·XXXII

O9

+1120 BARI, CUPOLETTA C·B·66

P2

+864 TORCELLO Φ

P3

+900? LYONS.
BAS·VII×

P4

LOMBARD, BERGAMO
AGL·205

P5

LOMBARD SICILY
AGL·204

P58

+105 FR
ADAMKLISSE
THERMAE

P8

+880 MURANO,

P9

S·DONATO Φ

P6

+520 TORCELLO ARIAN THRONE Φ

P7

ALBANIA
SA·V·20

Q1

+50
CREFELD
EG·6584
(6587)
(6611)

Q2

+400 TO 800
YUNKANG, BUDDHIST SA·112

Q3

+800 S·CANDIDE, RELIQUARY·BAS·XXIX×

Q4

+750 VIENNA GOSPELS LAM

Q5

+800 S·CANDIDE RELIQUARY·BAS·XXIX×

Q6

FE2 BIRKENFELD MOSELLE
SEE
LN·7I
AND LXXXVI
DF2 695

Q7

FE2 BIRKENFELD, MOSELLE DF2, 695

Q8

+616
TO 960 CHINA HSM43

Q9

+589 TO 616 CHINA SAC·XLVII

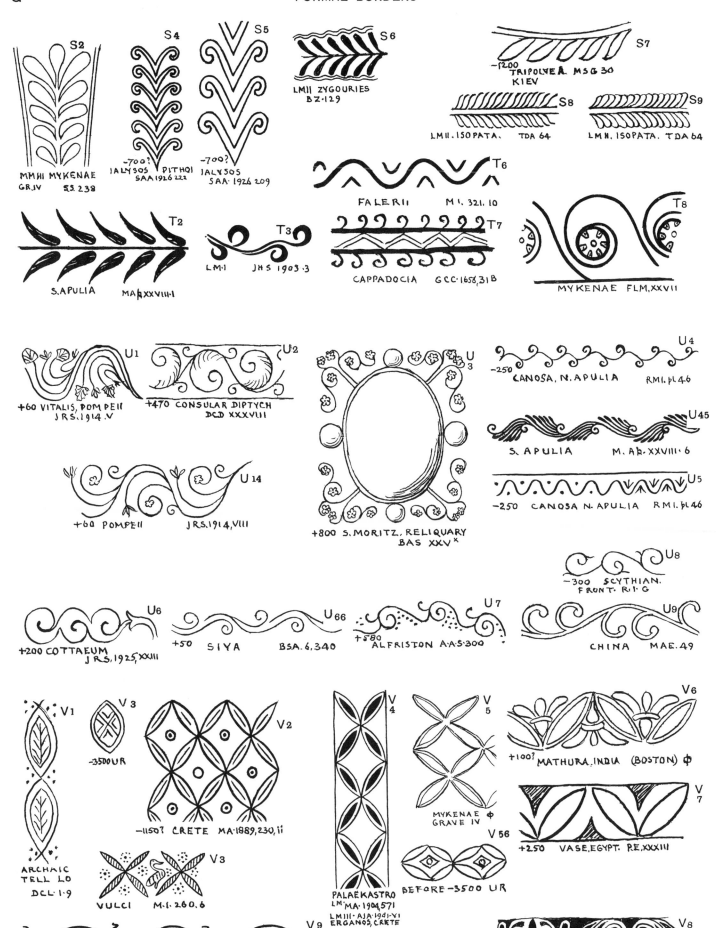

S2 MMHI MYKENAE GR.IV 55.238

S4 -700? IALYSOS PITHOI SAA 1926 222

S5 -700? IALYSOS SAA·1926 209

S6 LMII ZYGOURIES BZ·129

S7 -1200 TRIPOLYE A. MSG 30 KIEV

S8 LMII·ISOPATA. TDA 64

S9 LM II. ISOPATA. TDA 64

T2 S.APULIA MA.XXVIII·1

T3 LM·1 JHS 1903·3

T6 FALERII M·1. 321. 10

T7 CAPPADOCIA GCC·1658,31B

T8 MYKENAE FLM.XXVII

U1 +60 VITALIS, POMPEII JRS.1914.V

U2 +470 CONSULAR DIPTYCH DCD XXXVIII

U14 +60 POMPEII JRS.1914,VIII

U3 +800 S.MORITZ, RELIQUARY BAS XXVˣ

U4 -250 CANOSA, N.APULIA RMI·pl.46

U45 S.APULIA M. AB.XXVIII·6

U5 -250 CANOSA N.APULIA RMI·pl 46

U8 -300 SCYTHIAN. FRONT·R·1·G

U6 +200 COTTAEUM JRS,1925,XXIII

U66 +50 SIYA BSA.6,340

U7 +580 ALFRISTON A·A·S·300

U9 CHINA MAE.49

V1 ARCHAIC TELL LO DCL·1·9

V3 -3500 UR

V2 -1150? CRETE MA·1889,230,ii

V3 VULCI M·1·260.6

V4 PALAEKASTRO LM·MA·1904,571 LMIII·AJA·1941·VI ERGANOS,CRETE

V5 MYKENAE Φ GRAVE IV

V56 BEFORE -3500 UR

V6 +100? MATHURA,INDIA (BOSTON) Φ

V7 +250 VASE,EGYPT. P.E.XXXIII

V9 +440 RAVENNA GALLA PLACIDIA Φ

V8 TENE HELMET,BERRU M·F·S SEE ES6

GW 1

+616 to 960 CHINA HSM 58

+450 HASLINGFIELD, CAMBS. A·A·S·17 W5

W 2

-206 to +25 CHINA SAC·XX

W 4

+220 to 41 CHINA SAC XIII

W 6

+220 to 241 CHINA SAC XI

W 7

+600 (SUI or TANG) CHINA SEE LR8 HS M. 108

W 8

+265 to 300 CHINA SAC XLII

W 9

+589 to 616 CHINA SAC XLV

X 2

GOTHIC
RECESVINTH
CLUNY. OTP. II, 11

X 5

TARQUINII
MKE 204

X 7

MMIIa KNOSSOS
KAMARES WARE
EPM iii

X 9

+700? JSA III 15
QASR HARANEH

Z 1

LM·I· PALAIKASTRO
ABS. 1905, 276

Z 2

BR.
KOBAN
MAK·XXIV

Z 8

X 3

BRONZE AXE
KOBAN
MAK 25

X 6

PETROSSA
COLLAR OTP. II. 74

X 8

+500 HONAN
SSC XCIII

+546 RAVENNA
S. VITALE φ

Y 2

-700?
CUMA
MA, 1913, XLII

Y 3

POMPEII B.P.

Y 5

FE. 1
GRANDATE
COMO BC. 56

Y 6

Z 3

MM II KNOSSOS EPM, 186

Z 4

+825
ROME, S. SABINA φ

Z 9

Z 5

+200?
BAIA MA. 1922. 138

Y 8

+1050 S. CLEMENTE, ROME. BENO, φ

HALLSTATT
B.C. 54

Z 6

MM II KNOSSOS, EPM 186

Z 7

MMI, KNOSSOS
EPM. 186

+752 φ
CIVIDALE
CROSS OF
PELTRUDIS.

HA1

A8

−570
NAUKRT
JHS 1924 XI

BABYLONIA
J.C.B. LIII

4

B3

TELL LO, DCL I, 14

B4

ARCHAIC
TELL LO DCL I, 10

B6

ARCHAIC, SUSA, DCL, XVIII-17

B8

CAPPADOCIA
GCC I 9810

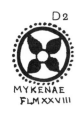

C2

+60 POTTER MEMOR,
POMPEII. JRS. 1914, XIV

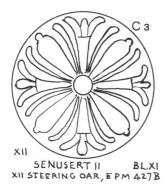

C3

XII
SENUSERT II BL. XI
XII STEERING OAR, EPM 427B

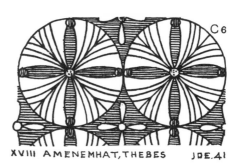

C6

XVIII AMENEMHAT, THEBES JOE. 41

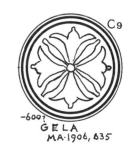

C9

−600?
GELA
MA. 1906, 635

D2

MYKENAE
FLM XXVIII

D4

−600
NAUKRATIS
P. NK IV

D5

−350 PIKERMI ATTICA
RELIEF, MAIA, 1924, 12

D6

WOODCHESTER
L·W· VII

D7

+100?
WORMS
L·A·V·1200a

D8

TAQ I BUSTAN HFD XXV

D9

MIKHAILOF POLAND?
JOAI·1906·32

5

E3

XVIII AMARNA
P.A. XVIII

E4

LM III ABS. 1903, 318, 17

E6

−730
NIMRUD
BELT,
LN. XXVI

E8

−700?
MELOS
K B, 113

6

F4

ARCHAIC, SUSA
DCL, XVI, 21

F6

CRETE M.S. III

F9

−570
NAUKRATIS
JHS·1924·XI

7

G1

−570
NAUKRATIS
JHS 1924 XI

G4

+600
NOCERA
MA. 1918, 243

G6

+600
NOCERA, A/ DISK
MA 1918 343

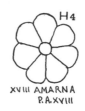

G8

COMMINGES EG 882

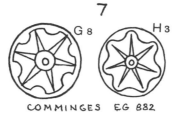

H3

H4

XVIII AMARNA
P.A. XVIII

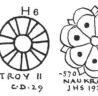

H6

TROY II
C·D·29

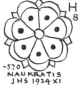

H8

−570
NAUKRATIS
JHS 1924 XI

H9

SASSANIAN HFD LXV
E. TURKESTAN

8

J1

MMI
PORTI
X. M. VIII

J3

MM II KNOSSOS, EPM, 194

J4

MM III
MOCHLOS, SM 35

J5

XVIII
GUROB, PIK
XXVI

J6

CRETE, HS. 25

J8

RELIEF
ASHUR
A.C.A. p·9

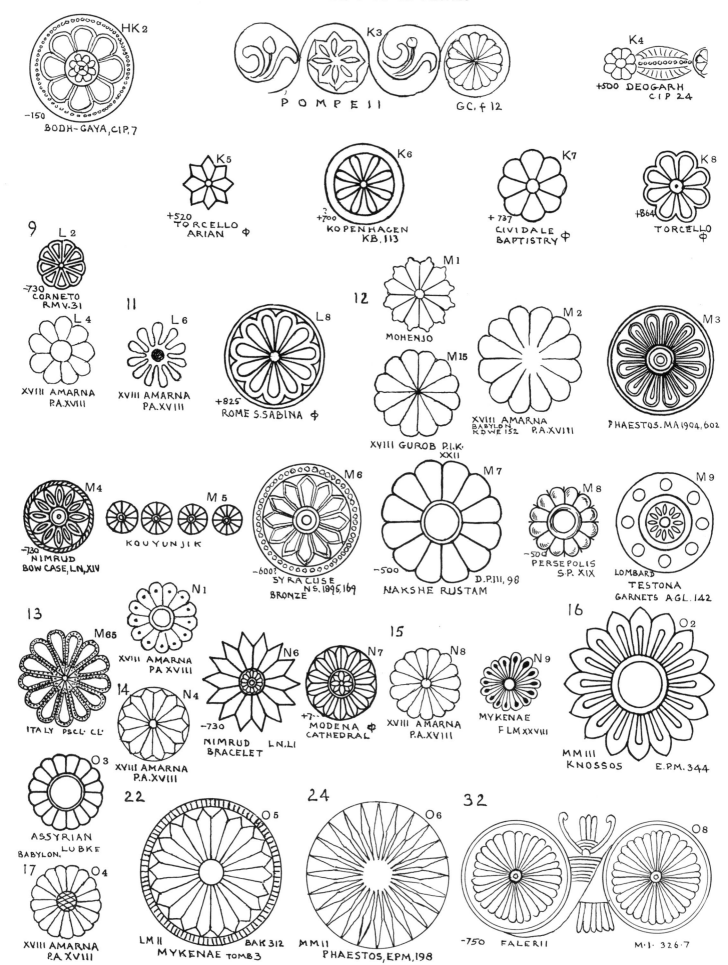

HK 2
-150
BODH-GAYA, CIP, 7

K 3
POMPEII
GC, f 12

K 4
+500 DEOGARH
CIP 24

K 5
+520
TORCELLO
ARIAN Φ

K 6
?
+700
KOPENHAGEN
KB, 113

K 7
+737
CIVIDALE
BAPTISTRY Φ

K 8
+864
TORCELLO
Φ

9
L 2
-730
CORNETO
RMV. 31

L 4
XVIII AMARNA
P.A. XVIII

11
L 6
XVIII AMARNA
PA. XVIII

L 8
+825
ROME S. SABINA Φ

12
M 1
MOHENJO

M 15
XVIII GUROB P.I.K.
XXII

M 2
XVIII AMARNA
BABYLON
KDWE 152 P.A. XVIII

M 3
PHAESTOS. MA 1904, 602

M 4
-730
NIMRUD
BOW CASE, LN, XIV

M 5
KOUYUNJIK

M 6
-600?
SYRACUSE
NS. 1895, 169
BRONZE

M 7
-500
NAKSHE RUSTAM
D.P. III, 98

M 8
-500
PERSEPOLIS
S.P. XIX

M 9
LOMBARD
TESTONA
GARNETS AGL. 142

13
M 65
ITALY PSCL· CL·

N 1
XVIII AMARNA
PA XVIII

14
N 4
XVIII AMARNA
P.A. XVIII

N 6
-730
NIMRUD
BRACELET LN. LI

N 7
+7···
MODENA Φ
CATHEDRAL

N 8
XVIII AMARNA
P.A. XVIII

N 9
MYKENAE
F LM XXVIII

15

16
O 2
MM III
KNOSSOS E.P.M. 344

O 3
ASSYRIAN
BABYLON. LUBKE

17
O 4
XVIII AMARNA
P.A. XVIII

22
O 5
LM II
MYKENAE TOMB 3 BAK 312

24
O 6
MM II
PHAESTOS, EPM, 198

32
O 8
-750 FALERII M·I· 326·7

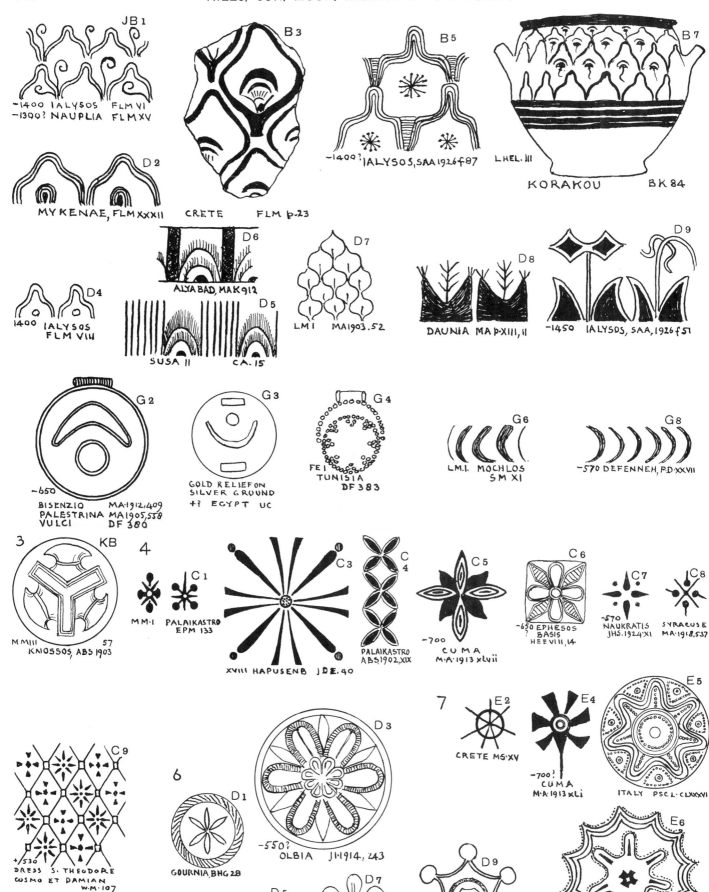

JB1 -1400 IALYSOS FLM VI
-1300? NAUPLIA FLM XV

D2 MYKENAE, FLM XXXII

B3 CRETE FLM p.23

B5 -1400? IALYSOS, SAA 1926 f 87

B7 L.HEL. III KORAKOU BK 84

D4 1400 IALYSOS FLM VIII

D6 ALYA BAD, MAK 912
D5 SUSA II CA. 15

D7 LM I MA 1903. 52

D8 DAUNIA MA p. XIII, 11

D9 -1450 IALYSOS, SAA, 1926 f 51

G2 -650 BISENZIO MA 1912, 409
PALESTRINA MA 1905, 558
VULCI DF 380

G3 GOLD RELIEF ON SILVER GROUND +? EGYPT UC

G4 FE I TUNISIA DF 383

G6 LM. I. MOCHLOS SM XI

G8 -570 DEFENNEH, P.D. XXVII

3 KB MM III 57 KNOSSOS, ABS 1903

4 MM·I C1 PALAIKASTRO EPM 133

C3 XVIII HAPUSENB J DE. 40

C4 PALAIKASTRO ABS 1902, XIX

C5 -700 CUMA M·A· 1913 xLvii

C6 -650 EPHESOS BASIS HEE VIII, 14

C7 -570 NAUKRATIS JHS. 1924 XI

C8 SYRACUSE MA 1918, 537

C9 +530 DRESS S. THEODORE COSMO ET DAMIAN W.M. 107

6 D1 GOURNIA, BHG 28

D3 -550? OLBIA J I.1914, 243

7 E2 CRETE MS. XV

E4 -700? CUMA M·A· 1913 xLi

E5 ITALY PSCL. CLXXXVI

D5 -500 ESTE R.M.I.7.7 BENVENUTE SITULA MM III KNOSSOS ABS 1903 82

D7 +1000 STROGANOFF IVORY WSA XXVI

D9 +570 FAIR·FORD AAS 28

E6 MONT·IV U.P. BAVARIA, SAK·127

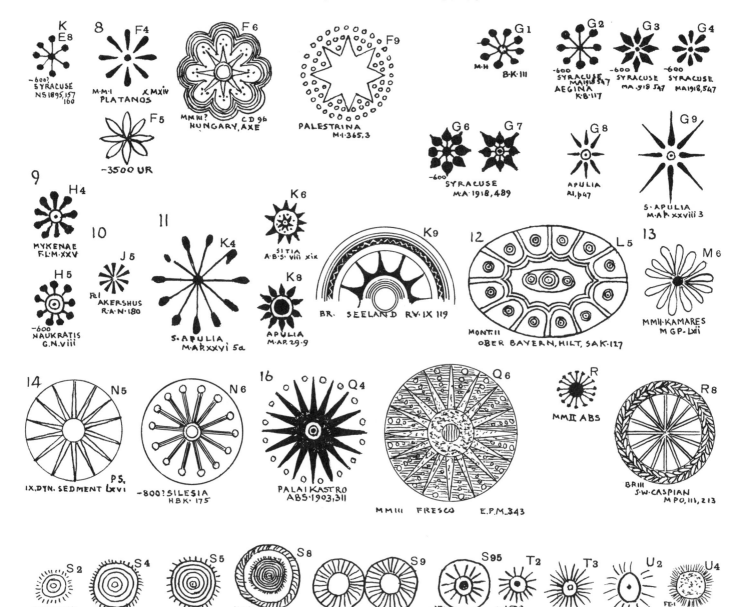

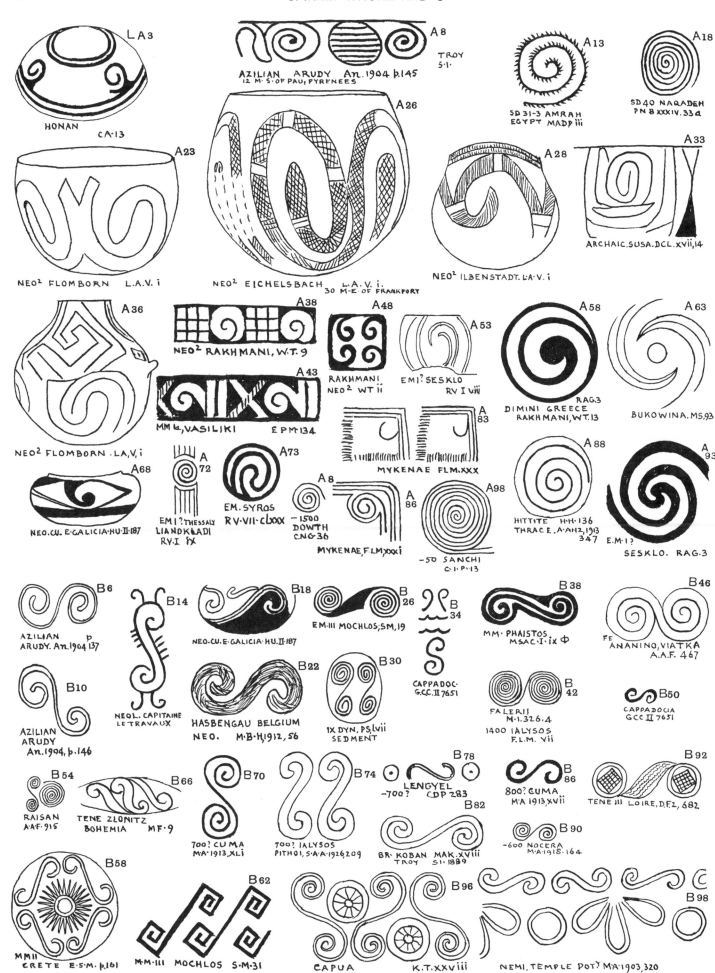

LA3
HONAN CA·13

A8
AZILIAN ARUDY An.1904 p.145
12 M·S·OF PAU, PYRENEES
TROY 5·1·

A13
SD 31-3 AMRAH
EGYPT MADP iii

A18
SD 40 NAQADEH
PN B XXXIV. 33 d

A26

A23
NEO² FLOMBORN L·A·V·i

NEO² EICHELSBACH L·A·V·i·
30 M·E·OF FRANKFORT

A28
NEO² ILBENSTADT·LA·V·i

A33
ARCHAIC·SUSA·DCL·XVII,14

A36
NEO² FLOMBORN·LA,V,i

A38
NEO² RAKHMANI, W.T. 9

A43
MM 4,VASILIKI E PM 134

A48
RAKHMANI
NEO² WT ii

A53
EM I? SESKLO
RV I viii

A
83
MYKENAE FLM.XXX

A58
DIMINI GREECE
RAKHMANI, W.T. 13
RAG.3

A63
BUKOWINA. M5,93

A68
NEO·CU. E·GALICIA·HU·II·187

A
72
EM I?·THESSALY
LIANOKLADI
RV·I IX

A73
EM. SYROS
RV·VII·CLXXX

A8
86
-1500
DOWTH
CNG·36

MYKENAE,F.LM.XXXi

A98
-50 SANCHI
C·I·P·13

A88
HITTITE H·H·136
THRACE A·AH2,1913
347

A
93
E.M·I?
SESKLO. RAG.3

B6
AZILIAN
ARUDY. An.1904 137 p

B10
AZILIAN
ARUDY
An.1904, p.146

B14
NEOL. CAPITAINE
LE TRAVAUX

B18
NEO·CU·E·GALICIA·HU·II·187

B22
HASBENGAU BELGIUM
NEO. M·B·H,1912, 56

B
26
EM·III MOCHLOS;SM, 19

B30
IX DYN, PS,lvii
SEDMENT

B
34

B38
MM· PHAISTOS
MSAC·I·ix Φ

CAPPADOC.
G.CC.II 7651

B
42
FALERII
M·1.326.4
1400 IALYSOS
F.L.M. Vii

B46
FE
ANANINO,VIATKA
A.A.F. 467

B50
CAPPADOCIA
GCC II 7651

B54
RAISAN
A·A·F. 915

B66
TENE ZLONITZ
BOHEMIA MF·9

B70
700? CUMA
M·A 1913.XLi

B74

B
78
LENGYEL
-700? CDP 283

B82
BR·KOBAN MAK.XVIII
TROY SI·1889

B
86
800? CUMA
M·A 1913.XVii

B90
-600 NOCERA
M·A.1918.164

B92
TENE III LOIRE, D.F.2, 682

700? IALYSOS
PITHOI, S·A·A·1926,209

B58
MM II
CRETE E·S·M·p.161

B62
M·M·III MOCHLOS S·M·31

B96
CAPUA K·T·XXViii

C
B98
NEMI, TEMPLE POT? M·A·1903, 320

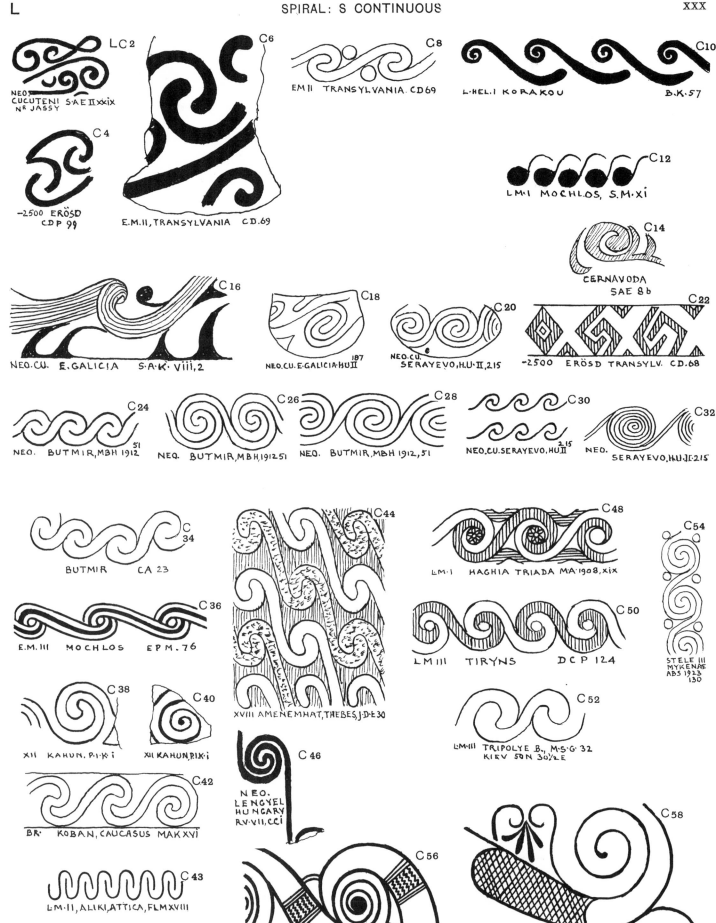

LC2
NEO. CUCUTENI S·AE II xxix
Nʳ JASSY

C4
~2500 ERÖSD
CDP 99

C6
E.M.II, TRANSYLVANIA CD.69

C8
EM II TRANSYLVANIA. CD69

C10
L·HEL·I KORAKOU B·K·57

C12
LM·I MOCHLOS, S.M·XI

C14
CERNAVODA SAE 8b

C16
NEO.CU. E.GALICIA S·A·K· viii,2

C18
NEO.CU. E.GALICIA·HU II ¹⁸⁷

C20
NEO.CU.
SERAYEVO, H.U·II,215

C22
~2500 ERÖSD TRANSYLV. CD.68

C24
NEO. BUTMIR, MBH 1912 ⁵¹

C26
NEO. BUTMIR, MBH,191251

C28
NEO. BUTMIR, MBH 1912,51

C30
NEO.CU.SERAYEVO, HU II ²¹⁵

C32
NEO. SERAYEVO, H.U·II·215

C34
BUTMIR CA 23

C36
E.M. III MOCHLOS EPM.76

C38
XII KAHUN. P·I·K·i

C40
XII KAHUN.P.I.K·i

C42
BR· KOBAN, CAUCASUS MAK XVI

C43
LM·II, ALIKI, ATTICA, FLM XVIII

C44
XVIII AMENEMHAT, THEBES, J·D·E 30

C46
NEO. LENGYEL HUNGARY RV·VII, CCi

C48
LM·I HAGHIA TRIADA M·A·1908, xix

C50
LM III TIRYNS DCP 124

C52
LM·III TRIPOLYE B., M·S·G· 32
KIEV 50N 30½E

C54
STELE III MYKENAE ABS 1923 130

C56
MYKENAE FLM·XXIX

C58
MM II. KNOSSOS EPM II ix
(AS SENUSERT II)
SEE LC 92

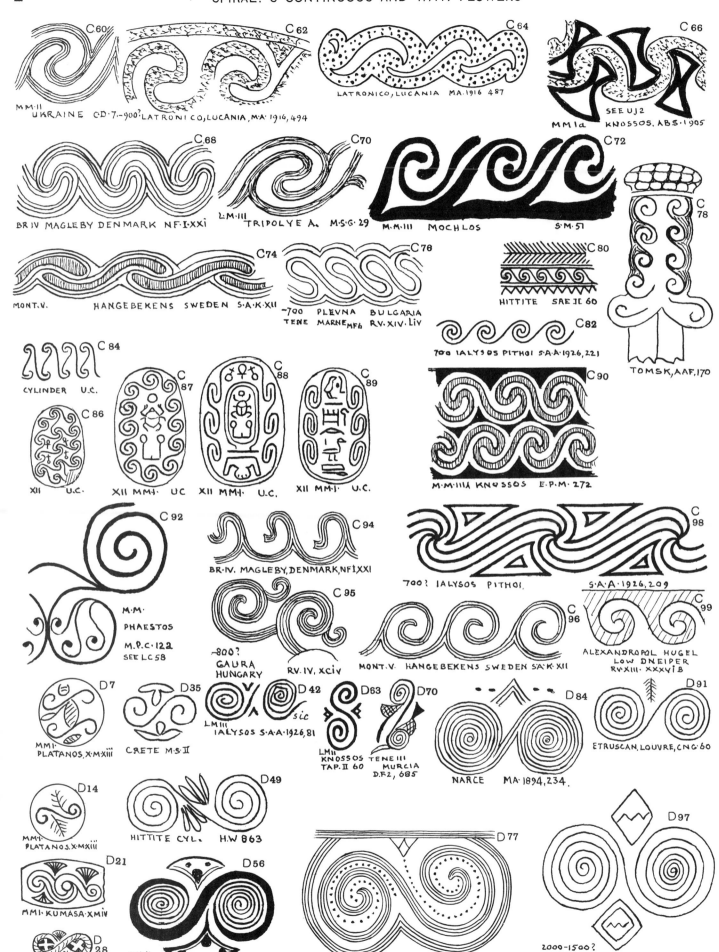

C60 MM·II UKRAINE C·D·7.-900?

C62 LATRONICO, LUCANIA, M·A· 1916, 494

C64 LATRONICO, LUCANIA MA.1916 487

C66 SEE UJ2 MM·Ia KNOSSOS. ABS·1905

C68 BR·IV MAGLEBY DENMARK NF·I·XXI

C70 LM·III TRIPOLYE A. M·S·G·29

C72 M·M·III MOCHLOS S·M·51

C78 TOMSK, AAF, 170

C74 MONT·V. HANGEBEKENS SWEDEN S·A·K·XII

C76 -700 PLEVNA BULGARIA TENE MARNE MF6 RV·XIV·LIV

C80 HITTITE SAE·II·60

C82 700 IALYSOS PITHOI S·A·A·1926, 221

C84 CYLINDER U.C.

C86 XII U.C.

C87 XII MM·I· UC

C88 XII MM·I· U.C.

C89 XII MM·I· U.C.

C90 M·M·IIIA KNOSSOS E·P·M·272

C92 M.M. PHAESTOS M.P.C·122 SEE LC58

C94 BR·IV. MAGLEBY, DENMARK, NF·I·XXI

C95 -800? GAURA HUNGARY RV·IV. XCIV

C98 700? IALYSOS PITHOI. S·A·A·1926, 209

C96 MONT·V. HANGEBEKENS SWEDEN S·A·K·XII

C99 ALEXANDROPOL HUGEL LOW DNEIPER RV·XIII· XXXVIB

D7 MMI· PLATANOS, X·M·XIII

D35 CRETE M·S·II

D42 LM·III IALYSOS S·A·A·1926,81

D63 LM·II KNOSSOS TENE III TAP. II 60

D70 MURCIA D.F.2, 685

D84 NARCE MA·1894, 234.

D91 ETRUSCAN, LOUVRE, CNG·60

D14 MMI· PLATANOS· X·M·XIII

D49 HITTITE CYL. H.W 863

D77 BR

D97 2000-1500? NEW GRANGE M·P·I·86 CNG·59

D21 MMI· KUMASA·X·M·IV

D56 L·H·II KORAKOU B·K·PL·V

D28 CRETE, M·G·P·39 AKBUNAR, MACEDONIA, A, 1925, XXVII

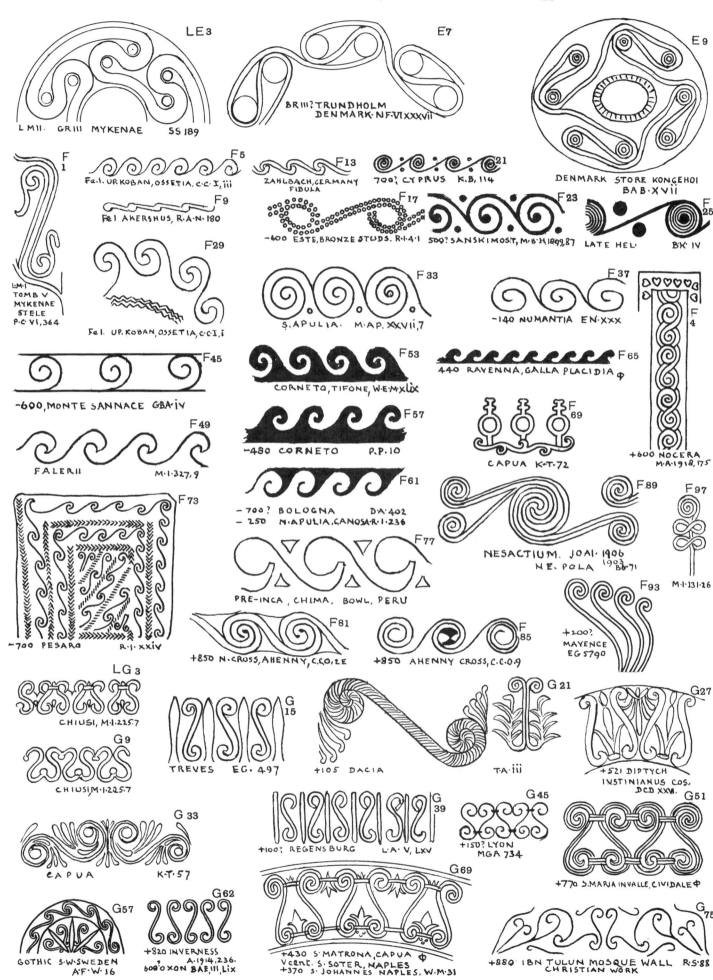

LE3

L·M·II. GR·III MYKENAE SS·189

E7

BR·III? TRUNDHOLM DENMARK·N·F·VI·XXXVII

E9

DENMARK STORE KONGEHOI BAB·XVII

F 1

L·M·I TOMB V MYKENAE STELE P·C·VI·364

F 5

Fæl·UR·KOBAN, OSSETIA, C·C·I, iii

F 9

Fæl·AKERSHUS, R·A·N·180

F29

Fæl·UR·KOBAN, OSSETIA, C·C·I, i

F13

ZAHLBACH, GERMANY FIBULA

F21

700? CYPRUS K·B·114

F17

−600 ESTE, BRONZE STUDS. R·I·4·I

F23

500? SANSKIMOST, M·B·H·1899,87

F25

LATE HEL· BK·IV

F33

S·APULIA. M·AP·XXVII,7

F37

−140 NUMANTIA EN·XXX

F 4

F45

−600, MONTE SANNACE GBA·IV

F49

FALERII M·I·327,9

F53

CORNETO, TIFONE, W·E·M·XLIX

F57

−480 CORNETO P·P·10

F61

−700? BOLOGNA D·A·402
−250 N·APULIA, CANOSA·R·I·236

F65

440 RAVENNA, GALLA PLACIDIA Φ

F69

CAPUA K·T·72

F73

−700 PESARO R·J·XXIV

F77

PRE-INCA, CHIMA. BOWL, PERU

F89

F97

NESACTIUM. JOAI·1906
N·E·POLA 1903 BB·71

M·I·131·26

F93

+200? MAYENCE EG·5790

+600 NOCERA M·A·1918,175

F81

+850 N·CROSS, AHENNY, C·CO·2E

F85

+850 AHENNY CROSS, C·C·O·9

LG3

CHIUSI, M·I·225·7

G9

CHIUSI·M·I·225·7

G15

TREVES EG·497

G21

+105 DACIA TA·iii

G27

+521 DIPTYCH IUSTINIANUS COS. DCD·XXVI.

G33

CAPUA K·T·57

G39

+100? REGENSBURG L·A·V, LXV

G45

+150? LYON MGA·734

G51

+770 S·MARIA INVALLE, CIVIDALE Φ

G57

GOTHIC S·W·SWEDEN A·F·W·16

G62

+820 INVERNESS ? A·1914,236.
600'OXON BAE·III, LIX

G69

+430 S·MATRONA, CAPUA Φ
V·cent. S·SOTER, NAPLES
+370 S·JOHANNES NAPLES, W·M·31

G75

+880 IBN TULUN MOSQUE WALL R·S·88
CHRISTIAN WORK

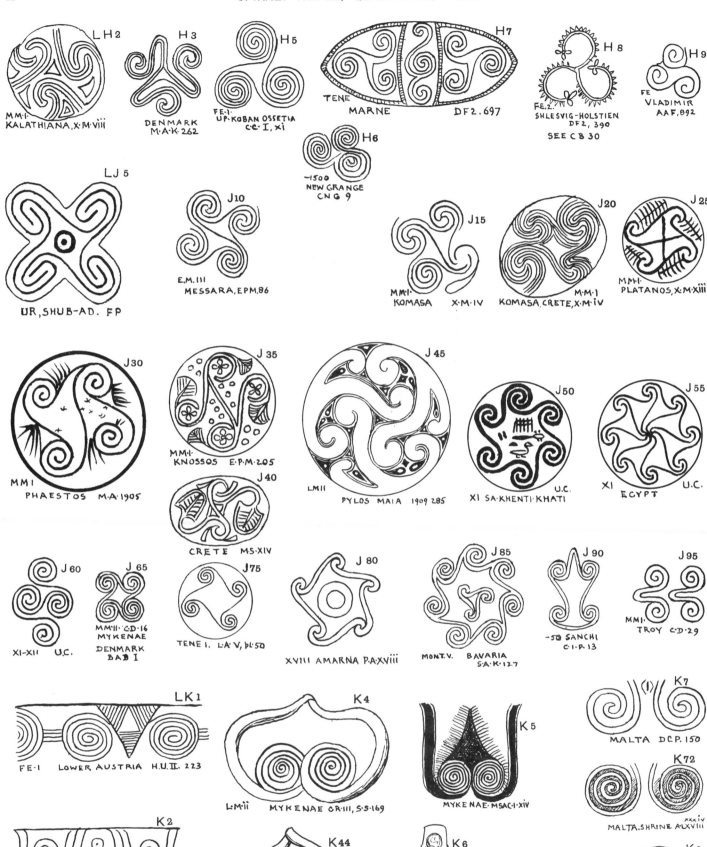

LH2
MM·I
KALATHIANA, X·M·VIII

H3
DENMARK
M·A·K·262

H5
FE·I·
UP. KOBAN OSSETIA
C·C·I, xi

H7
TENE MARNE DF2.697

H8
FE.2.
SHLESVIG-HOLSTIEN
DF2, 390
SEE C B 30

H9
FE
VLADIMIR
AAF, 892

H6
-1500
NEW GRANGE
CNG 9

LJ5
UR, SHUB-AD. FP

J10
E.M.III
MESSARA, EPM.86

J15
MM·I·
KOMASA X·M·IV

J20
M·M·I
KOMASA, CRETE, X·M·IV

J25
MM·I·
PLATANOS, X·M·XIII

J30
MMI
PHAESTOS M·A·1905

J35
MM·I·
KNOSSOS E·P·M·205

J40
CRETE MS·XIV

J45
LMII
PYLOS MAIA 1909 285

J50
XI SA·KHENTI·KHATI U.C.

J55
XI EGYPT U.C.

J60
XI-XII U.C.

J65
MM·II· C·D·16
MYKENAE
DENMARK
BAB I

J75
TENE I. L·A·V, pl.50

J80
XVIII AMARNA P·A·XVIII

J85
MONT.V. BAVARIA
S·A·K·127

J90
-50 SANCHI
C·I-P. 13

J95
MM·I·
TROY C·D·29

LK1
FE·I LOWER AUSTRIA H.U.II. 223

K4
L·M·II MYKENAE OR·III, S·5·169

K5
MYKENAE·MSAC·I·XIV

K7
(1)
MALTA DC·P. 150

K72
xxxiv
MALTA, SHRINE A·LXVIII

K2
FE·I· LOWER AUSTRIA H·U·II·224

K44
L·M·ii MYKENAE, GR·III·SS·170

K6
-1300 MYKENAE
ABS 1923 381

K8
MMI· KUMASA, X·M· V

K9
BR.
1257
AKERSHUS, RAN.

K3
DONETZ C·D·86

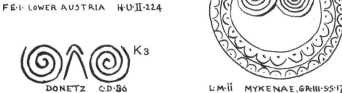

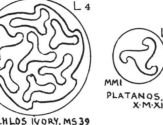

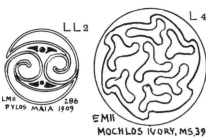

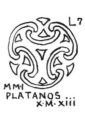

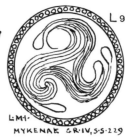

LL2 LMII 286 PYLOS MAIA 1909

L4 EMII MOCHLOS IVORY, MS.39

L5 MMI PLATANOS X.M.Xiii

L7 MMI PLATANOS X.M.Xiii

L9 LMI· MYKENAE GR.IV,S.S.229

M2 PERTOSA, M.A.1916,594

M4 SALERNO, CAVE M.A 1899,583

M7 V.DYN, ASSA.U.C.

M13 IX.DYN P.S.Lvii SEDMENT

M16 X.DYN, P.S.Lvii SEDMENT

M19 NEO· BUTMIR HBK·VI

M20 NEO· BUTMIR·HBK·VI

M29 EM·III KAMARES EPM,77

M32 EM·III CDii CRETE H.TRIADA,THOLOS

M37 EMII CRETE,M·S·XII

M40 XII LAHUN P.I.K.X,144

M43 M·M.I, XM viii PORTI, CRETE

M46 MM.I, XM Xiii PLATANOS

M48 XI? U.C. EGYPT

M52 XII U.C. EGYPT

M55 XII.P.I.K.X.176 EGYPT

M57 XII MMI-II, U.C. EGYPT

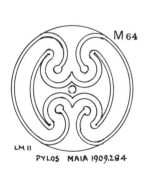

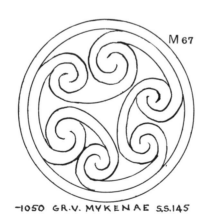

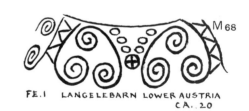

M64 LM II PYLOS MAIA 1909.284

M67 −1050 GR.V. MYKENAE S.S.145

M68 FE.I LANGELEBARN LOWER AUSTRIA CA..20

M73 XVIII U.C. EGYPT

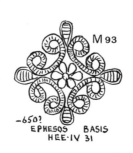

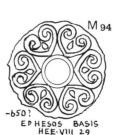

M88 CRETE AJA 1897, 259

M79 FE·I· W.NORWAY RAN 294

M82

M76 −650? EPHESOS BASIS HEE·VIII 27

M83 −650? EPHESOS BASIS HEE·IX 47

M87 EPHESOS WEST HEE·IX 46

M92 −650 EPHESOS BASIS HEE VIII 25

M93 −650? EPHESOS BASIS HEE·IV 31

M94 −650? EPHESOS BASIS HEE·VIII 29

M96 700 CRETE K·B· 114

M97 −1800? HUNGARY CD P.270

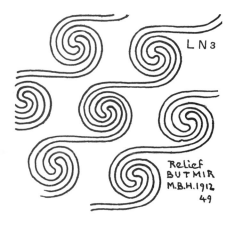

LN3

Relief
BUTMIR
M.B.H. 1912
49

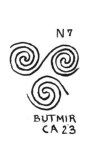

N7

BUTMIR
CA 23

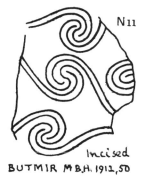

N11

Incised
BUTMIR M.B.H. 1912,50

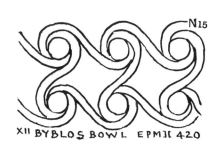

N15

XII BYBLOS BOWL EPMII 420

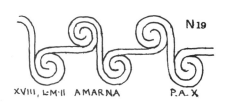

N19

XVIII, L·M·II AMARNA P·A·X

N23

KAMEIROS
SINGLE LINE·ABS·1906,72

N27

−700 IALYSOS PITHOI S·A·A 1926, 210
SYRO·HITTITE CYLINDERS, HW855-7
−650 CRETE MAIA 1906.xxiii

N31

L·M·I PSEIRA B·A·K·167

N35

−200 SCV 87
CHINA

N39

−1100 SCV 13

N43 N47

−1100,300 SCV 70

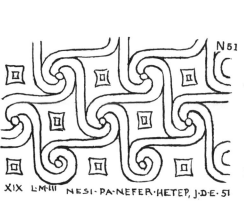

N51

XIX L·M·III NESI·PA·NEFER·HETEP, J·D·E· 51

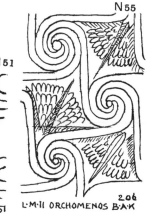

N55

206
L·M·II ORCHOMENOS B·A·K

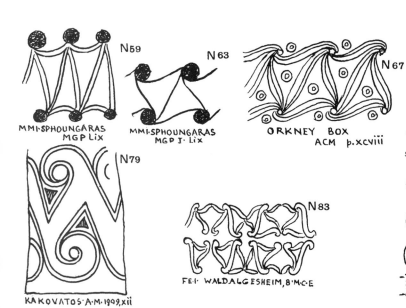

N59

MMI·SPHOUNGARAS
MGP LIX

N63

MMI·SPHOUNGARAS
MGP I· LIX

N67

ORKNEY BOX
ACM p.xcviii

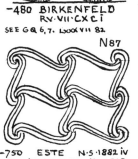

N71

−480 BIRKENFELD
RV· VII·CXCi
SEE GQ 6, 7. LXXXVII 82

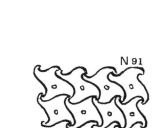

N75

FE·2· BIRKENFELD, MOSELLE DF2· 695

N79

KAKOVATOS·A·M·1909,xii

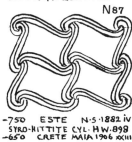

N83

FE·I· WALDALGESHEIM, B·M·C·E

N87

−750 ESTE N·S·1882 iv
SYRO·HITTITE CYL· HW·898
−650 CRETE MAIA 1906 xxiii

N91

X CENT. GRAIGUENAMANACH
C·C·0·13

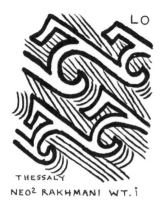

LO

THESSALY
NEO² RAKHMANI WT. i

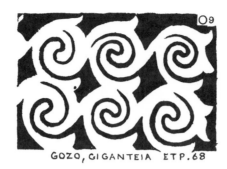

O9

GOZO, GIGANTEIA ETP.68

O14

BARANYA, HUNGARY S·A·26

O19

TARXIEN A.1916, XXii

O24

TARXIEN, A.1916, XVi

O29

MALTA SHRINE ᶲ
A·LXVIII,XXXiV

O34

MALTA, BENCH, A.LXVIII,XXXVii

O39

TARXIEN, A.1916 XVi

O49

CRETE MA· 1895 IX

O54

MALTA A·LXVIII,282

O64

MORITZING, TYROL
B.C. 77

O44

TARXIEN A.1916, XXi

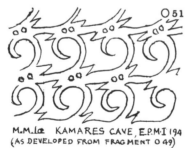

O51

M.M.Iα KAMARES CAVE, E.P.M.I 194
(AS DEVELOPED FROM FRAGMENT O 49)

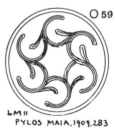

O59

LM II
PYLOS MAIA, 1909, 283

O69

MALTA, BENCH A LXVIII, XXXVii ᶲ

O 71

DRESS,H ACHIA TRIADA MA·1903 X

O 79

MALTA, BENCH, A.LXVIII, XXXi ᶲ
= A.1916 XXii

O 84

TARXIEN
A 1916 XXii

C 89

MALTA BENCH A. LXVIII, XXXVii ᶲ

O 74

MALTA BOWL A. LXVIII, 280

O 94

TARXIEN A.1914 XXi

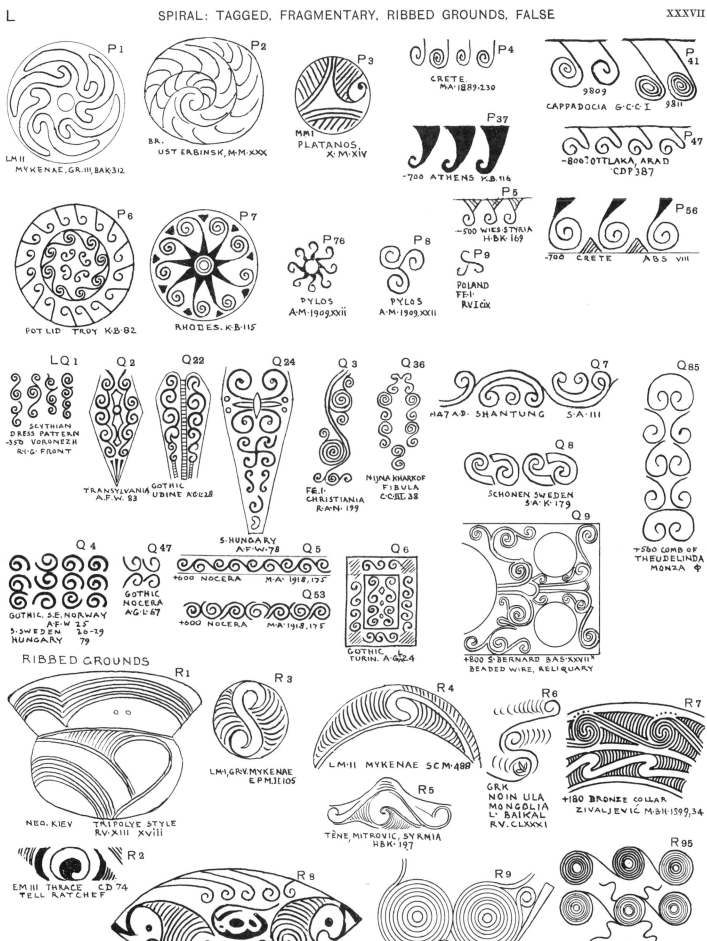

P1 LM II MYKENAE, GR. III, BAK·312

P2 BR. UST ERBINSK, M·M·XXX

P3 MMI PLATANOS X·M·XIV

P4 CRETE. M·A·1889·230

P41 CAPPADOCIA G·C·C I 9809 9811

P37 -700 ATHENS K·B·116

P47 -800? OTTLAKA, ARAD ·CDP 387

P6 POT LID TROY K·B·82

P7 RHODES. K·B·115

P76 PYLOS A·M·1909,XXII

P8 PYLOS A·M·1909,XXII

P5 -500 WIES·STYRIA H·BK·169

P9 POLAND FE·I· RVI·cix

P56 -700 CRETE ABS VIII

LQ1 SCYTHIAN DRESS PATTERN -350 VORONEZH R·I·G· FRONT

Q2 Q22 TRANSYLVANIA A·F·W 83 GOTHIC UDINE A·G·L·28

Q24 S. HUNGARY A·F·W·78

Q3 FE·I· CHRISTIANIA R·A·N· 199

Q36 NIJNA KHARKOF FIBULA C·C·III·38

Q7 H47A·D· SHANTUNG S·A·III

Q85

Q8 SCHONEN SWEDEN S·A·K·179

Q9 +800 S·BERNARD BAS·XXVII BEADED WIRE, RELIQUARY

Q4 GOTHIC. S·E· NORWAY A·F·W 25 S·SWEDEN 26-29 HUNGARY 79

Q47 GOTHIC NOCERA A·G·L· 67

Q5 +600 NOCERA M·A·1918,175

Q53 +600 NOCERA M·A·1918,175

Q6 GOTHIC TURIN. A·G·L·4

+560 COMB OF THEUDELINDA MONZA Φ

RIBBED GROUNDS

R1 NEO. KIEV TRIPOLYE STYLE RV·XIII xviii

R3 LM·I, GR·V. MYKENAE E·P·M·II·105

R4 LM·II MYKENAE SCM·488

R6 GRK NOIN ULA MONGOLIA L· BAIKAL RV·CLXXXI

R7 +180 BRONZE COLLAR ZIVALJEVIĆ M·B·H·1899,34

R5 TÈNE, MITROVIC, SYRMIA H·BK·197

R2 EM III THRACE CD 74 TELL RATCHEF

R8 + -25 TO +220 CHINA SEE GW7 S·A·C XXIV

R9 LM·II MYKENAE, GR·III, S·S·191

R95 -1000 BOLOGNA R·M·V. 4

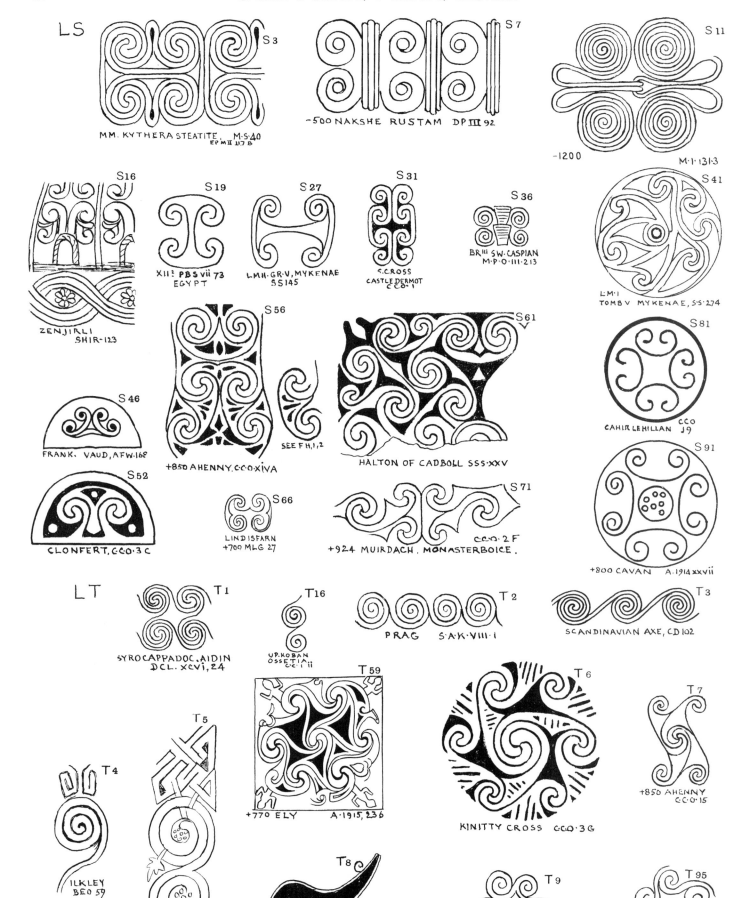

LS

S3 — MM. KYTHERA STEATITE. M·S·40 EP·M·II·117·B

S7 — −500 NAKSHE RUSTAM DP III 92

S11 — −1200 M·I·131·3

S16 — ZENJIRLI SHIR·123

S19 — XII? PBS vii 73 EGYPT

S27 — LM II. GR·V, MYKENAE SS 145

S31 — S.CROSS CASTLE DERMOT CCO·1

S36 — BR III S.W. CASPIAN M·P·O·III·213

S41 — LM·I TOMB V MYKENAE, S·S·274

S46 — FRANK. VAUD, AFW·168

S56 — +850 AHENNY. CCO·XIVA — SEE FH.1,2

S61 — HALTON OF CADBOLL SSS·XXV

S81 — CAHIR LEHILLAN CCO J9

S52 — CLONFERT, CCO·3C

S66 — LINDISFARN +700 MLG 27

S71 — +924 MUIRDACH. MONASTERBOICE. CCO·2F

S91 — +800 CAVAN A·1914 xxvii

LT

T1 — SYRO CAPPADOC. AIDIN DCL. XCVI, 24

T16 — UP. KOBAN OSSETIA ii CC·I·ii

T2 — PRAG S·A·K·VIII·1

T3 — SCANDINAVIAN AXE, CD 102

T5

T4 — ILKLEY BEO 59

T59 — +770 ELY A·1915, 236

T6 — KINITTY CROSS CCO·3G

T7 — +850 AHENNY CC·O·15

DACRE BEO.42

T8 — −1350 MYKENAE ABS 1923,107

T9 — +450 FRILFORD A·A·S·19

T95 — +450 OXON·A·A·S·18

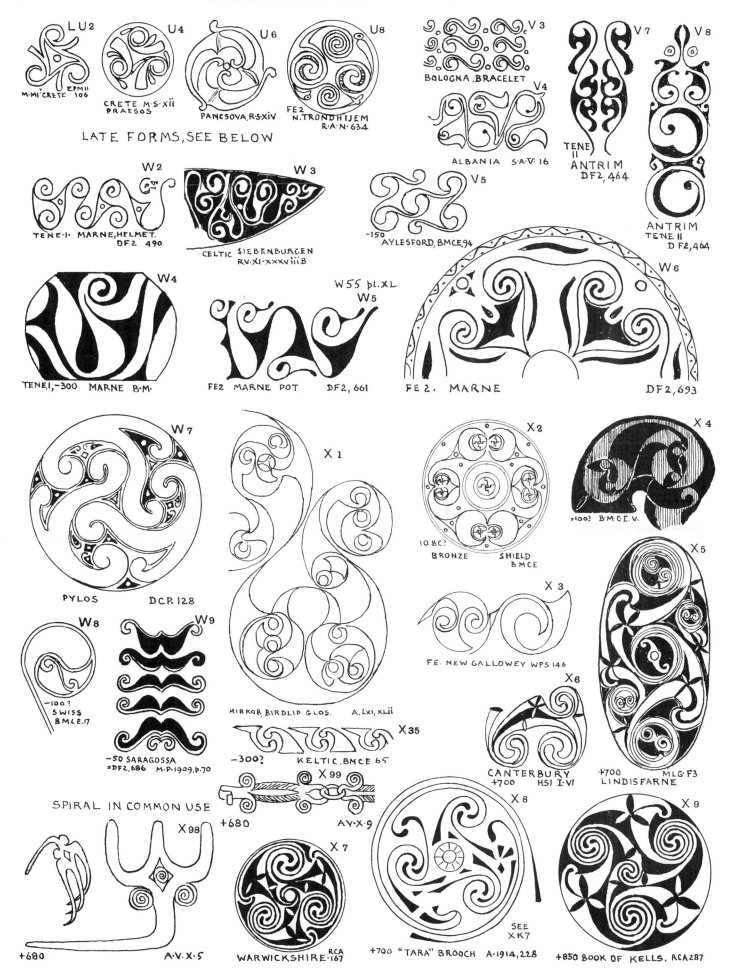

LU2
M. MI'CRETE 106 EPM II

U4
CRETE M.S.XII PRAESOS

U6
PANCSOVA, R.S.XIV

U8
FE2 N. TRONDHJEM R.A.N. 634

LATE FORMS, SEE BELOW

V3
BOLOGNA, BRACELET

V4
ALBANIA S.A.V. 16

V7

V8

TENE II ANTRIM DF2, 464

W2
TENE I. MARNE, HELMET. DF2 490

W3
CELTIC SIEBENBURGEN RV.XI.XXXViiiB

V5
-150 AYLESFORD, BMCE, 94

ANTRIM TENE II D F2, 464

W4
TENE I, -300 MARNE B.M.

W55 pl.XL
W5
FE2 MARNE POT DF2, 661

W6
FE 2. MARNE DF2, 693

W7
PYLOS DCP. 128

X1
MIRROR, BIRDLIP GLOS. A. Lxi, xLii

X2
10 BC? BRONZE SHIELD BMCE

X4
+100? B.M.C.E.V.

X3
FE. NEW GALLOWEY WPS 146

X5
+700 LINDISFARNE MLG F3

X6
CANTERBURY +700 HSI I. VI

W8
-100? SWISS BMCE.17

W9
-50 SARAGOSSA =DF2,686 M.P.1909, p.70

X35
-300? KELTIC. BMCE 65

SPIRAL IN COMMON USE

X98

X99
+680 AV.X.9

X7
WARWICKSHIRE .167 RCA

X8
+700 "TARA" BROOCH A-1914,228 SEE XK7

X9
+850 BOOK OF KELLS. RCA287

+680 A.V.X.5

Y 2

FE 2. NORWAY
R·A·N· 635

Y 25

FE STICHEL W.P.S.I3I

Y 3

KIRKCUDBRIGHT
BR· ARM² W.P.S·I32

Y 35

LINZ MUS.
R·S·xiii,I

Y 40

LINZ MUS R·S·xiii,II

Y 43

LINZ MUS.
R·S·xiii I,4

Y 47

KLAUSENBERG MUS.R·S·xiv,2

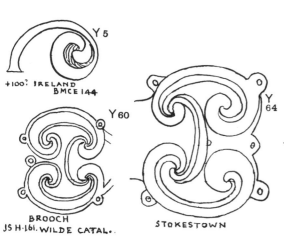

Y 5

+100? IRELAND
BMCE 144

Y 60

BROOCH
JS H·I6I. WILDE CATAL.

Y 64

STOKESTOWN

Y 7

GOTHIC BOHEMIA
A·F·W·18

Y 8

COPTIC CHURCH, OLD CAIRO, R·S· 87

Y 67

WALTERS
HIST·ANC·POTT
204

Y 68

+100? FAYUM PRE,LV,92

Y 90

TENE MF·12
RHEINHESSEN

Y 96

MODERN
LOUIS QUINZE

RACIAL REVIVAL
OF C BLOBS

Z 2

BR. LOCHAR MOSS TORC W.P.S ix

Z 4

-50 GLASTONBURY B·G·G· Lxxxiv

Z 5

-50 GLASTONBURY. B·G·G·Lxxiii

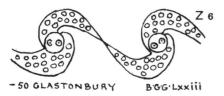

Z 6

-50 GLASTONBURY B·G·G·Lxxiii

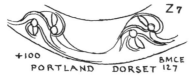

Z 7

+100
PORTLAND DORSET BMCE 127

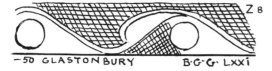

Z 8

-50 GLASTONBURY B·G·G· Lxxi

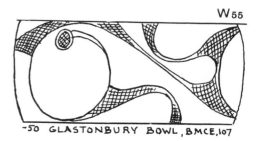

W 55

-50 GLASTONBURY BOWL, BMCE,107

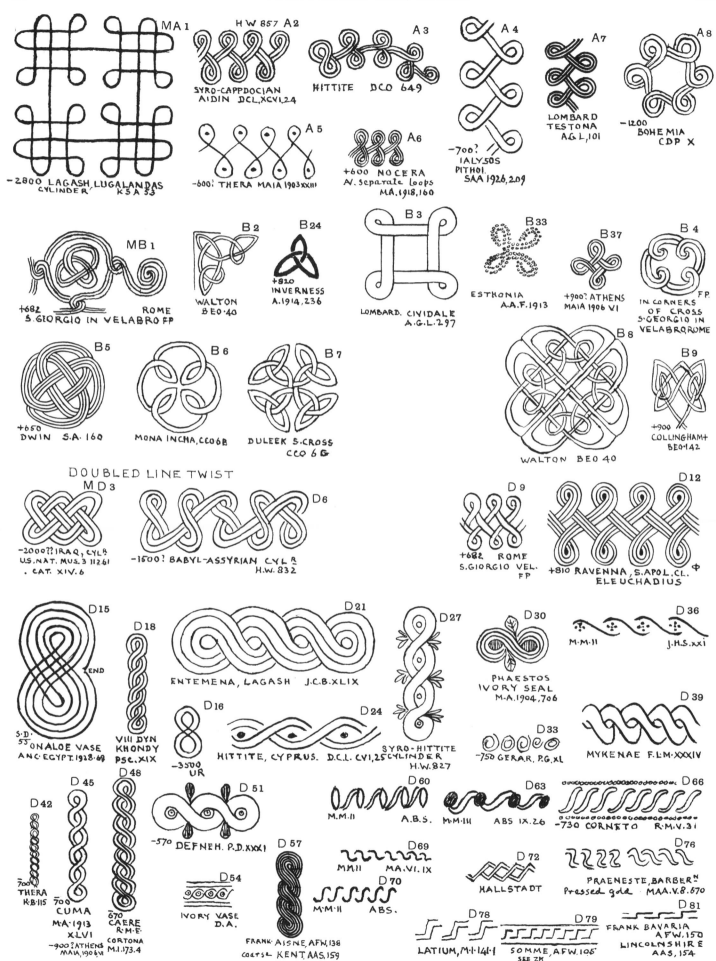

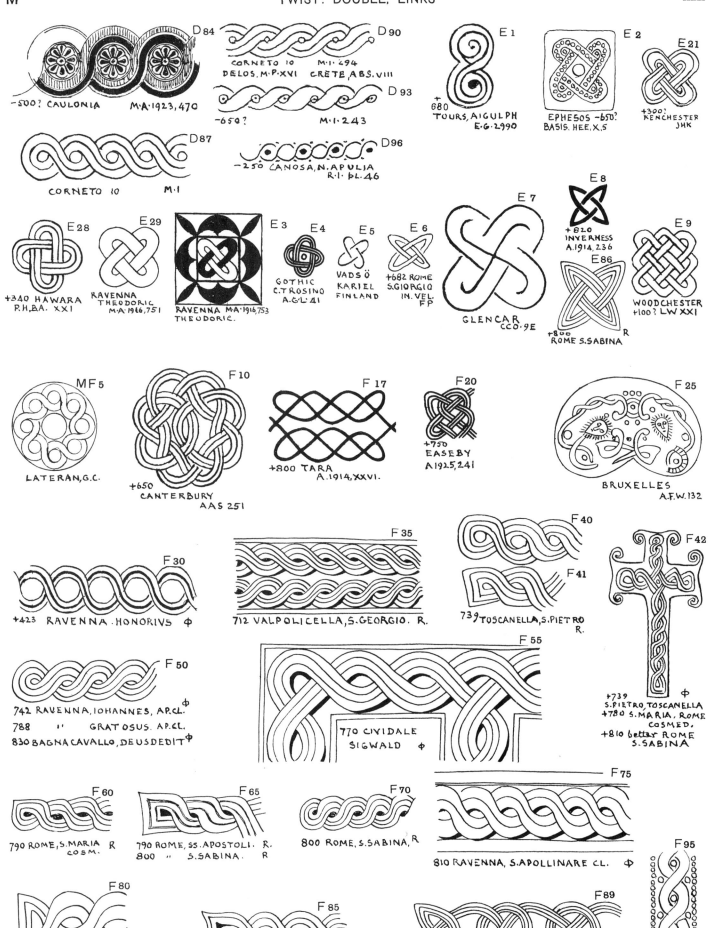

D 84

-500? CAULONIA M·A·1923, 470

D 90
CORNETO 10 M·I·294
DELOS, M·P·XVI CRETE ABS. VIII

D 93
-650? M·I·243

D 87
CORNETO 10 M·I

D 96
-250 CANOSA, N. APULIA
R·I· pl. 46

E 1
+680
TOURS, AIGULPH
E·G·2990

E 2
EPHESOS -650?
BASIS. HEE. X. 5

E 21
+300?
KENCHESTER
JHK

E 28
+340 HAWARA
P·H·BA· XXI

E 29
RAVENNA
THEODORIC
M·A·1916,751

E 3
RAVENNA M·A·1916,753
THEODORIC.

E 4
GOTHIC
C. TROSINO
A·G·L· 41

E 5
VADSÖ
KARIEL
FINLAND

E 6
+682 ROME
S. GIORGIO
IN. VEL.
FP

E 7
GLENCAR
CCO. 9E

E 8
+820
INVERNESS
A·1914, 236

E 86
+800
ROME S. SABINA

E 9
WOODCHESTER
+100? LW XXI

MF 5
LATERAN, G.C.

F 10
+650
CANTERBURY
AAS 251

F 17
+800 TARA
A·1914, XXVI.

F 20
+750
EASEBY
A·1925, 241

F 25
BRUXELLES
A·F·W·132

F 30
+423 RAVENNA · HONORIVS φ

F 35
712 VALPOLICELLA, S. GEORGIO. R.

F 40

F 41

F 42

F 50
742 RAVENNA, IOHANNES, AP. CL.
788 '' GRAT OSUS. AP. CL.
830 BAGNA CAVALLO, DEUSDEDIT φ

739 TOSCANELLA, S. PIETRO
R.

F 55
770 CIVIDALE
SIGWALD φ

+739
S. PIETRO, TOSCANELLA
+780 S. MARIA, ROME
COSMED.
+810 better ROME
S. SABINA

F 60
790 ROME, S. MARIA R
COSM.

F 65
790 ROME, SS. APOSTOLI. R.
800 '' S. SABINA. R

F 70
800 ROME, S. SABINA, R

F 75
810 RAVENNA, S. APOLLINARE CL. φ

F 95
BENIN
ESA

F 80
810 RAVENNA, S. APOL. CL.
ELEUCHADIUS

F 85
825 ROME S. SABINA φ

F 89
+1032 MONTE FIASCONE R

M G 2

HITTITE CYLINDER. H.W.2084
SYRO-with spots in spaces H.W.854
+500 ATHENS. S.A.68

G 7

-700?
ARCEVIA M.I.154,4
MONTE FORTINO DF2,488
HELMET

G 12

-700? CUMA. M.A.1913, xxxix.

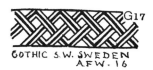

G 17

GOTHIC S.W.SWEDEN
AFW. 16

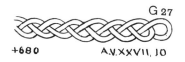

G 22

POMPEII G.C.fig 8

G 27

+680 A.V.XXVII, 10

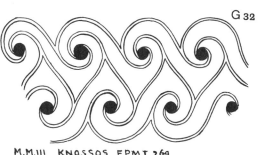

G 32

M.M.III KNOSSOS EPMI,26ª

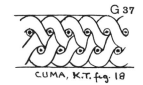

G 37

CUMA, K.T. fig. 18

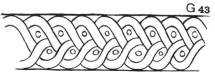

G 43

MONTE CALVARIO, N.S.1905,232,25

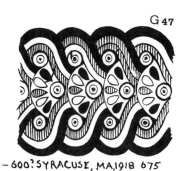

G 47

-600? SYRACUSE, MA.1918 675

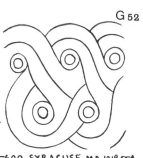

G 52

-600 SYRACUSE, MA.1918,554

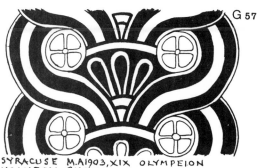

G 57

SYRACUSE M.A1903,XIX OLYMPEION
KALYDON P.K.XXVI.
blain centres ST.ANGELO. TA.fig 27

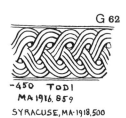

G 62

-450 TODI
MA 1916,859

SYRACUSE, MA-1918,500

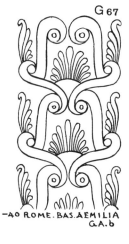

G 67

-40 ROME. BAS.AEMILIA
G.A.b

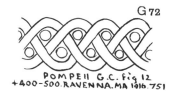

G 72

POMPEII G.C. fig 12
+400-500.RAVENNA.MA 1916.751

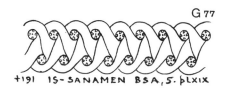

G 77

+191 IS-SANAMEN BSA, 5. þLXIX

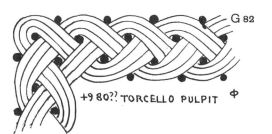

G 82

+9 80?? TORCELLO PULPIT ф

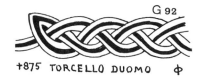

G 92

+875 TORCELLO DUOMO ф

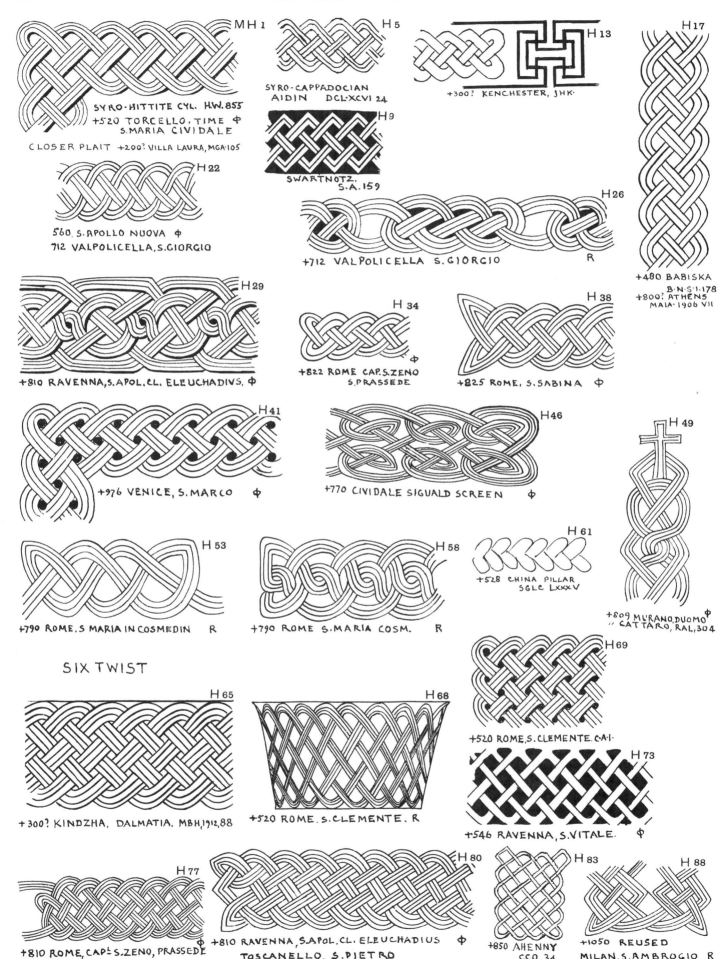

MH 1 SYRO-HITTITE CYL. H.W. 855
+520 TORCELLO, TIME Φ
S. MARIA CIVIDALE
CLOSER PLAIT +200? VILLA LAURA, MGA·105

H 5 SYRO-CAPPADOCIAN
AIDIN DCL·XCVI 24

H 9 SWARTNOTZ.
S.A. 159

H 13 +300? KENCHESTER, JHK.

H 17 +480 BABISKA
B·N·S·1·178
+800? ATHENS
MAIA·1906 VII

H 22 560. S. APOLLO NUOVA Φ
712 VALPOLICELLA, S. GIORGIO

H 26 +712 VALPOLICELLA S. GIORGIO R

H 29 +810 RAVENNA, S. APOL. CL. ELEUCHADIVS, Φ

H 34 +822 ROME CAP. S. ZENO
S. PRASSEDE

H 38 +825 ROME, S. SABINA Φ

H 41 +976 VENICE, S. MARCO Φ

H 46 +770 CIVIDALE SIGUALD SCREEN Φ

H 49

H 53 +790 ROME, S MARIA IN COSMEDIN R

H 58 +790 ROME S. MARIA COSM. R

H 61 +528 CHINA PILLAR
SGLC LXXV

+809 MURANO, DUOMO Φ
" CATTARO, RAL, 304

SIX TWIST

H 65 +300? KINDZHA, DALMATIA. MBH, 1912, 88

H 68 +520 ROME. S. CLEMENTE. R

H 69 +520 ROME, S. CLEMENTE. C·A·I·

H 73 +546 RAVENNA, S. VITALE. Φ

H 77 +810 ROME, CAP. S. ZENO, PRASSEDE Φ

H 80 +810 RAVENNA, S. APOL. CL. ELEUCHADIUS Φ
TOSCANELLO, S. PIETRO

H 83 +850 AHENNY
CCO 34

H 88 +1050 REUSED
MILAN, S. AMBROGIO R

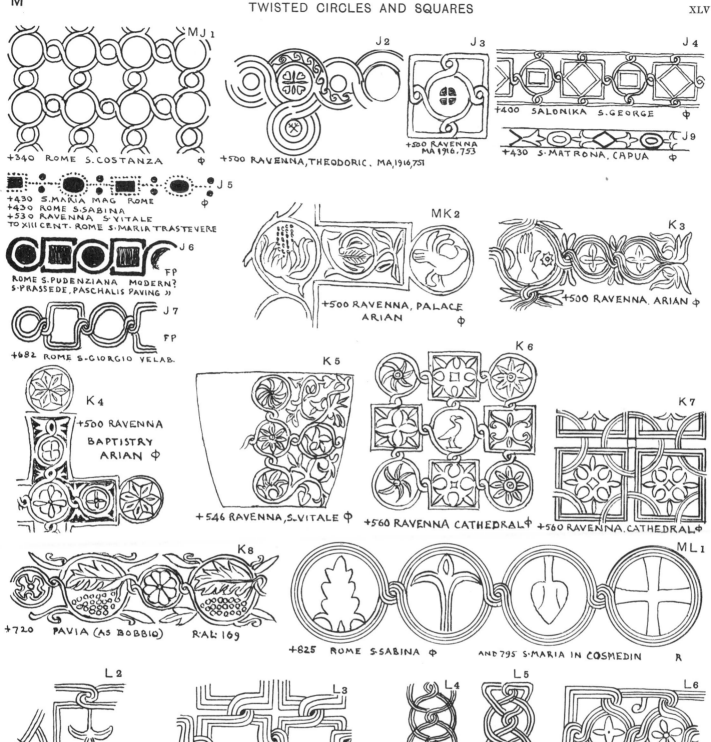

MJ1
+340 ROME S.COSTANZA φ

J2
+500 RAVENNA, THEODORIC. MA,1916,751

J3
+500 RAVENNA MA 1916, 753

J4
+400 SALONIKA S.GEORGE φ

J9
+430 S.MATRONA. CAPUA φ

J5
+430 S.MARIA MAG ROME
+430 ROME S.SABINA
+530 RAVENNA S.VITALE
TO XIII CENT. ROME S.MARIA TRASTEVERE φ

J6
ROME S.PUDENZIANA MODERN?
S.PRASSEDE, PASCHALIS PAVING »
FP

J7
+682 ROME S.GIORGIO VELAB. FP

MK2
+500 RAVENNA, PALACE ARIAN φ

K3
+500 RAVENNA. ARIAN φ

K4
+500 RAVENNA BAPTISTRY ARIAN φ

K5
+546 RAVENNA, S.VITALE φ

K6
+560 RAVENNA CATHEDRAL φ

K7
+560 RAVENNA. CATHEDRAL φ

K8
+720 PAVIA (AS BOBBIO) R·AL·169

ML1
+825 ROME S.SABINA φ AND 795 S·MARIA IN COSMEDIN R

L2
+650 OR 750 S.MARIA ANTIQUA FP ROME

L3
+739 TOSCANELLA, S.PIETRO R

L4
+682 ROME S.GIORG·VEL. FP

L5
+790 ROME S.MARIA COSMED.

L6
+790 ROME S.MARIA COSMEDIN R

L7
+810 RAVENNA S.APOL·IN CLASSE φ

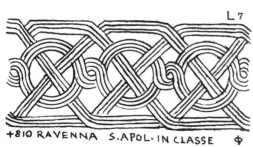

L8
+880 MILAN, S.AMBROGIO
+1050 REUSED R

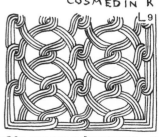

L9
+880 MILAN. S.AMBROGIO R reused in 1050

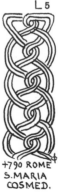
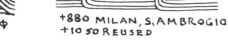
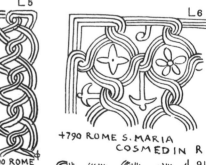

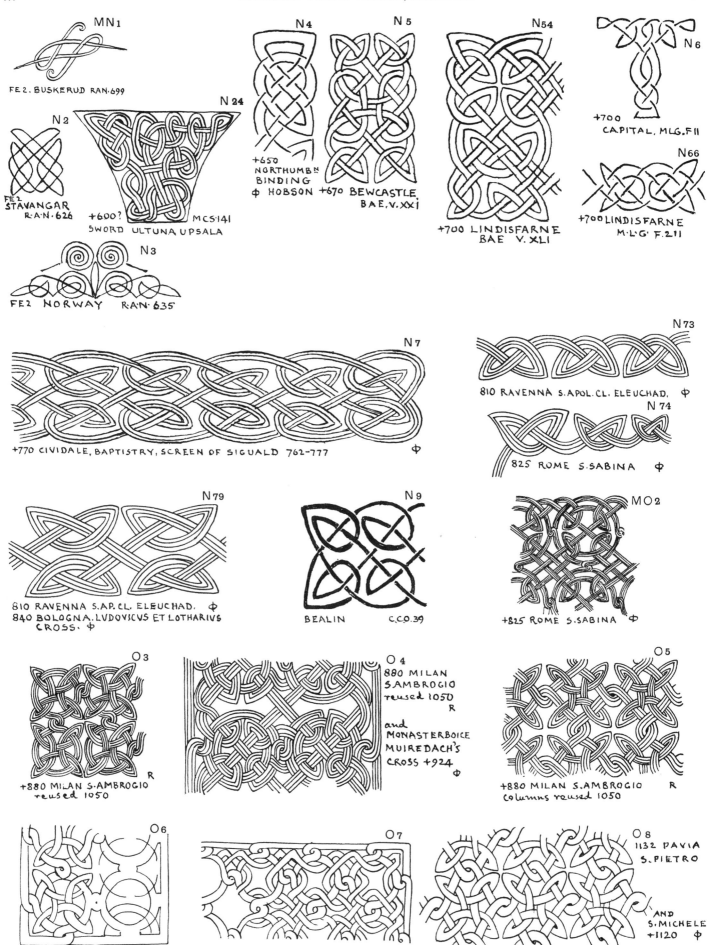

MN1
FE2. BUSKERUD RAN·699

N2
FE2 STAVANGAR R·A·N·626

N24
+600? SWORD ULTUNA UPSALA MCS·141

N3
FE2 NORWAY R·A·N·635

N4
+650 NORTHUMBᴺ BINDING Φ HOBSON

N5
+670 BEWCASTLE BAE.V.XXi

N54
+700 LINDISFARNE BAE V. XLi

N6
+700 CAPITAL. MLG.FII

N66
+700 LINDISFARNE M·L·G· F.211

N7
+770 CIVIDALE, BAPTISTRY, SCREEN OF SIGUALD 762-777 Φ

N73
810 RAVENNA S.APOL.CL. ELEUCHAD, Φ

N74
825 ROME S.SABINA Φ

N79
810 RAVENNA S.AP. CL. ELEUCHAD. Φ
840 BOLOGNA. LVDOVICVS ET LOTHARIVS CROSS. Φ

N9
BEALIN C.C.O.39

MO2
+825 ROME S.SABINA Φ

O3
+880 MILAN S·AMBROGIO reused 1050 R

O4
880 MILAN S AMBROGIO reused 1050 R
and MONASTERBOICE MUIREDACH'S CROSS +924 Φ

O5
+880 MILAN S.AMBROGIO columns reused 1050 R

O6
MILAN, S·AMBROGIO Φ

O7
MILAN S.AMBROGIO R.

O8
1132 PAVIA S.PIETRO
AND S.MICHELE +1120 Φ

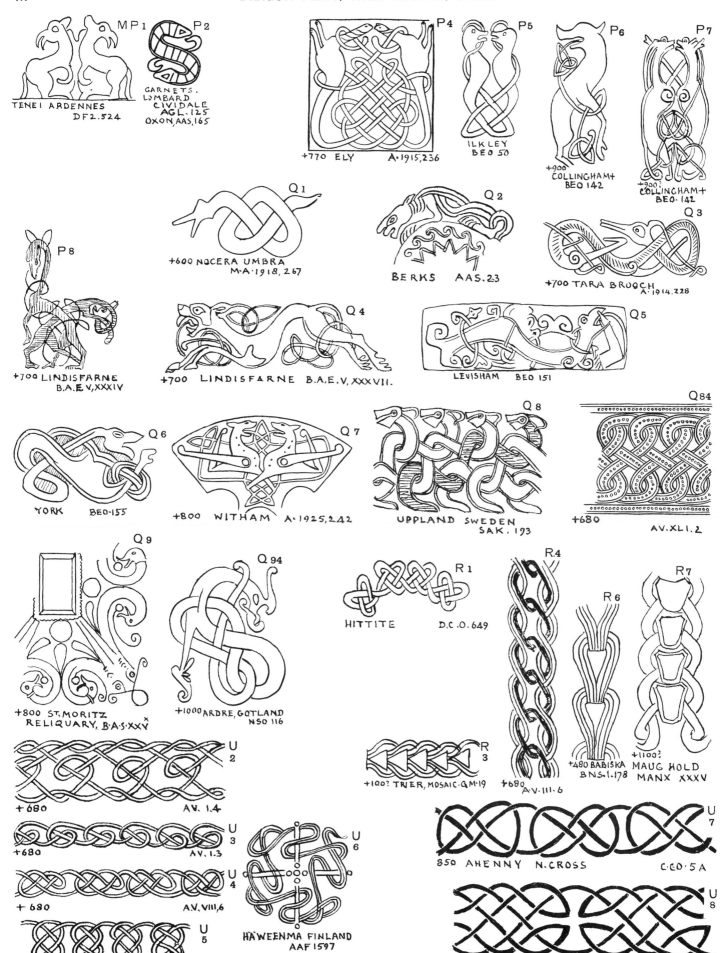

MP 1

TENEI ARDENNES
DF 2.524

P 2
GARNETS.
LOMBARD
CIVIDALE
AGL.125
OXON, AAS, 165

P 4
+770 ELY A·1915, 236

P 5
ILKLEY
BEO 50

P 6
+900
COLLINGHAM+
BEO 142

P 7
+900?
COLLINGHAM+
BEO·142

P 8
+700 LINDISFARNE
B.A.E V, XXXIV

Q 1
+600 NOCERA UMBRA
M·A·1918, 267

Q 2
BERKS AAS.23

Q 3
+700 TARA BROOCH
A·1914, 228

Q 4
+700 LINDISFARNE B.A.E.V, XXXVII.

Q 5
LEVISHAM BEO 151

Q 6
YORK BEO·155

Q 7
+800 WITHAM A·1925, 242

Q 8
UPPLAND SWEDEN
SAK. 193

Q 84
+680 AV.XLI.2

Q 9
+800 ST.MORITZ
RELIQUARY, B·A·S·XXV

Q 94
+1000 ARDRE, GOTLAND
N SO 116

R 1
HITTITE D.C.O. 649

R 3
+100? TRIER, MOSAIC.GM·19

R 4
+680
A.V. III.6

R 6
+480 BABISKA
BNS.1.178

R 7
+1100?
MAUG HOLD
MANX XXXV

U 2
+680 AV. 1.4

U 3
+680 AV. 1.3

U 4
+680 AV. VIII, 6

U 5
+680 A.V. VIII.8

U 6
HÄWEENMA FINLAND
AAF 1597
SIM. GETA, ALAND IS
AAF 1723

U 7
850 AHENNY N.CROSS C.C·O·5A

U 8
924 MONASTERBOICE, MUIREDACH, CCO 5C

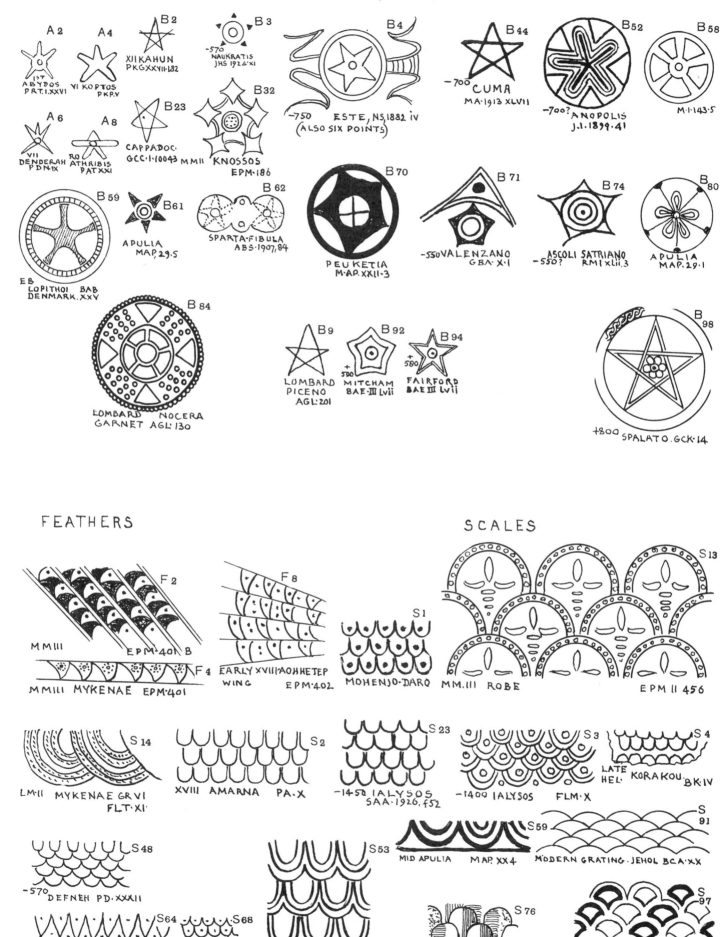

FEATHERS

SCALES

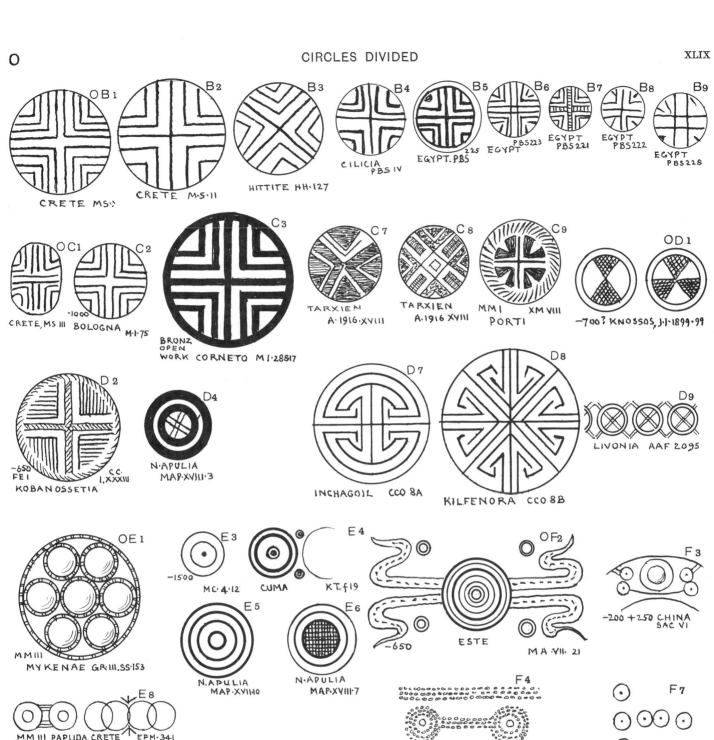

OB1 — CRETE MS.\

B2 — CRETE M·S·11

B3 — HITTITE HH·127

B4 — CILICIA PBS IV

B5 — EGYPT·PBS 225

B6 — EGYPT PBS223

B7 — EGYPT PBS221

B8 — EGYPT PBS222

B9 — EGYPT PBS228

OC1 — CRETE, MS III

C2 — -1000 BOLOGNA M·1·75

C3 — BRONZ OPEN WORK CORNETO M·1·28817

C7 — TARXIEN A·1916·XVIII

C8 — TARXIEN A·1916·XVIII

C9 — MMI PORTI XM VIII

OD·1 — -700? KNOSSOS, J·1·1899·99

D2 — -650 FEI KOBAN OSSETIA C.C. 1·XXXIII

D4 — N·APULIA MAP·XVIII·3

D7 — INCHAGOIL CCO 8A

D8 — KILFENORA CCO 8B

D9 — LIVONIA AAF 2095

OE1 — MMIII MYKENAE GR·III·SS·153

E3 — -1500 MC·4·12

CUMA

E4 — KT·f19

E5 — N·APULIA MAP·XVIII·0

E6 — N·APULIA MAP·XVIII·7

OF2 — ESTE -650 M·A·VII·21

F3 — -200 +250 CHINA SAC VI

F4 — NIMRUD BOTTA·XX·XV BALDRIC STUDDED LEATHER? ·LXXXIII

F7 — CHINA -250 SCV·121

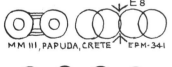
E8 — MM III, PAPUDA, CRETE EPM·341

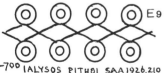
E9 — -700 IALYSOS PITHOI SAA 1926, 210

F8 — -670 CUMA R1·57

F9 — KHARKOF CC·III·37

F5 — -570 NAUKRATIS JHS·1924·XI

OG — +340 ROME S.COSTANZA Φ

G2 — GOTHIC LOMBARDY AGL 12

G5 — LOMBARD TESTONA AGL·110

G8

G9 — +480 BABISKA BNS·1·178

G26 — +580 THEUDELINDA GCK 12

G7 — +500? JAPAN RAR·1923 AbpLiii

G3 — +451 MILAN, S.AQUILINO

G4 — +750 ROME WM·178

G6 — +600 NOCERA COMB M·A·1918, 285

NEUMAGEN EG 5149 +200?.

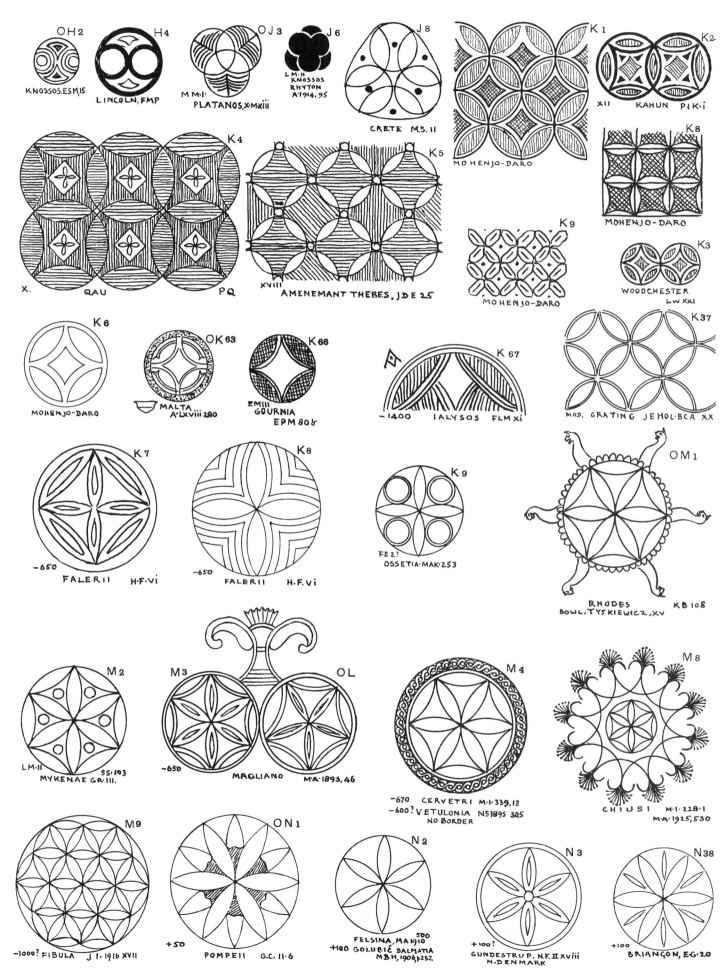

OH2 KNOSSOS.ESM.15

H4 LINCOLN, FMP

OJ3 M.M.I. PLATANOS.X.M.XIII

J6 L.M.II KNOSSOS RHYTON A·1914,95

J8 CRETE M.S.II

K1 MOHENJO-DARO

K2 XII KAHUN PLK·I

K4 X. QAU PQ

K5 XVIII AMENEMANT THEBES, JDE 25

K8 MOHENJO-DARO

K9 MOHENJO-DARO

K3 WOODCHESTER LW XXI

K6 MOHENJO-DARO

OK63 MALTA A·LXVIII 280

K66 EMIII GOURNIA EPM 80b

K67 -1400 IALYSOS FLM XI

K37 MOD. GRATING JEHOL BCA XX

K7 -650 FALERII H·F·VI

K8 -650 FALERII H·F·VI

K9 FE2? OSSETIA·MAK·253

OM1 RHODES BOWL.TYSKIEWICZ.XV KB 108

M.2 LM·II 55·193 MYKENAE GR.III.

M3 -650 MAGLIANO OL M·A·1893,46

M4 -670 CERVETRI M·I·339,13 -600? VETULONIA N51895 305 NO BORDER

M8 CHIUSI M·I·228·1 M·A·1925,530

M9 -1000? FIBULA J 1·1916 XVII

ON1 +50 POMPEII G.C. II·6

N2 FELSINA, MA 1910 +100 GOLUBIĆ DALMATIA MBH, 1906,p232 500

N3 +100? GUNDESTRUP, N.F.II XVIII N.DENMARK

N38 +100 BRIANÇON, E.G·20

N4

DURA C·XCI
+1400? ASCOLI CATHED^R

N.5

COMMINGES
E·G·879

N6

+1200? BONN E·G·6272

N.68

LOMBARD
TOSCANA
A·G·L·170

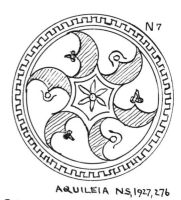

N7

AQUILEIA NS,1927,276

N8

+500? DABRAVINA MBH 1907,21

N9

+850
AHENNY S·CROSS
CCO·4A

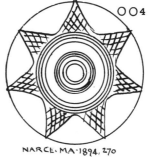

OO4

NARCE·MA·1894,270

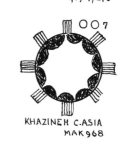

OO7

KHAZINEH C·ASIA
MAK 968

P

SKIRLS

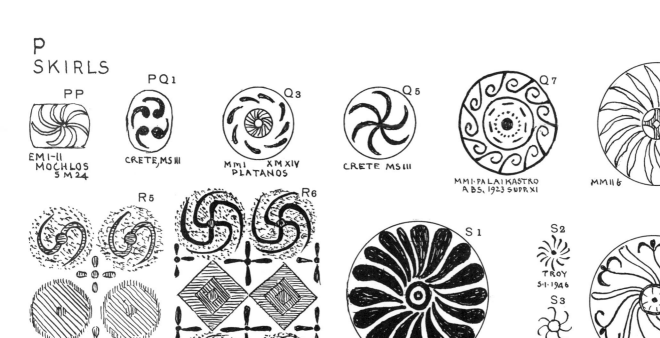

PP

EM I-II
MOCHLOS
5 M 24

PQ1

CRETE, MS III

Q3

MM I XM XIV
PLATANOS

Q5

CRETE MS III

Q7

MM I·PALAI KASTRO
A BS, 1923 SUPR XI

Q9

MM II 6

EPM·194

R5

R6

XVIII THEBES JDE 21
MENTUHETEP

XVIII THEBES JDE 19
AMENHETEP

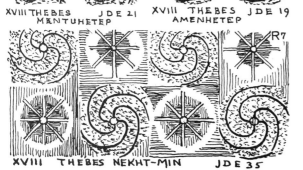

R7

XVIII THEBES NEKHT-MIN JDE 35

S 1

-1450
SAQQARA, TETI, FG6XLII φ

S2

TROY
S·I·1946

S3

TROY
S·I·1993

S4

LM I 6

SAQQARA EPM II 304

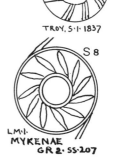

S6

TROY, S·I·1837

S 7

LM I
MYKENAE GR 4, SS
226

S8

LM·I·
MYKENAE
GR 2·SS·207

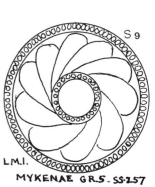

S 9

LM·I·
MYKENAE GR·5·SS·257

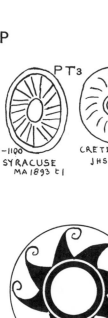

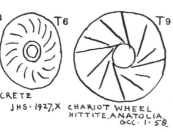

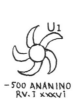

PT3

T6

T9

U1

U3

U6

U9

-1100
SYRACUSE
MA 1893 t1

CRETE
JHS·1927,X

CHARIOT WHEEL
HITTITE, ANATOLIA
GCC·1·58

-500 ANANINO
RV·T xxxvi

-500
S·MAURO SICILY MA 1910·VI

-650?
IALYSOS SAA 1926·187

-550?
IALYSOS SAA 1926·192

BEFORE
+870 S·CLEMENTE, ROME FE 2? OSSETIA·MAK, CVIII
-200? KERTCH, RK·XXIV

V2

V3

V4

V5

V6

-700
CUMA MA·1913,XLVII

NARCE·MA 1894 288

-700? VETULONIA
N·S·1898,154

FLORENCE, M·AA·I·XVII,2
GRANULAR WOR'

MONTIV
-750
UPPER BAVARIA SAK·129

V7

V8

W2

W5

W9

-650
FALERII HF VI

-1100,200 SCV 60
CHINA

-250 ORENBURG RI·G·XXIV
PERSIAN

MARSH FLOWER

-300
TUNEH PETOSIRIS
LP·PL XXXVIII

L·AEMILIO
MEMMIO

SPAIN LEON

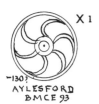

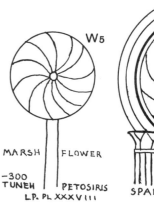

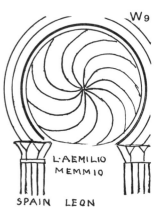

X1

-130?
AYLESFORD
BMCE 93

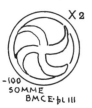

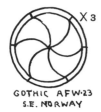

X2

X3

X5

X6

-100
SOMME
BMCE·pL III

GOTHIC AFW·23
S.E. NORWAY

+500 OXYRHYNKHOS PTC.XLV

+500?
KAMMUNTA
CC·III·XXI

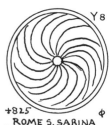

X7

X8

Y2

Y4

Y6

Y8

NARBONNE
EG 6901,6908

682 ROME
S.GIORG.VEL
SEE SY6 FR.

+650
or
750
ROME, S·MARIA·ANT FP

+7--
MODENA
CATHEDRAL

+770
CIVIDALE S·MARIA φ

+825
ROME S.SABINA φ
+513 CLEMENTINUS
DIPTYCH·DCD XVI
+525 PHILOXENUS
DRESS.DCD,XXIX

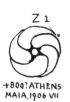

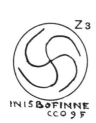

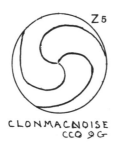

Z1

Z3

Z5

Z7

Z9

+800? ATHENS
MAIA, 1906 VII

INISBOFINNE
CCO 9F

CLONMACNOISE
CCO 9G

RHEFERT CCO·9·1
GLENDALOCH

LOCHLEE SCOTLAND
MLW p·415

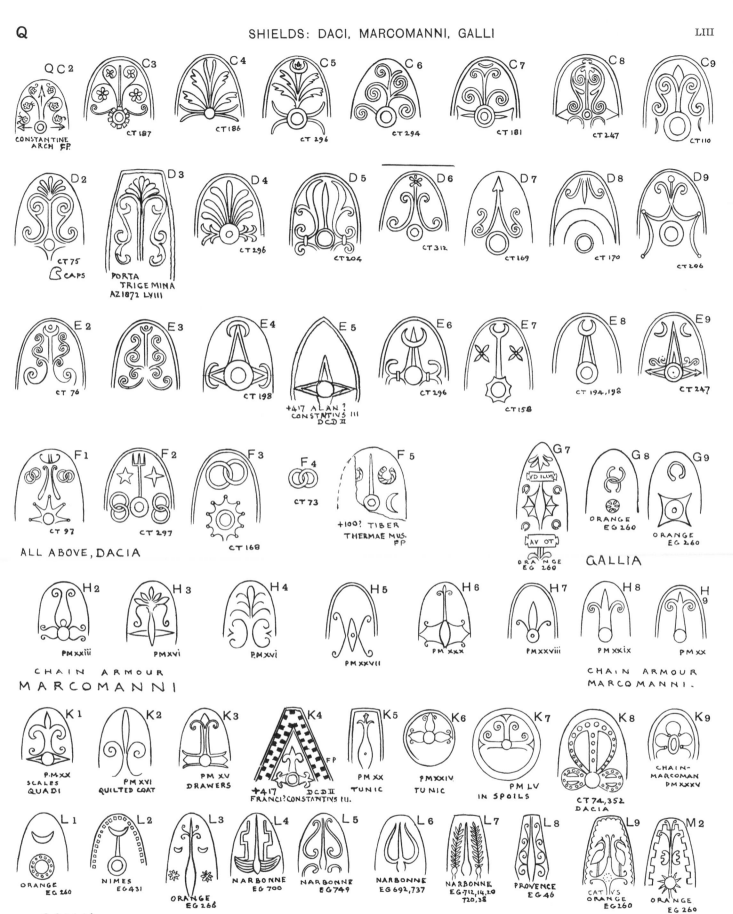

QC2 — CONSTANTINE ARCH F.P.

C3 — CT 187

C4 — CT 186

C5 — CT 296

C6 — CT 294

C7 — CT 181

C8 — CT 247

C9 — CT 110

D2 — CT 75 — B CAPS

D3 — PORTA TRIGEMINA AZ 1872 LVIII

D4 — CT 296

D5 — CT 204

D6 — CT 312

D7 — CT 169

D8 — CT 170

D9 — CT 206

E2 — CT 76

E3

E4 — CT 198

E5 — +417 ALAN? CONSTNTIVS III DCD II

E6 — CT 296

E7 — CT 158

E8 — CT 194,198

E9 — CT 247

F1 — CT 97

F2 — CT 297

F3 — CT 168

F4 — CT 73

F5 — +100? TIBER THERMAE MUS. F.P.

ALL ABOVE, DACIA

G7 — VD ILLVS — AV OT — ORANGE EG 260

G8 — ORANGE EG 260

G9 — ORANGE EG 260

GALLIA

H2 — PM xxiii

H3 — PMxvi

H4 — P.M.xvi

H5 — PM XXVII

H6 — PM xxx

H7 — PMxxviii

H8 — PM xxix

H9 — PM xx

CHAIN ARMOUR
MARCOMANNI

CHAIN ARMOUR
MARCOMANNI.

K1 — P.M.XX SCALES QUADI

K2 — PM XVI QUILTED COAT

K3 — PM XV DRAWERS

K4 — +417 DCD II FRANCI? CONSTANTINS IU.

K5 — PM XX TUNIC

K6 — P.M.XXIV TUNIC

K7 — PM LV IN SPOILS

K8 — CT 74,352 DACIA

K9 — CHAIN-MARCOMAN PM XXXV

L1 — ORANGE EG 260

L2 — NIMES EG 431

L3 — ORANGE EG 268

L4 — NARBONNE EG 700

L5 — NARBONNE EG 749

L6 — NARBONNE EG 692,737

L7 — NARBONNE EG 712,14,20 T20,38

L8 — PROVENCE EG 46

L9 — CATIVS ORANGE EG 260

M2 — ORANGE EG 260

GALLIA

M3 — NARBONNE EG 712

M4 — NARBONNE EG 712

M5 — ORANGE EG 260

M6 — MAVILLY 200? EG 2067

M7 — NARBONNE EG 699

M8 — ORANGE EG 260

M9 — ARLES EG 159

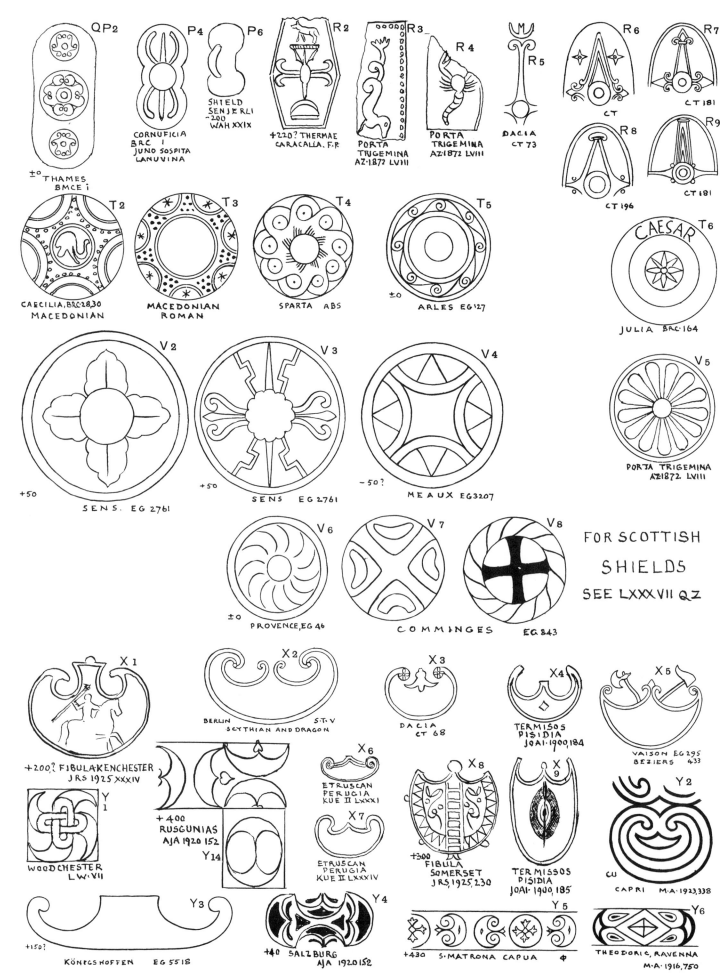

QP2

P4

P6

R2

R3

R4

R5

R6

R7
CT 181

R8
CT 196

R9
CT 181

CT

±0 THAMES
BMCE i

CORNUFICIA
BRC I
JUNO SOSPITA
LANUVINA

SHIELD
SENJERLI
~200
WAH XXIX

+220? THERMAE
CARACALLA. F.R

PORTA
TRIGEMINA
AZ·1872 LVIII

PORTA
TRIGEMINA
AZ·1872 LVIII

DACIA
CT 73

T2

T3

T4

T5

T6

CAECILIA, BRC 28,30
MACEDONIAN

MACEDONIAN
ROMAN

SPARTA ABS

±0 ARLES EG 127

CAESAR

JULIA BRC·164

V2

V3

V4

V5

+50

+50

−50?

SENS. EG 2761

SENS EG 2761

MEAUX EG 3207

PORTA TRIGEMINA
AZ·1872 LVIII

V6

V7

V8

±0

FOR SCOTTISH

PROVENCE, EG 46

COMMINGES

EG 843

SHIELDS

SEE LXXXVII QZ

X1

X2

X3

X4

X5

+200? FIBULA KENCHESTER
JRS 1925 XXXIV

BERLIN
SCYTHIAN AND DRAGON

S·T·V

DACIA
CT 68

TERMISOS
PISIDIA
JOAI·1900,184

VAISON EG 295
BEZIERS 433

Y1

+400
RUSGUNIAS
AJA 1920 152

X6

X8

X
9

Y2

WOODCHESTER
LW·VII

Y14

ETRUSCAN
PERUGIA
KUE II LXXXI

X7

ETRUSCAN
PERUGIA
KUE II LXXXIV

+300
FIBULA
SOMERSET
JRS,1925,230

TERMISSOS
PISIDIA
JOAI·1900,185

CU

CAPRI M·A·1923,338

Y3

Y4

Y5

Y6

+150?

KÖNIGSHOFFEN EG 5518

+40 SALZBURG
AJA 1920 152

+430 S·MATRONA CAPUA Φ

THEODORIC, RAVENNA
M·A·1916,750

RN1
= MM1 MONDSEE
E. SWITZ? C·D·125

N3
MM III
SITEIA EPM 371
SEE ME 2

N4
L·M·II
GR·III MYKENAE, S·S·149

N5
BR·III
S·W·CASPIAN
MPO, III, 213

N8
−600 SYRACUSE, MA 1918, 554

N6
−720
HALLSTATT, A 1916, XXX

N9
GOLD EARRING
ETRUSCAN, WEM·10

N7
−500? SANSKI MOST
MBH, 1899, 173

RO2
−550
OLBIA, BEADS
JI·1914·246

O3
FE2
BERGENHUS
R·A·N·668
SEE RQ3

O4
FE·2 BUSKERUD
R·A·N·701

O5
FE2. HEDEMARKEN R·A·N·720

O6
WATSCH, CARNIOLA B·C·67

O7
−50 GLASTONBURY, BGG LXXiii

O8
−100? GLASTONBURY
POT B·G·G, LXXi

P7

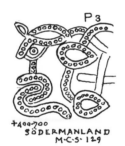

P1
+400?
GENEVA
LAMP. BAS II×

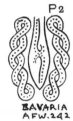

P2
BAVARIA
AFW. 242

P3
+400−700
SÖDERMANLAND
M·C·S· 129

P4
+414
KSEJBEH
B·N·S·I·170

P5
+525 DIPTYCH
PHILOXENUS
DC·D·XXIX

P6
+462
DAR KITA BNS·1·196

+418 DAR KITA
BNS·I·189

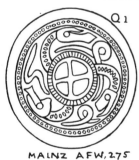

Q1
MAINZ AFW, 275

Q4
LOMBARD, BRESCIA
A·G·L, 274

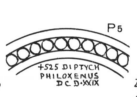

Q6
+600 TAPLOW AAS·2

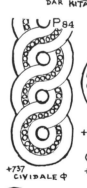

P84
+737
CIVIDALE Φ

P8
+650 BEHIOH SYRIA, CAI·23

P9
+600 NOCERA A·1918, 210

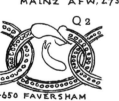

Q2
+650 FAVERSHAM
AAS· 250

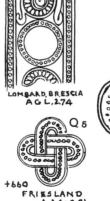

Q5
+660
FRIESLAND
AAS·291

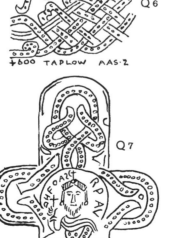

Q7
+610
LANGENEHRINGEN, LA·IV,10

Q76

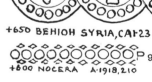

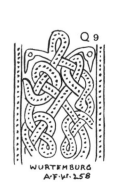

Q9
WURTEMBURG
A·F·W· 258

Q3
CANTERBURY, S.MARTIN, FONT
SEE RO3

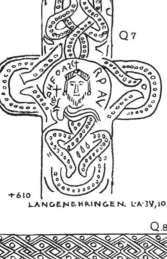

Q8
+700 A·V·XXIX, 4

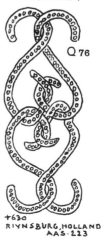

+630
RIJNSBURG, HOLLAND
AAS· 223

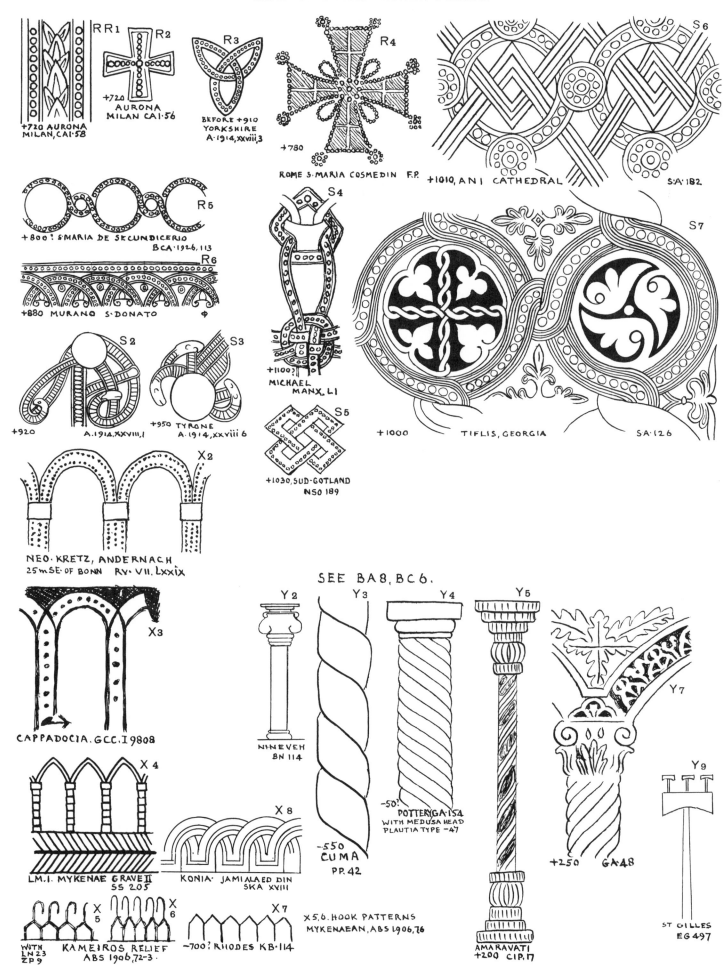

R

RR1 R2
+720
AURONA
MILAN CA1.56

+720 AURONA
MILAN, CA1.58

R3
BEFORE +910
YORKSHIRE
A.1914, XXVIII.3

R4
+780
ROME S. MARIA COSMEDIN F.P.

S6
+1010, ANI CATHEDRAL

S.A.182

R5
+800? S. MARIA DE SECUNDICERIO
BCA.1926, 113

R6
+880 MURANO S. DONATO

S4
+1100?
MICHAEL
MANX. LI

S5
+1030, SUD-GOTLAND
NSO 189

S7
+1000 TIFLIS, GEORGIA SA.126

S2
+920 A.1914.XXVIII,1

S3
+950 TYRONE
A.1914, XXVIII 6

X2
NEO. KRETZ, ANDERNACH
25m SE. OF BONN RV. VII. LXXIX

X3
CAPPADOCIA. GCC. I 9808

X4
LM.I. MYKENAE GRAVE II
SS 205

X8
KONIA. JAMIALAED DIN
SKA XVIII

X5
WITH
LN23
ZP9

X6
KAMEIROS RELIEF
ABS 1906, 72-3.

X7
-700? RHODES KB.114

X5,6. HOOK PATTERNS
MYKENAEAN, ABS 1906, 76

SEE BA8, BC6.

Y2
NINEVEH
BN 114

Y3
-550
CUMA
PP. 42

Y4
-50?
POTTER GA.154
WITH MEDUSA HEAD
PLAUTIA TYPE -47

Y5
AMARAVATI
+200 CIP. 17

Y7
+250 GA.48

Y9
ST GILLES
EG 497

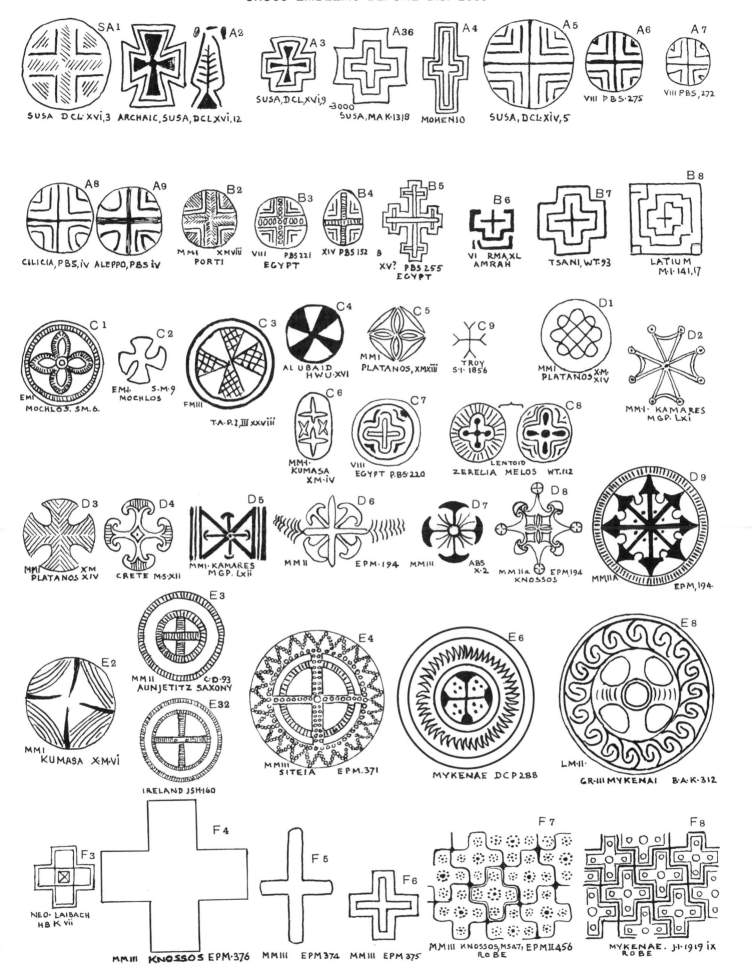

SA1 SUSA D.CL.XVI,3

A2 ARCHAIC, SUSA, DCL XVI,12

A3 SUSA, DCL.XVI,9

A36 -3000 SUSA, MAK-1318

A4 MOHENJO

A5 SUSA, DCL.XIV,5

A6 VIII P.BS·275

A7 VIII PBS, 272

A8 CILICIA, P.B.S, iv

A9 ALEPPO, P.B.S iv

B2 MMI XMVIII PORTI

B3 VIII P.BS 221 EGYPT

B4 XIV P.BS 152 B

B5 XV? PBS 255 EGYPT

B6 VI RMA,XL AMRAH

B7 TSANI, W.T.93

B8 LATIUM M·I·141,17

C1 EMI MOCHLOS. SM.6.

C2 EMI. S.M.9 MOCHLOS

C3 FMIII T.A.P.I.III xxviii

C4 AL UBAID HWU·XVI

C5 MMI PLATANOS, XMXiii

C9 TROY S·I·1856

D1 MMI PLATANOS XM XIV

D2 MMI. KAMARES MGP. Lxi

C6 MMI KUMASA XM·IV

C7 VIII EGYPT P.BS·220

C8 LENTOID ZERELIA MELOS WT.112

D3 MMI PLATANOS XIV XM

D4 CRETE M.S·XII

D5 MMI· KAMARES MGP. Lxii

D6 EPM.194 MMII

D7 ABS X·2 MMIII

D8 MMIIa EPM 194 KNOSSOS

D9 EPM, 194 MMIIA

E2 MMI KUMASA X·M·VI

E3 MMII C.D·93 AUNJETITZ SAXONY

E32 IRELAND JSH 160

E4 MMIII SITEIA EPM.371

E6 MYKENAE DCP 288

E8 LM·II· GR·III MYKENAI B·A·K·312

F3 NEO· LAIBACH HB K Vii

F4 MMIII KNOSSOS EPM·376

F5 MMIII EPM374

F6 MMIII EPM 375

F7 MMIII KNOSSOS, MS47, EPMII.456 ROBE

F8 MYKENAE. J·I·1919 iX ROBE

HAGHIA TRIADA M·A·1903·X

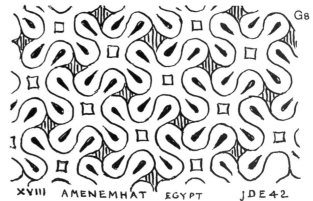

XVIII AMENEMHAT EGYPT JDE42

SH2

ABS.
PHYLAKOPI, xiii

H4

MM CRETE K·M·

H6

MYKENAE
VASE
DCP 288

H8

-600?
PRAESOS
ABS·1906·41

SJ1

MYKENAE
F.L.M.XXVIII

J2

MYKENAE
F.L.M.XXVIII

J3

MYKENAE
FLM.XXVIII

J5

1500 GERAR
P.G.LXIV

J6

-1150?
CRETE MYKENAEAN COFFER
M·A·1889 I,230

J8

1150? CRETE, M·A·1889,230

J9

LM IIIa. TDA ii
KNOSSOS

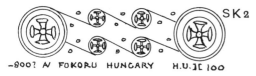

SK2

-800? N FOKORU HUNGARY H.U.II 100

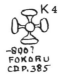

K4

-800?
FOKORU
CDP.385

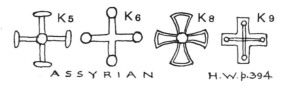

K5 K6 K8 K9

A S S Y R I A N H.W.p.394

L1

BR.
CORNETO N
M·I·276·16

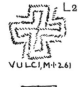

L2

VULCI, M·I·261

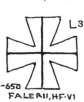

L3

-650
FALERII, HF·VI

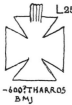

L25

-600? THARROS
BMJ

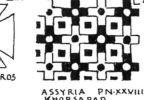

L4

ASSYRIA PN·XXVIII
KHORSABAD

L35

-570 FIKELLURA DAFNE, PD·XXVII

L5

TENE III
SARAGOSSA
DF2:686

L6

-600
DAFNEH
P.D.XXV

L7

FEI
SILESIA
DF333

L8

PALESTRINA, M·I·365·5

M1

-250
FICORONIAN CISTA,TOP·FP

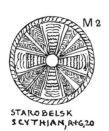

M2

STAROBELSK
SCYTHIAN, R+G,20

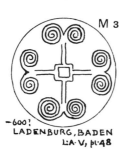

M3

-600?
LADENBURG, BADEN
L·A·V, pl·48

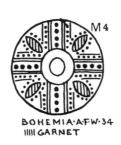

M4

BOHEMIA·A.F.W·34
IIIII GARNET

M5

+100?
CAERWENT
A·1902; X

M6

+200· NYDAM. EDE.N·ix

M7

250
ORENBURG
R·I·G·XXIV
(PERSIAN)

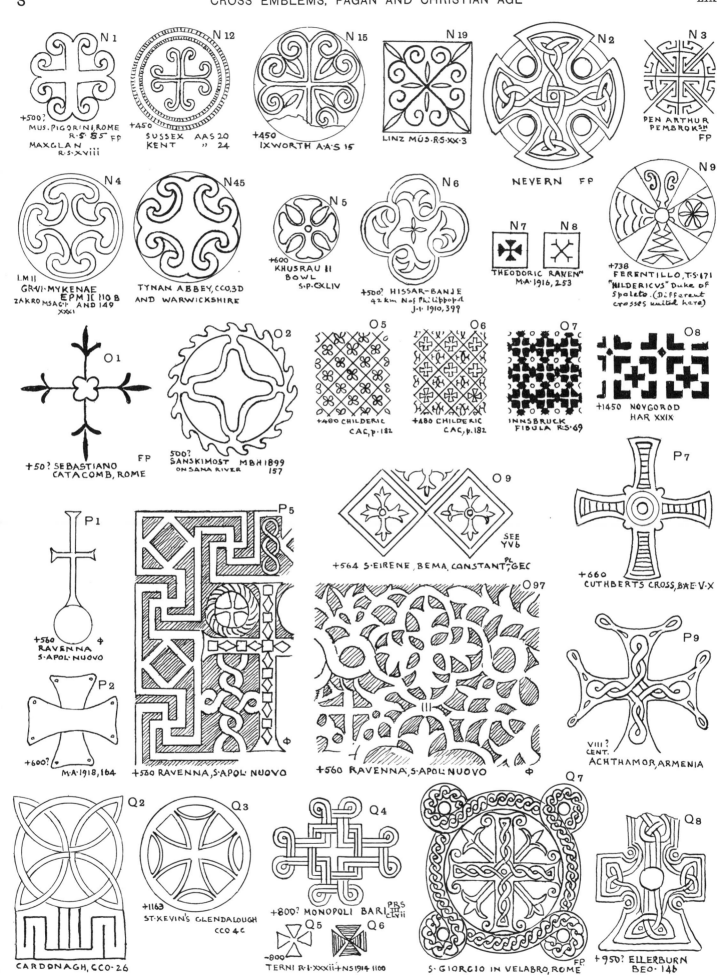

N 1
+500?
MUS. PIGORINI, ROME
R.S. 85 FP
MAXGLAN
R.S. XVIII

N 12
+450
SUSSEX AAS 20
KENT " 24

N 15
+450
IXWORTH A.A.S 15

N 19
LINZ MÚS. R.S. XX. 3

N 2
NEVERN FP

N 3
PEN ARTHUR
PEMBROKSH
FP

N 4
LM II
GR.VI.MYKENAE
EPM II 110 B
ZAKROMSAG.I. AND 149
XXXI

N 45
TYNAN ABBEY, CCO.3D
AND WARWICKSHIRE

N 5
+600
KHUSRAU II
BOWL
S.P. CXLIV

N 6
+500? HISSAR-BANJE
42 km N of Philippopol
J.I. 1910, 399

N 7 N 8
THEODORIC RANEN
M.A. 1916, 253

N 9
+738
FERENTILLO, T.S. 171
"HILDERICVS" Duke of
Spaleto. (Different
crosses united here)

O 1
+50? SEBASTIANO
CATACOMB, ROME
FP

O 2
500?
SANSKIMOST MBH 1899
ON SANA RIVER 157

O 5
+480 CHILDERIC
CAC, p. 182

O 6
+480 CHILDERIC
CAC, p. 182

O 7
INNSBRUCK
FIBULA RS. 69

O 8
+1450 NOVGOROD
HAR XXIX

O 9
+564 S. EIRENE, BEMA. CONSTANT, GEC
SEE
YV 6
PL

P 7
+660
CUTHBERTS CROSS, BAE V. X

P 1
+560
RAVENNA
S. APOL. NUOVO

P 5
+560 RAVENNA, S. APOL. NUOVO

O 97
+560 RAVENNA, S. APOL. NUOVO

P 2
+600?
M.A. 1918, 164

P 9
VIII?
CENT.
ACHTHAMOR, ARMENIA

Q 2
CARDONAGH, CCO. 26

Q 3
+1163
ST. KEVIN'S GLENDALOUGH
CCO 4 C

Q 4
+800? MONOPOLI BARI
PRS
III
CLVII

Q 5 Q 6
~800
TERNI R.I. XXXII + NS 1914 1100

Q 7
S. GIORGIO IN VELABRO, ROME
FP

Q 8
+950? ELLERBURN
BEO. 14 b

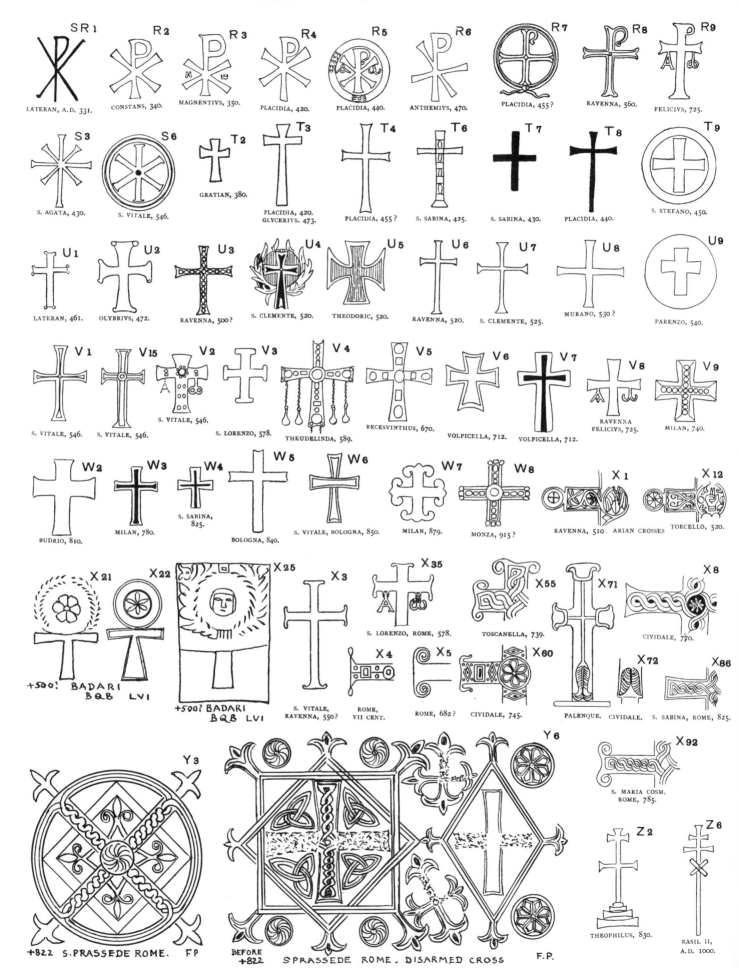

SR 1 — LATERAN, A.D. 331.
R 2 — CONSTANS, 340.
R 3 — MAGNENTIVS, 350.
R 4 — PLACIDIA, 420.
R 5 — PLACIDIA, 440.
R 6 — ANTHEMIVS, 470.
R 7 — PLACIDIA, 455?
R 8 — RAVENNA, 560.
R 9 — FELICIVS, 725.

S 3 — S. AGATA, 430.
S 6 — S. VITALE, 546.
T 2 — GRATIAN, 380.
T 3 — PLACIDIA, 420. GLYCERIVS, 473.
T 4 — PLACIDIA, 455?
T 6 — S. SABINA, 425.
T 7 — S. SABINA, 430.
T 8 — PLACIDIA, 440.
T 9 — S. STEFANO, 450.

U 1 — LATERAN, 461.
U 2 — OLYBRIVS, 472.
U 3 — RAVENNA, 500?
U 4 — S. CLEMENTE, 520.
U 5 — THEODORIC, 520.
U 6 — RAVENNA, 520.
U 7 — S. CLEMENTE, 525.
U 8 — MURANO, 530?
U 9 — PARENZO, 540.

V 1 — S. VITALE, 546.
V 15 — S. VITALE, 546.
V 2 — S. VITALE, 546.
V 3 — S. LORENZO, 578.
V 4 — THEUDELINDA, 589.
V 5 — RECESVINTHUS, 670.
V 6 — VOLPICELLA, 712.
V 7 — VOLPICELLA, 712.
V 8 — RAVENNA FELICIVS, 725.
V 9 — MILAN, 740.

W 2 — BUDRIO, 810.
W 3 — MILAN, 780.
W 4 — S. SABINA, 825.
W 5 — BOLOGNA, 840.
W 6 — S. VITALE, BOLOGNA, 850.
W 7 — MILAN, 879.
W 8 — MONZA, 915?
X 1 — RAVENNA, 510. ARIAN CROSSES
X 12 — TORCELLO, 520.

X 21 — +500? BADARI BQB LVI
X 22 — +500? BADARI BQB LVI
X 25 — +500? BADARI BQB LVI
X 3 — S. VITALE, RAVENNA, 550?
X 35 — S. LORENZO, ROME, 578.
X 55 — TOSCANELLA, 739.
X 71
X 8 — CIVIDALE, 770.
X 4 — ROME, VII CENT.
X 5 — ROME, 682?
X 60 — CIVIDALE, 745.
X 72 — PALENQUE.
X 86 — S. SABINA, ROME, 825.

Y 3 — +822 S. PRASSEDE ROME. FP
Y 6 — BEFORE +822 S. PRASSEDE ROME. DISARMED CROSS FP.
X 92 — S. MARIA COSM. ROME, 785.
Z 2 — THEOPHILUS, 830.
Z 6 — BASIL II, A.D. 1000.

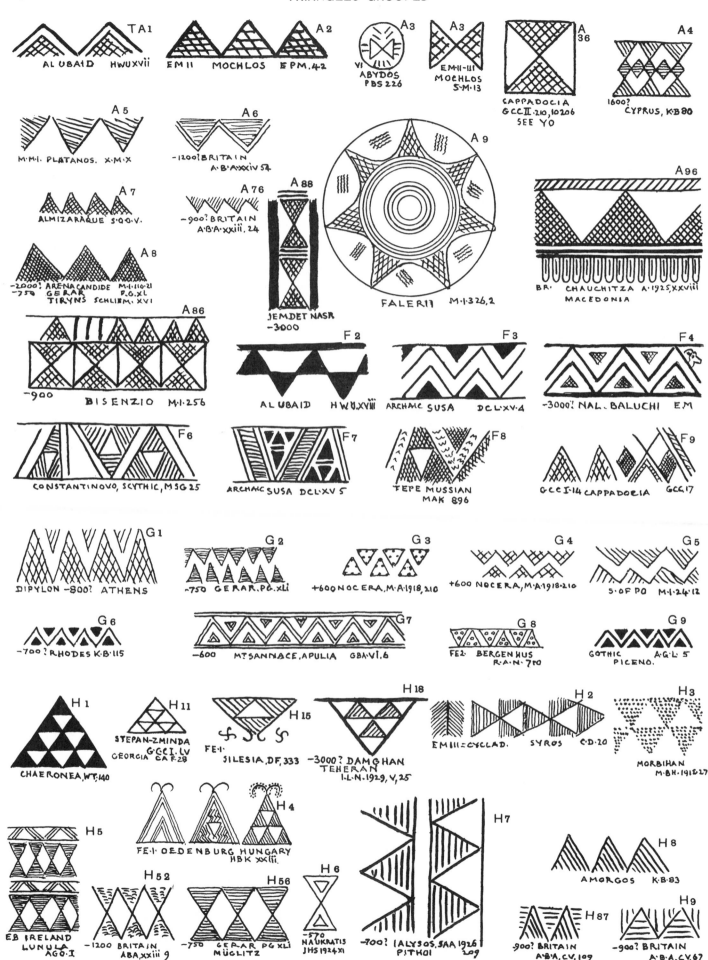

TA 1 · AL UBAID · HWU.XVII

A 2 · EM II · MOCHLOS · EPM.42

A 3 · VI ABYDOS · PBS 226

A 3 · EM II-III MOCHLOS S·M·13

A 36 · CAPPADOCIA GCC II·210,10206 SEE YO

A 4 · 1600? · CYPRUS, K·B·80

A 5 · M·M·I· PLATANOS· X·M·X

A 6 · -1200? BRITAIN A·B·A·XXIV 57

A 7 · ALMIZARAQUE S·Q·O·V·

A 76 · -900? BRITAIN A·B·A·XXIII, 24

A 88 · JEMDET NASR -3000

A 9 · FALERII M·I·326,2

A 96 · BR· CHAUCHITZA A·1925,XXVIII MACEDONIA

A 8 · -2000? ARENACANDIDE M·I·116·21 -750 GERAR P.G·XL TIRYNS SCHLIEM·XVI

A 86 · -900 · BISENZIO M·I·256

F 2 · AL UBAID · HWU.XVIII

F 3 · ARCHAIC SUSA DCL·XV·4

F 4 · -3000? NAL· BALUCHI EM

F 6 · CONSTANTINOVO, SCYTHIC, MSG 25

F 7 · ARCHAIC SUSA DCL·XV 5

F 8 · TEPE MUSSIAN MAK 896

F 9 · GCC I·14 CAPPADOCIA GCC 17

G 1 · DIPYLON -800? ATHENS

G 2 · -750 GERAR P.G·XLI

G 3 · +600 NOCERA, M·A·1918, 210

G 4 · +600 NOCERA, M·A·1918,210

G 5 · S· OF PO M·I·24·12

G 6 · -700? RHODES K·B·115

G 7 · -600 M·SANNACE, APULIA GBA·VI·6

G 8 · FE2· BERGEN HUS R·A·N· 710

G 9 · GOTHIC PICENO· A·G·L· 5

H 1 · CHAERONEA, WT·140

H 11 · STEPAN-ZMINDA GEORGIA G·C·I· LV CA F·28

H 15 · FE·I· SILESIA, DF, 333

H 18 · -3000? DAMGHAN TEHERAN I·L·N·1929, V, 25

H 2 · EM III = CYCLAD. SYROS C·D·20

H 3 · MORBIHAN M·B·H·1912·27

H 4 · FE·I· OEDENBURG HUNGARY HBK XXII·

H 5 · EB IRELAND LUNULA A.G·O·I

H 52 · -1200 BRITAIN ABA·XXIII 9

H 56 · -750 GERAR P.G· XLI MÜGLITZ

H 6 · -570 NAUKRATIS JHS 1924 XI

H 7 · -700? IALYSOS, SAA 1926 PITHOI 209

H 8 · AMORGOS K·B·83

H 87 · -900? BRITAIN A·B·A, CV, 109

H 9 · -900? BRITAIN A·B·A·CV·67

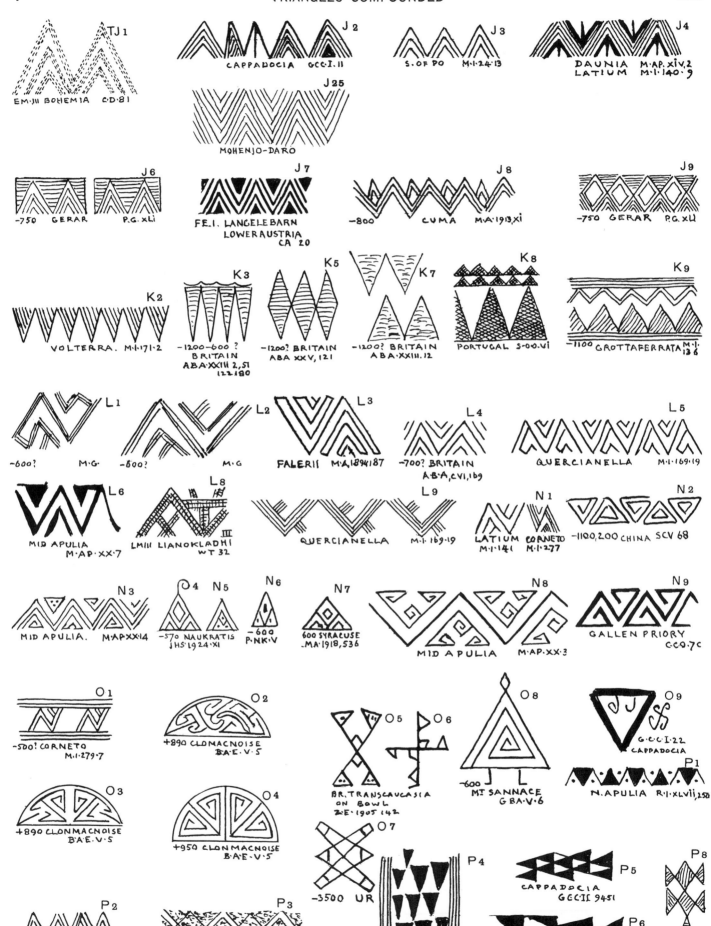

J1 EM·III BOHEMIA C·D·81

J2 CAPPADOCIA G·C·I·11

J3 S.OF PO M·I·24·13

J4 DAUNIA M·AP·XIV·2 / LATIUM M·I·140·9

J25 MOHENJO-DARO

J6 −750 GERAR P.G·xLi

J7 FE·I. LANGELEBARN LOWER AUSTRIA CA 20

J8 −800 CUMA M·A·1913·XI

J9 −750 GERAR P.G·xLi

K2 VOLTERRA. M·I·171·2

K3 −1200−600? BRITAIN ABA·XXIII 2,51 122 180

K5 −1200? BRITAIN ABA·XXV, 121

K7 −1200? BRITAIN ABA·XXIII.12

K8 PORTUGAL S·00·Vi

K9 −1100 GROTTAFERRATA M·I·13 6

L1 −600? M·G·

L2 −800? M·G

L3 FALERII M·A·1894·187

L4 −700? BRITAIN A·B·A·CVI·1b9

L5 QUERCIANELLA M·I·169·19

L6 MID APULIA M·AP·XX·7

L8 LM·III LIANOKLADHI WT 32

L9 QUERCIANELLA M·I·169·19

N1 LATIUM M·I·141 CORNETO M·I·277

N2 −1100,200 CHINA SCV 68

N3 MID APULIA. M·AP·XX·14

N4 / **N5** −570 NAUKRATIS JHS·1924·XI

N6 −600 P.NK·V

N7 600 SYRACUSE ·MA·1918,536

N8 MID APULIA M·AP·XX·3

N9 GALLEN PRIORY C·C·O·7C

O1 −500! CORNETO M·I·279·7

O2 +890 CLONMACNOISE B·A·E·V·5

O3 +890 CLONMACNOISE B·A·E·V·5

O4 +950 CLONMACNOISE B·A·E·V·5

O5 / **O6** BR. TRANSCAUCASIA ON BOWL Z·E·1905·142

O7 −3500 UR

O8 −600 MT SANNACE G·BA·V·6

O9 G·C·I·22 CAPPADOCIA

P1 N. APULIA R·I·XLVII,250

P2 −500 CORNETO, M·I·2797

P3 N. APULIAN. M·AP·XVII 10

P4 CAPPADOCIA G·C·X·I·74

P5 CAPPADOCIA G·C·I·9451

P6 CAPPADOCIA G·C·I·73

P8 FE·I OEDENBURG HUNGARY D·F·218

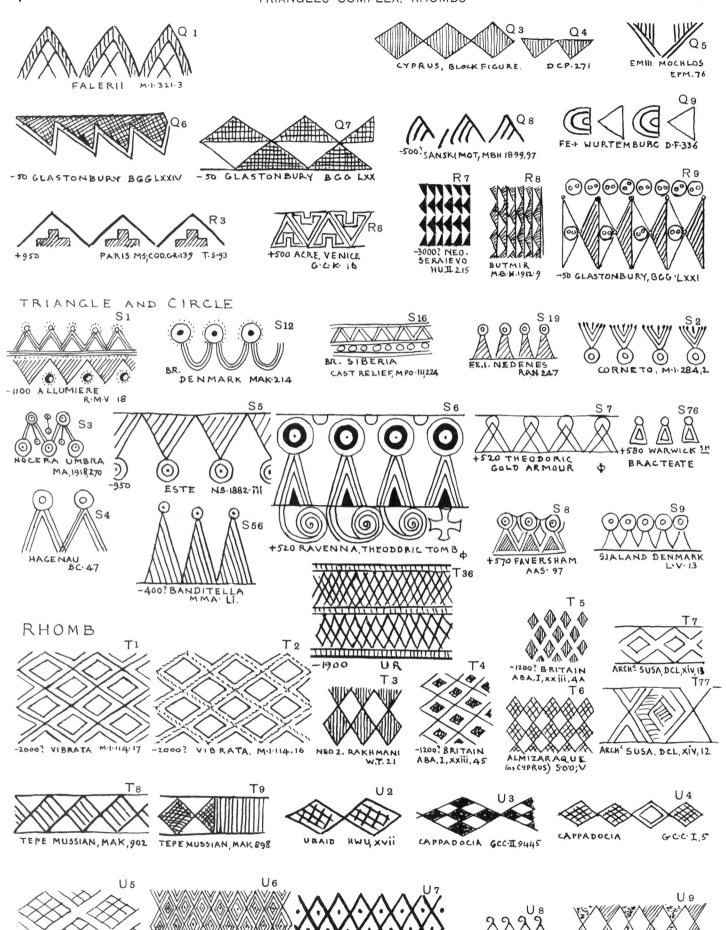

Q1 FALERII M·I·321·3

CYPRUS, BLOCK FIGURE. Q3 Q4 DCP·271 Q5 EM III MOCHLOS EPM·76

Q6 -50 GLASTONBURY BGG LXXIV

Q7 -50 GLASTONBURY BGG LXX

Q8 -500? SANSKI MOT, MBH 1899,97

Q9 FE·I· WURTEMBURG D·F·336

R3 +950 PARIS MS; COD·GR·139 T·S·93

R6 +500 ACRE, VENICE G·C·K·16

R7 -3000? NEO. SERAIEVO HU II 215

R8 BUTMIR M·B·H·1912·9

R9 -50 GLASTONBURY, BGG·LXXI

TRIANGLE AND CIRCLE

S1 -1100 ALLUMIERE R·M·V 18

S12 BR. DENMARK MAK·214

S16 BR. SIBERIA CAST RELIEF, MPO·III,224

S19 FE·I· NEDENES RAN 247

S2 CORNETO, M·I·284,2

S3 NOCERA UMBRA MA, 1918,270

S5 ESTE N·S·1882·711 -950

S6 +520 RAVENNA, THEODORIC TOMB Φ

S7 +520 THEODORIC GOLD ARMOUR

S76 +580 WARWICK 5H BRACTEATE

S4 HAGENAU BC·47

S56 -400? BANDITELLA MMA·Li.

S8 +570 FAVERSHAM AAS·97

S9 SJALAND DENMARK L·V·13

T36 -1900 UR

RHOMB

T1 -2000? VIBRATA M·I·114·17

T2 -2000? VIBRATA, M·I·114,16

T3 NEO 2. RAKHMANI W·T·21

T4 -1200? BRITAIN ABA,I,xxiii,45

T5 -1200? BRITAIN ABA,I,xxiii,4A

T6 ALMIZARAQUE (as CYPRUS) 5·0·0;V

T7 ARCH⁵ SUSA, DCL,XIV,13

T77 ARCH⁵ SUSA, DCL,XIV,12

T8 TEPE MUSSIAN, MAK,902

T9 TEPE MUSSIAN, MAK 898

U2 UBAID HWU xvii

U3 CAPPADOCIA GCC·II 9445

U4 CAPPADOCIA G·C·C I,5

U5 -1200? BRITAIN ABA,I,xxiv,60

U6 -700 CRETE ABS viii

U7 FALERII M·I·320, 14

U8 -700 ATHENS K·B·116

U9 CAPUA K·T·50

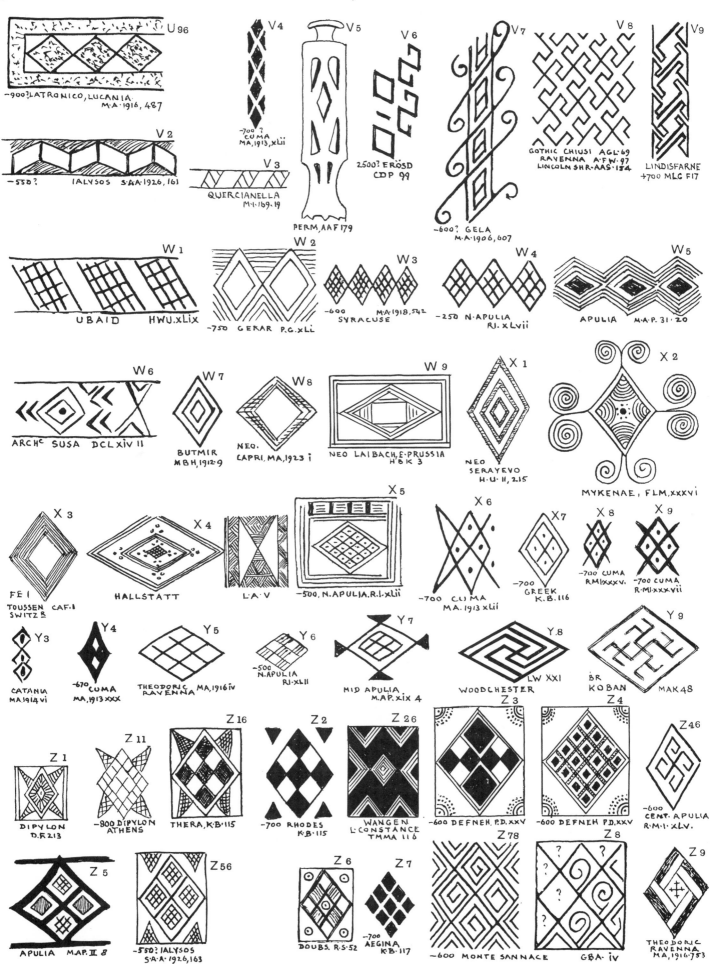

U 96 -900? LATRONICO, LUCANIA. M.A. 1916, 487

V 2 -550? IALYSOS S.A.A. 1926, 161

V 3 QUERCIANELLA M.I. 169. 19

V 4 -700? CUMA MA. 1913, xLii

V 5 PERM, AAF 179

V 6 2500? ERÖSD CDP 99

V 7 -600? GELA M.A. 1906, 607

V 8 GOTHIC CHIUSI AGL·69 RAVENNA A·F·W·97 LINCOLN SHR·AAS·154

V 9 LINDISFARNE +700 MLG F17

W 1 UBAID HWU. xLix

W 2 -750 GEZAR P.G. xLi

W 3 -600 M.A 1918, 542 SYRACUSE

W 4 -250 N. APULIA RJ. xLvii

W 5 APULIA M.A.P. 31·20

W 6 ARCHᶜ SUSA DCLXiV 11

W 7 BUTMIR MBH, 1912·9

W 8 NEO. CAPRI, MA, 1923 i

W 9 NEO LAIBACH, E. PRUSSIA HBK 3

X 1 NEO SERAYEVO H·U· II, 2.15

X 2 MYKENAE, FLM, xxxvi

X 3 FE I TOUSSEN CAF·1 SWITZᴮ

X 4 HALLSTATT

L·A·V

X 5 -500, N. APULIA. R.I. xLii

X 6 -700 CUMA MA. 1913 xLii

X 7 -700 GREEK K.B. 116

X 8 -700 CUMA RM.xxxv.

X 9 -700 CUMA R.MI.xxxvii

Y 3 CATANIA MA.1914 vi

Y 4 -670 CUMA MA, 1913 xxx

Y 5 THEODORIC RAVENNA MA, 1916 iv

Y 6 -500 N. APULIA RJ. xLii

Y 7 MID APULIA M.A.P. xix 4

Y 8 WOODCHESTER LW XXI

Y 9 BR KOBAN MAK 48

Z 1 DIPYLON D.F. 213

Z 11 -800 DIPYLON ATHENS

Z 16 THERA, K.B. 115

Z 2 -700 RHODES K.B. 115

Z 26 WANGEN L. CONSTANCE TMMA 116

Z 3 -600 DEFNEH. P.D. xxv

Z 4 -600 DEFNEH P.D. xxv

Z 46 -600 CENT. APULIA R.M.I. xLV.

Z 5 APULIA M.A.P. II 8

Z 56 -550? IALYSOS S.A.A. 1926, 163

Z 6 DOUBS. R.S. 52

Z 7 -700 AEGINA K.B. 117

Z 78 -600 MONTE SANNACE

Z 8 GBA· iv

Z 9 THEODORIC RAVENNA MA, 1916, 753

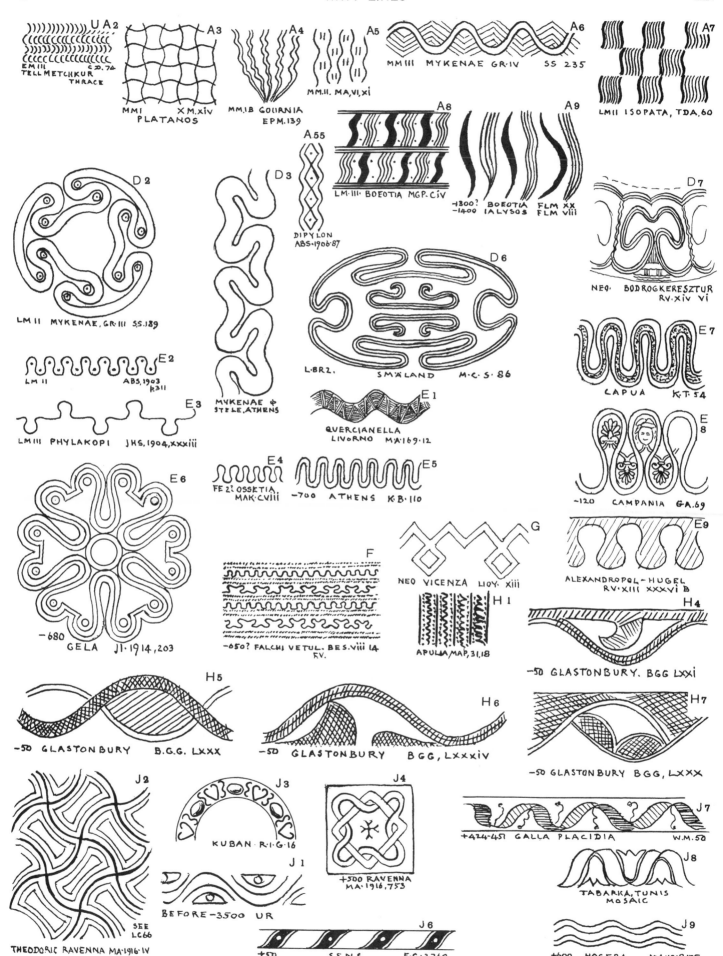

UA2
EM III C D. 74
TELL METCHKUR
THRACE

A3
MM I X M. xiv
PLATANOS

A4
MM.IB GOURNIA
EPM.139

A5
MM.II. MA,VI,XI

A6
MM III MYKENAE GR·IV SS 235

A7
LM II ISOPATA, TDA. 60

A8
LM·III· BOEOTIA MGP·CIV

A9
+1300?
-1400 BOEOTIA FLM XX
IALYSOS FLM viii

A55
DIPYLON
ABS·1906·87

D2
LM II MYKENAE, GR·III S.S.189

D3
MYKENAE φ
STELE, ATHENS

D6
L·BR2. SMÄLAND M·C·S·86

D7
NEQ. BODROGKERESZTUR
RV·xiv vi

E2
LM II ABS, 1903
k311

E3
LM III PHYLAKOPI JHS.1904,xxxiii

E6
-680
GELA JI·1914,203

E1
QUERCIANELLA
LIVORNO MA·169·12

E4
FE 2? OSSETIA
MAK·CVIII

E5
-700 ATHENS K·B·110

E7
CAPUA K·T·54

E8
CAMPANIA GA.69
-120

E9
ALEXANDROPOL - HUGEL
RV·XIII XXXVI B

F
-650? FALCHI VETUL. BES·viii L4
RV.

G
NEQ VICENZA LIOY. xiii

H1
APULIA/MAP, 31,18

H4
-50 GLASTONBURY. BGG LXXi

H5
-50 GLASTONBURY B.G.G. LXXX

H6
-50 GLASTONBURY BGG, LXXXiv

H7
-50 GLASTONBURY BGG, LXXX

J2
SEE
LC66
THEODORIC RAVENNA MA·1916·IV

J3
KUBAN·R·I·G·16

J4
+500 RAVENNA
MA·1916,753

J1
BEFORE -3500 UR

J6
+50 SENS E·G·2760

J7
+424-451 GALLA PLACIDIA W.M.50

J8
TABARKA, TUNIS
MOSAIC

J9
+600 NOCERA MA·1918,175

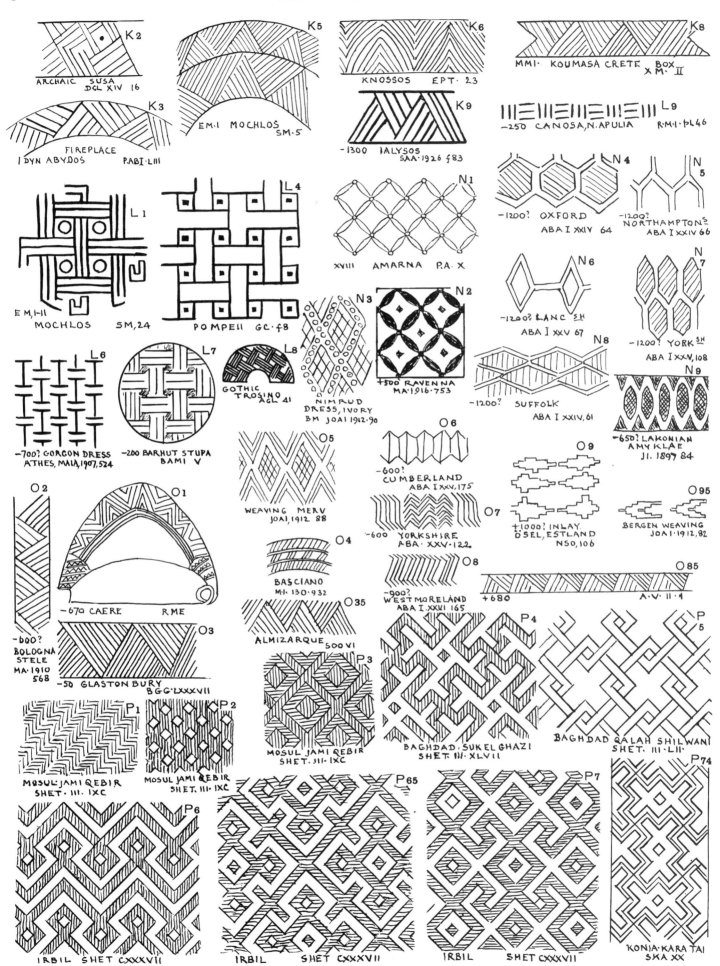

K2 — ARCHAIC SUSA DGL XIV 16

K3 — FIREPLACE I DYN ABYDOS P.ABI·LIII

K5 — EM·I MOCHLOS SM·5

K6 — KNOSSOS EPT·23

K9 — -1300 IALYSOS SAA·1926 f83

K8 — MMI· KOUMASA CRETE BOX X M·II

L9 — -250 CANOSA, N. APULIA R·M·I·PL46

N4 — -1200? OXFORD ABA I XXIV 64

N5 — -1200? NORTHAMPTON⁵ ABA I XXIV 66

N6 — -1200? LANC ⁵ᴴ ABA I XXV 67

N7 — -1200? YORK ⁵ᴴ ABA I XXV, 108

N1 — XVIII AMARNA P.A. X

N2 — +500 RAVENNA MA·1916·753

N3 — NIMRUD DRESS, IVORY BM JOAI 1912·90

N8 — -1200? SUFFOLK ABA I XXIV, 61

N9 — -650? LAKONIAN AMYKLAE JI. 1897 84

L1 — E M, I-II MOCHLOS SM, 24

L4 — POMPEII GC·f8

L6 — -700? GORGON DRESS ATHES, MAIA, 1907, 524

L7 — -200 BARHUT STUPA BAMI V

L8 — GOTHIC TROSINO AGL 41

O5 — WEAVING MERV JOAI, 1912 88

O6 — -600? CUMBERLAND ABA I XXV, 175

O9

O7 — +1000? INLAY. O SEL, ESTLAND NSO, 106

O95 — BERGEN WEAVING JOAI·1912, 82

O2

O1 — -670 CAERE R ME

O3 — -50 GLASTONBURY BGG·LXXXVII

O4 — BASCIANO MI· 130·932

O35 — ALMIZARQUE 500 VI

O8 — -900? WESTMORELAND ABA I. XXVI 165

-600 YORKSHIRE ABA· XXV·122

O2 — -600? BOLOGNA STELE MA·1910 568

O85 — +680 A·V·II·4

P4 — BAGHDAD, SUK EL GHAZI SHET III· XLVII

P5 — BAGHDAD QALAH SHILWANI SHET· III·LII

P3 — MOSUL JAMI QEBIR SHET· III·IXC

P1 — MOSUL JAMI QEBIR SHET· III. IXC

P2 — MOSUL JAMI QEBIR SHET. III· IXC

P6 — IRBIL SHET CXXXVII

P65 — IRBIL SHET CXXXVII

P7 — IRBIL SHET CXXXVII

P74 — KONIA·KARA TAI SKA XX

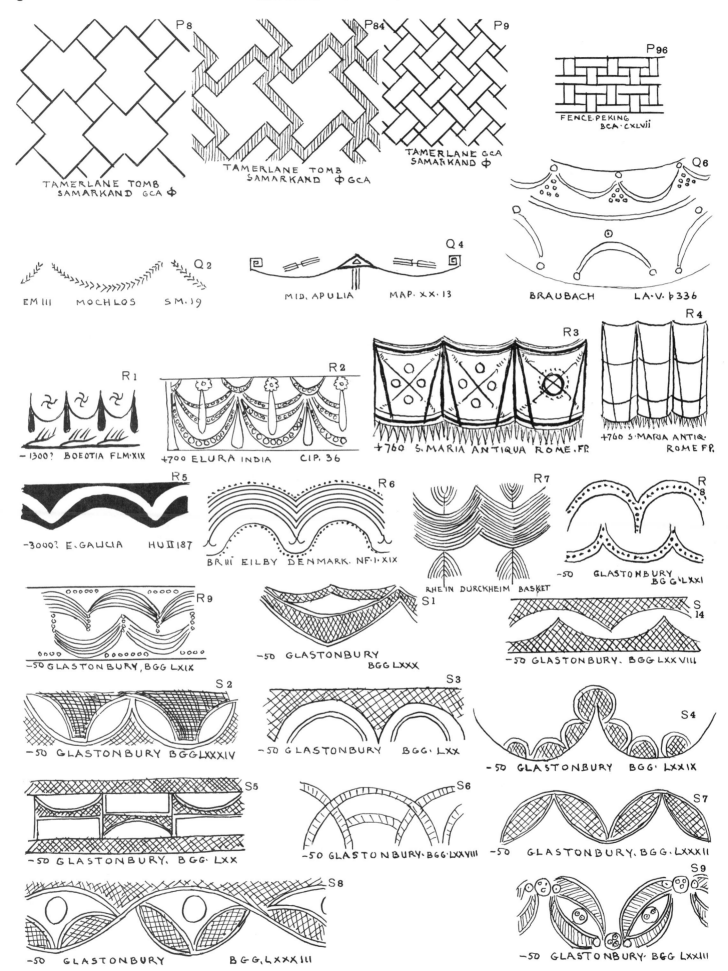

P8 P84 P9

P96
FENCE·PEKING
BCA·CXLVII

TAMERLANE TOMB
SAMARKAND GCA Φ

TAMERLANE TOMB
SAMARKAND Φ GCA

TAMERLANE GCA
SAMARKAND Φ

Q6

Q2
EM III MOCHLOS SM·19

Q4
MID. APULIA MAP·XX·13

BRAUBACH LA·V·Þ336

R3
+760 S·MARIA ANTIQUA ROME·FR.

R4
+760 S·MARIA ANTIQ.
ROME F.P.

R1
−1300? BOEOTIA FLM·XIX

R2
+700 ELURA INDIA CIP. 36

R5
−3000? E·GALICIA HU II 187

R6
BR III EILBY DENMARK. NF·I·XIX

R7
RHEIN DURCKHEIM BASKET

R8
−50 GLASTONBURY
BGG·LXXI

R9
−50 GLASTONBURY, BGG LXIX

S1
−50 GLASTONBURY
BGG LXXX

S14
−50 GLASTONBURY. BGG LXXVIII

S2
−50 GLASTONBURY BGG LXXXIV

S3
−50 GLASTONBURY BGG·LXX

S4
−50 GLASTONBURY BGG·LXXIX

S5
−50 GLASTONBURY. BGG. LXX

S6
−50 GLASTONBURY·BGG LXXVIII

S7
−50 GLASTONBURY. BGG·LXXXII

S8
−50 GLASTONBURY BGG·LXXXIII

S9
−50 GLASTONBURY· BGG LXXIII

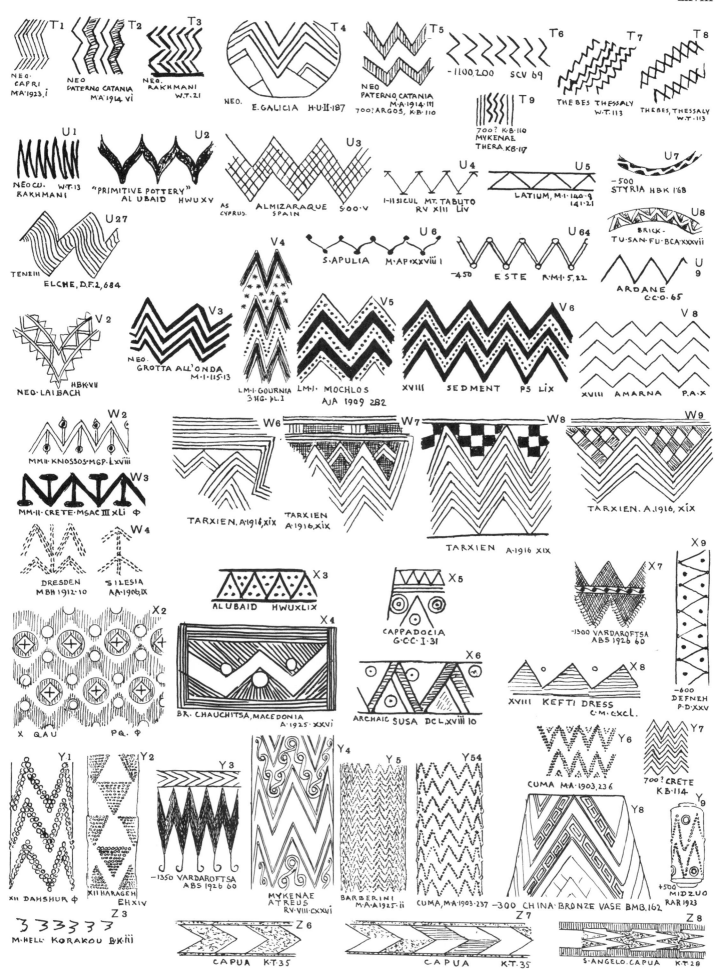

T1 NEO. CAPRI M·A·1923.i

T2 NEO PATERNO CATANIA M·A·1914·vi

T3 NEO. RAKHMANI W.T.21

T4 NEO. E.GALICIA H·U·II·187

T5 NEO. PATERNO CATANIA M·A·1914·III 700? ARGOS, K·B·110

T6 -1100,200 SCV 69

T7 THEBES THESSALY W.T.113

T8 THEBES, THESSALY W.T.113

T9 700? K·B·110 MYKENAE THERA, K·B·117

U1 NEO CU. RAKHMANI W.T.13

U2 "PRIMITIVE POTTERY" AL UBAID HWUXV

U3 AS CYPRUS. ALMIZARAQUE SPAIN S·O·O·V

U4 I-II SICUL MT. TABUTO RV XIII Liv

U5 LATIUM, M·I·140·9 141·21

U7 -500 STYRIA HBK I·68

U27 TENE III ELCHE, D.F.2,684

V4

U6 S. APULIA M·AP·XXVIII 1

U64 -450 ESTE R·M·I·5,22

U8 BRICK. TU·SAN·FU·BCA·XXXVII

U9 ARDANE C·C·O·65

V2 NEO·LAIBACH HBK·VII

V3 NEO. GROTTA ALL'ONDA M·I·115·13

V5 LM·I·GOURNIA 3 HG· pl·I LM·I· MOCHLOS AJA 1909 282

V6 XVIII SEDMENT PS LIX

V8 XVIII AMARNA P·A·X

W2 MMII·KNOSSOS·MGP·Lxviii

W3 MM·II·CRETE·MSAC III xLi Φ

W6 TARXIEN, A·1916, xix

W7 TARXIEN A·1916, xix

W8 TARXIEN A·1916 xix

W9 TARXIEN. A.1916, xix

W4 DRESDEN MBH 1912-10 SILESIA AA·1906.IX

X9 -600 DEFNEH P·D·XXV

X7 -1300 VARDAROFTSA ABS 1926 60

X3 ALUBAID HWUXLIX

X5 CAPPADOCIA G·C·C·I·31

X2 X QAU PQ. Φ

X4 BR. CHAUCHITSA, MACEDONIA A·1925·XXVI

X6 ARCHAIC SUSA DCL·XVIII 10

X8 XVIII KEFTI DRESS c·m·excl.

Y1 XII DAHSHUR Φ

Y2 XII HARAGEH EH XIV

Y3 -1350 VARDAROFTSA ABS 1926 60

Y4 MYKENAE ATREUS RV·VIII·CXXVI

Y5 BARBERINI M·A·AI925·ii

Y54 CUMA, M·A·1903·237

Y6 CUMA M·A·1903,236

Y7 700? CRETE K·B·114

Y8 -300 CHINA BRONZE VASE BMB.162

Y9 +500 MIDZUO RAR 1923

Z3 333333 M·HELL· KORAKOU B·K·iii

Z6 CAPUA K·T·35

Z7 CAPUA K·T·35

Z8 S·ANGELO·CAPUA K·T·28

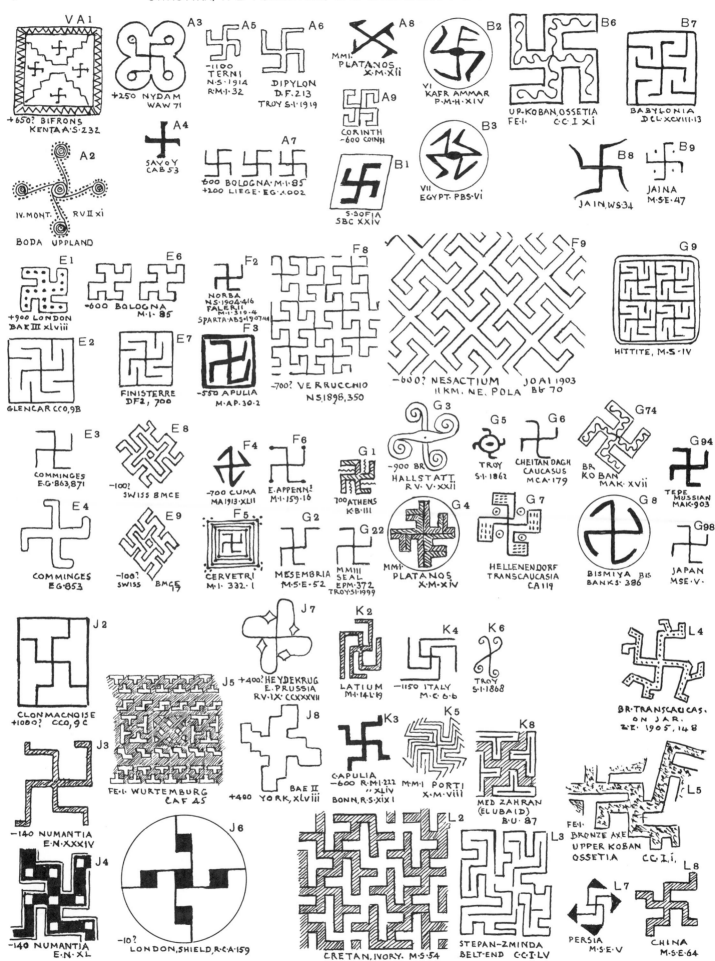

V A 1 +650? BIFRONS KENTA·A·S·232

A 3 +250 NYDAM WAW 71

A 5 -1100 TERNI N·S·1914 R·M·I·32

A 6 DIPYLON D.F.213 TROY·S·I·1919

A 8 MMI. PLATANOS X·M·XII

B 2 VI KAFR AMMAR P·M·H·XIV

B 6 UP·KOBAN, OSSETIA FE·I· C·C·I·Xi

B 7 BABYLONIA D·CL·XCVIII·13

A 4 SAVOY CAB·53

A 7 -600 BOLOGNA·M·I·85 +200 LIEGE·EG·A·002

A 9 CORINTH -600 COINH

B 3 VII EGYPT· PBS·Vi

B 8 JAIN, WS·34

B 9 JAINA M·S·E·47

A 2 IV. MONT. RVII xi BODA UPPLAND

B 1 S. SOFIA SBC XXIV

E 1 +900 LONDON BAK III xlviii

E 6 -600 BOLOGNA M·I·85

F 2 NORBA N·S·1904·416 FALERII M·I·319·4 SPARTA·ABS·1907·III

F 8

F 9 -600? NESACTIUM II KM. NE. POLA JOAI 1903 B·G 70

G 9 HITTITE, M·S·IV

E 2 GLENCAR CCO,9B

E 7 FINISTERRE DF2, 700

F 3 -550 APULIA M·AP·30·2

-700? VERRUCCHIO N·S,1898,350

E 3 COMMINGES E·G·863,871

E 8 -100? SWISS BMCE

F 4 -700 CUMA MA1913·XLII

F 6 E. APPENN! M·I·159·16

G 1 700 ATHENS K·B·III

G 3 -900 BR HALLSTATT. R·V·V·XXII

G 5 TROY S·I·1862

G 6 CHEITAN DAGH CAUCASUS M·C·A·179

G 74 BR KO BAN MAK·XVII

G 94 TEPE MUSSIAN MAK·903

E 4 COMMINGES EG·853

E 9 -100? SWISS BMCE 77

F 5 CERVETRI M·I· 332·1

G 2 MESEMBRIA M·S·E·52

G 22 MMIII SEAL EPM·372 TROY·SI·1999

G 4 MMI PLATANOS X·M·XIV

G 7 HELLENENDORF TRANSCAUCASIA CA 119

G 8 BISMIYA BIS BANKS· 386

G 98 JAPAN MSE·V·

J 2 CLONMACNOISE +1000? CCO,9 C

J 7 +400? HEYDEKRUG E. PRUSSIA RV·IX· CCXXXVII

K 2 LATIUM M·I·141·19

K 4 -1150 ITALY M·C·6·b

K 6 TROY S·I·1868

L 4

BR. TRANSCAUCAS. ON JAR. Z·E· 1905, 148

J 5 FE·I· WURTEMBURG CAF 45

J 3 -140 NUMANTIA E·N·XXXIV

J 8 +400 YORK, xlviii BAE II

K 3 CAPULIA -600 R·M·I·212 " xLIV BONN, R·S·XiX 1

K 5 MM·I PORTI X·M·Viii

K 8 MED ZAHRAN (ELUBAID) B·U· 87

L 3 FE·I· BRONZE AXE UPPER KOBAN OSSETIA CC·I,i,

L 5

J 4 -140 NUMANTIA E·N·XL

J 6 -10? LONDON, SHIELD, R·C·A·159

L 2 CRETAN, IVORY· M·S·54

STEPAN-ZMINDA BELT-END C·C·I·LV

L 7 PERSIA M·S·E·V

L 8 CHINA M·S·E·64

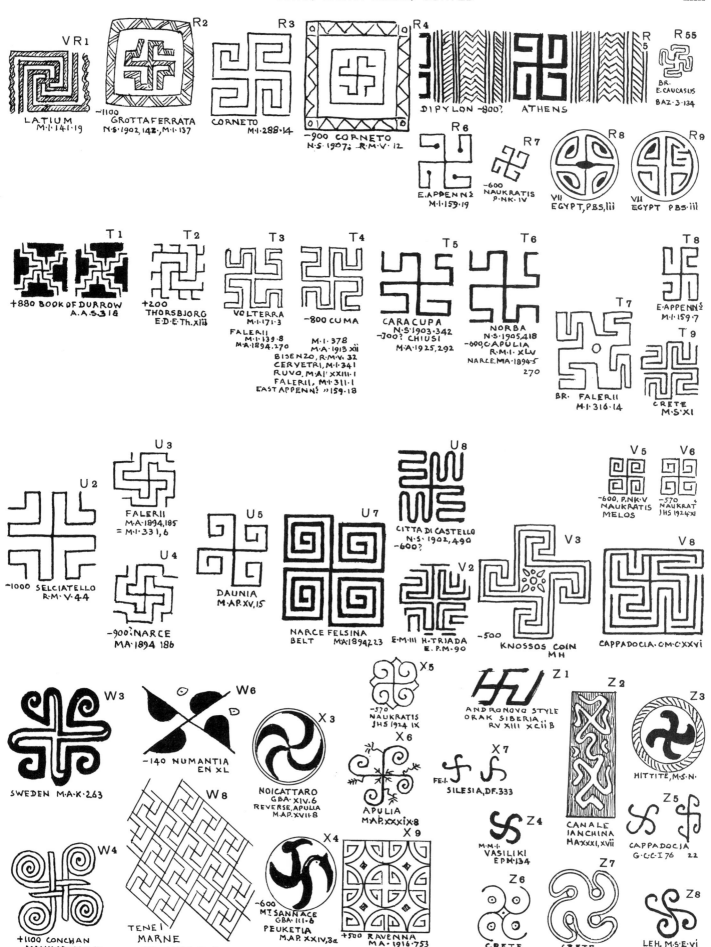

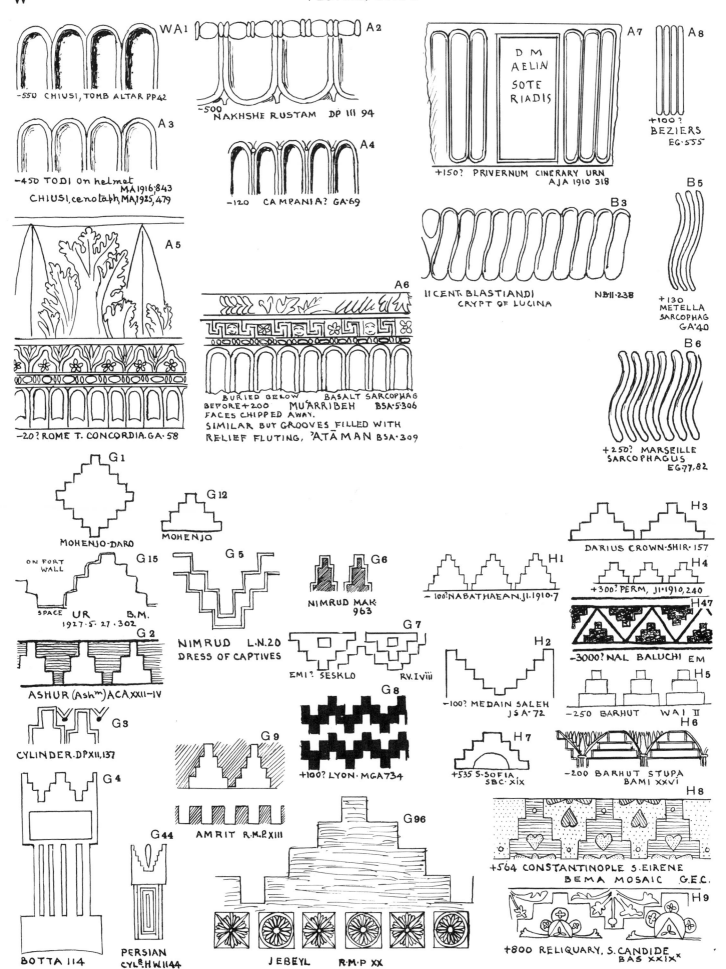

WA1 -550 CHIUSI, TOMB ALTAR PP42

A2 -500 NAKHSHE RUSTAM DP III 94

A3 -450 TODI on helmet MA 1916;843 CHIUSI, cenotaph MA 1925, 479

A4 -120 CAMPANIA? GA·69

A5 -20? ROME T. CONCORDIA. GA·58

A6 BURIED BELOW BASALT SARCOPHAG BEFORE +200 MUʿARRIBEH BSA·5·306 FACES CHIPPED AWAY. SIMILAR BUT GROOVES FILLED WITH RELIEF FLUTING, ʾATĀMAN BSA·309

A7 +150? PRIVERNUM CINERARY URN AJA 1910 318

D M AELIN SOTE RIADIS

A8 +100? BEZIERS EG·555

B3 II CENT. BLASTIANDI CRYPT OF LUCINA NB II·238

B5 +130 METELLA SARCOPHAG GA·40

B6 +250? MARSEILLE SARCOPHAGUS EG.77,82

G1 MOHENJO-DARO

G12 MOHENJO

G15 ON FORT WALL SPACE UR B.M. 1927·5·27·302

G2 ASHUR (Ashᵐ) ACA XXII-IV

G3 CYLINDER. DPXII,137

G4 BOTTA 114

G44 PERSIAN CYLᵉ·HW 1144

G5 NIMRUD L.N.20 DRESS OF CAPTIVES

G6 NIMRUD MAK· 963

G7 EM I? SESKLO RV. Iviii

G8 +100? LYON. MGA 734

G9 AMRIT R.M.P XIII

G96 JEBEYL R.M·P XX

H1 - 100? NABATHAEAN. JI·1910·7

H2 -100? MEDAIN SALEH JSA·72

H7 +535 S-SOFIA SBC·xix

H3 DARIUS CROWN·SHIR·157

H4 +300? PERM, JI·1910,240

H47 -3000? NAL BALUCHI EM

H5 -250 BARHUT WAI II

H6 -200 BARHUT STUPA BAMI XXVI

H8 +564 CONSTANTINOPLE S. EIRENE BEMA MOSAIC G.E.C.

H9 +800 RELIQUARY, S. CANDIDE BAS XXIXˣ

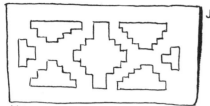

J1

+600 HEJNUM GOTLAND
OPEN WORK NSO 40

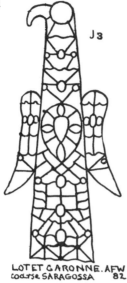

J3

LOT ET GARONNE. AFW
coarse SARAGOSSA 82

J4

W. SWITZERLAND
GARNET. AFW. 102

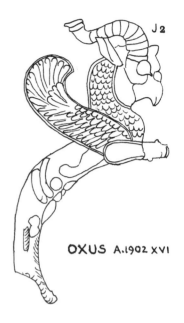

J2

OXUS A.1902 XVI

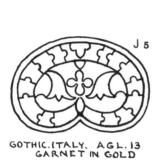

J5

GOTHIC. ITALY. AGL. 13
GARNET IN GOLD

J7

BR. MARIASSOVA
MM XXX

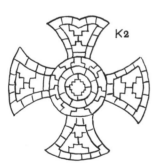

J6

WURTEMBURG
GARNET. AFW. 115

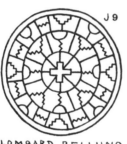

J9

LOMBARD BELLUNO
GARNET AGL 128

J8

CAUCASUS AFW. 3
GARNET BOSS

J 83

+480 CHILDERIC
AFW 62
C.A.C. p.104

K2

+650 IXWORTH, AAS. 259

K 4

+700 MLG 211
LINDIS FARNF

K 5

+700 LINDISFARNE
BAE. V. XXXIV

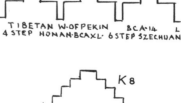

K 7

TIBETAN W. OF PEKIN BCA-14 L
4 STEP HONAN-BCAXL· 6 STEP SZECHUAN

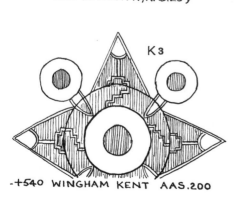

K3

-+540 WINGHAM KENT AAS. 200

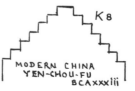

K 8

MODERN CHINA
YEN-CHOU-FU
BCA XXXiii

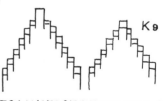

K 9

FRANKFORT TOWN-HALL Φ

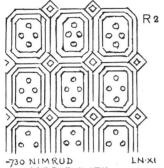

R2

-730 NIMRUD
SADDLE CLOTH LN·XI

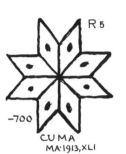

R5

-700
CUMA
MA·1913,XLI

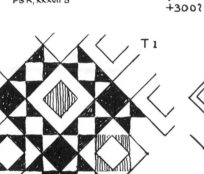

R6

+500? RIFEH
P&R, XXXVII 8

R8

SARDINIA, ALGHERO
NS·1904·333

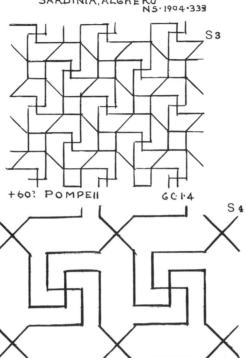

S3

+60? POMPEII GC·1·4

S4

+300? PISTOIA NS·1904 257

S2

+60 POMPEII GC·15

S5

ROME, VIA TUSCOLANA. NS·1905·72

S8

+340 ROME, S.COSTANZA φ

T1

+400
RAVENNA
HONORIUS MA·1916·766

T2

+500 RAVENNA
THEODORIC MA·1916,759

S9

+100? NENNIG GM.20

T3

+500 RAVENNA
THEODORIC MA·1916·758

T5

+500 RAVENNA MA·1916,751
THEODORIC

T6

+500 RAVENNA
THEODORIC MA·1916·790

T7

+800 GOSPEL OF
CHARLEMAGNE
AJA 1920 152

T8

+820 SOISSONS GOSPEL
AJA 1920 152

T9

+1080 DYSERT O'DEA
CCO 72

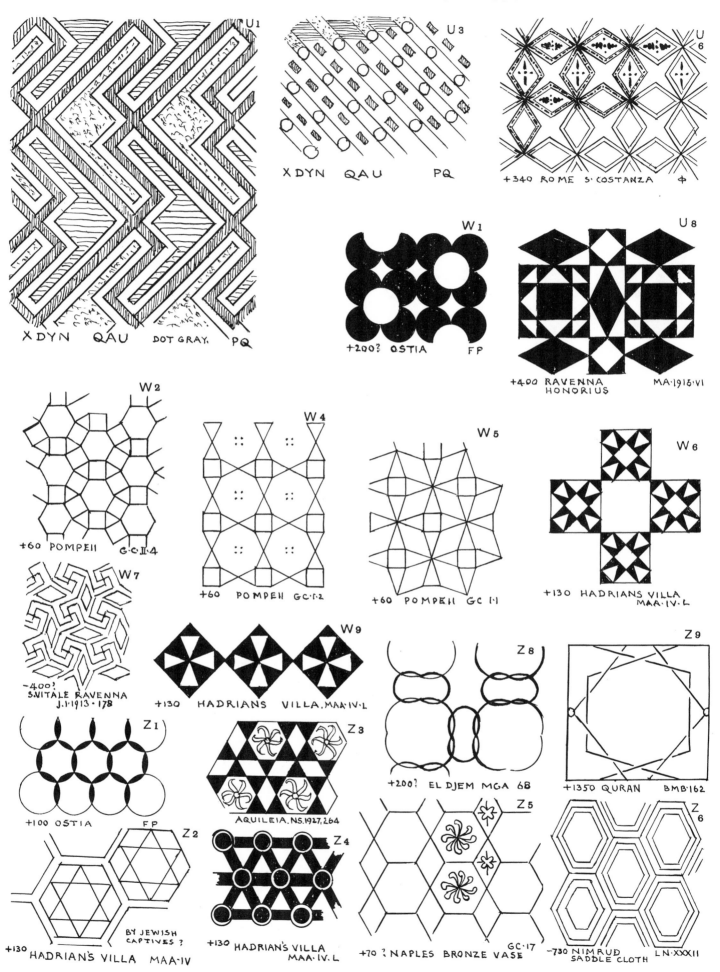

U1 X DYN QAU PQ

U3 X DYN QAU PQ

U6 +340 ROME S·COSTANZA Φ

X DYN QAU DOT GRAY. PQ

W1 +200? OSTIA FP

U8 +400 RAVENNA HONORIUS MA·1918·VI

W2 +60 POMPEII G·C·II·4

W4 +60 POMPEII GC·I·2

W5 +60 POMPEII GC·I·1

W6 +130 HADRIANS VILLA MAA·IV·L

W7 −400? SNITALE RAVENNA J·I·1913·178

W9 +130 HADRIANS VILLA, MAA·IV·L

Z8 +200? EL DJEM MGA 6B

Z9 +1350 QURAN BMB·162

Z1 +100 OSTIA FP

Z3 AQUILEIA. NS.1927, 264

Z2 BY JEWISH CAPTIVES? +130 HADRIAN'S VILLA MAA·IV

Z4 +130 HADRIAN'S VILLA MAA·IV·L

Z5 +70? NAPLES BRONZE VASE GC·17

Z6 −730 NIMRUD SADDLE CLOTH L·N·XXXII

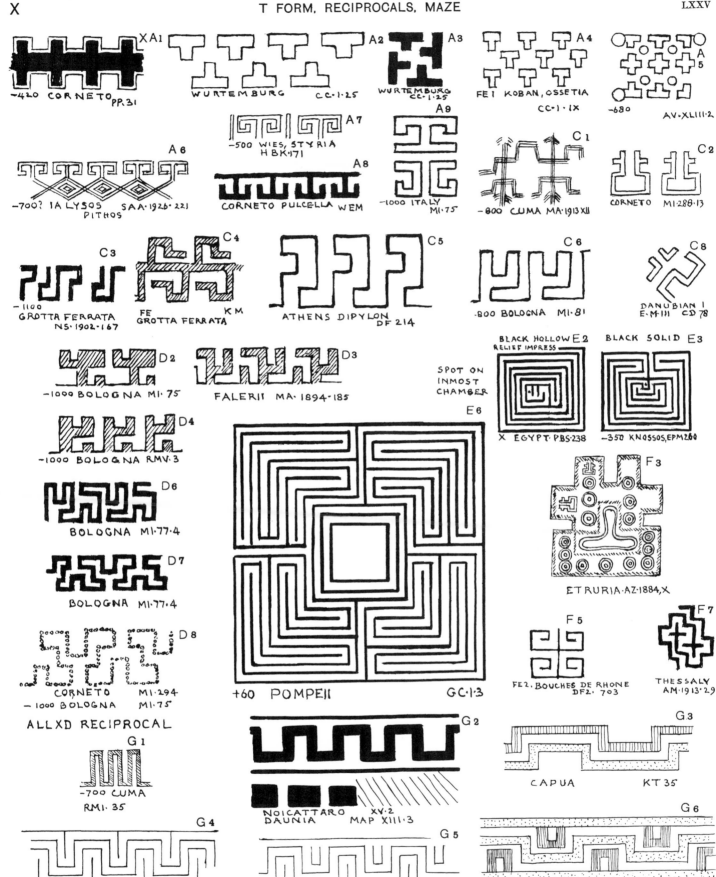

XA1 -420 CORNETO PP.31

A2 WURTEMBURG CC·1·25

A3 WURTEMBURG CC·1·25

A4 FE I KOBAN, OSSETIA CC·1·IX

A5 -680 AV·XLIII·2

A7 -500 WIES, STYRIA HBK·171

A9 -1000 ITALY MI·75

C1 -800 CUMA MA·1913 XII

C2 CORNETO MI·288·13

A6 -700? IALYSOS PITHOS SAA·1926·221

A8 CORNETO PULCELLA WEM

C3 -1100 GROTTA FERRATA NS·1902·167

C4 FE GROTTA FERRATA KM

C5 ATHENS DIPYLON DF 214

C6 -800 BOLOGNA MI·81

C8 DANUBIAN I E·M·III CD 78

D2 -1000 BOLOGNA MI·75

D3 FALERII MA·1894·185

SPOT ON INMOST CHAMBER

E6

BLACK HOLLOW E2 RELIEF IMPRESS

BLACK SOLID E3

X EGYPT·PBS·238

-350 KNOSSOS,EPM260

D4 -1000 BOLOGNA RMV·3

D6 BOLOGNA MI·77·4

F3 ETRURIA·AZ·1884,X

D7 BOLOGNA MI·77·4

D8 CORNETO MI·294 -1000 BOLOGNA MI·75

+60 POMPEII GC·1·3

F5 FE2. BOUCHES DE RHONE DF2. 703

F7 THESSALY AM·1913·29

ALLXD RECIPROCAL

G1 -700 CUMA RMI·35

G2 NOICATTARO XV·2 DAUNIA MAP XIII·3

G3 CAPUA KT 35

G4 -600 BOLOGNA MI·85

G5 -600 BOLOGNA MI·85

G6 CAPUA KT·35

G7 -680 CENTRAL APULIA GBA·II·1 -600 MONTE SANNACE

G8 KAMEIROS. ABS·1906·72

G9 APULIA MAP·I2 DAUNIA MAP·XII·14

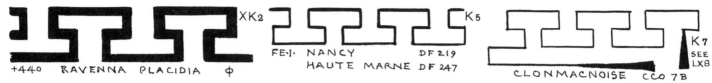

XK2 +440 RAVENNA PLACIDIA Φ

K5 FE·1· NANCY DF 219 HAUTE MARNE DF 247

K7 SEE LX8 CLONMACNOISE CCO 7B

L2 −600 S·APULIA RMI·45

L3 −500 ESTE BRONZE STUDS RMI·4·5

L4 LATIUM M·I·140·9 DAUNIA MAP XIII·4 VOLTERRA, MI·171·1

L5 CAPUA KT·40

L6 −2000? VIBRATA M·I·14, 18

L7 −700? ATHENS K·B·110 −700? CUMA MA·1913·XXXIX −500 CAULONIA MA·1923·471

L8 −800 BOLOGNA RMV·7

L9 −600 BOLOGNA M·I·85

M2 BR. TOKAY RV II BODROGKERESZTUR ONGODROONED BOWL

M3 FE2. FINISTERRE DF2·700

M4 CLONMACNOISE CCO·7A

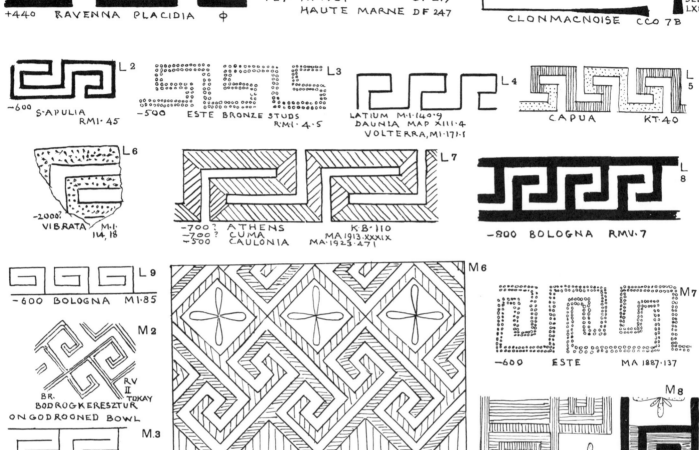

M6 XDYN QAU PQ

M7 −600 ESTE MA 1887·137

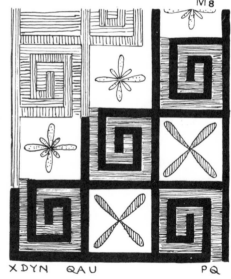

M8 XDYN QAU PQ

M5 −600 BOLOGNA M·I·85 RAVENNA, S·APOL·N· MAP XXVII

N3 CAPUA KT·33

N4 −700 CAPUA CRETE KT 40 ABS VIII

N5 CAPUA KT 54

N8 +520 RAVENNA S·APOL·NUOV· Φ

O3 VALENZANO GBA·XII·5

O6 MID APULIA MAP XIX Q

O7

O8 AHENNY, S·CROSS CCO·9D

+924 MONASTERBOICE MUIRDACH CCO 7G

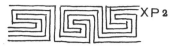
CERVETRI MI·340·4 XP2

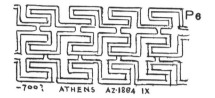
-700? ATHENS AZ·1884 IX P6

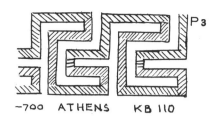
-700 ATHENS KB 110 P3

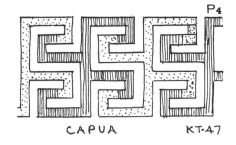
CAPUA KT·47 P4

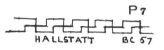
HALLSTATT BC 57 P7

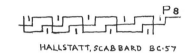
HALLSTATT, SCABBARD BC·57 P8

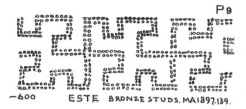
-600 ESTE BRONZE STUDS. MA 1897.139. P9

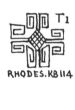
RHODES. KB 114 T1

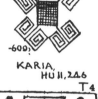
KARIA, HU II, 246 -600? T2

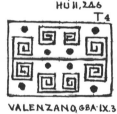
CROPTHORNE CROSS HEAD BEQ 38 T3
VALENZANO, GBA·IX.3 T4

CAMBRIDGE A.1925,245 T5

-670 CAERE R·M·E T6

+1080 CCO.56 DYSERT O'DEA T7
DIAGONAL AT FERNS

MEIGLE RCA 286 T8

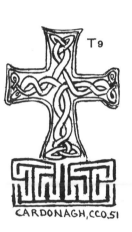
CARDONAGH, CCO.51 T9

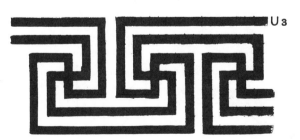
-500 ATHENS DRESS Φ U2

-450 SYRACUSE U3

N·CHINA SCREEN. BCA ALSO RHOMBIC CLXIII U4
+100? AIX PROVENCE MGA·47 U5

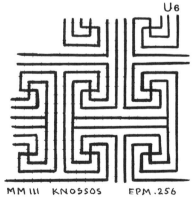
MM III KNOSSOS EPM.256 U6

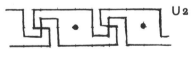
+440 RAVENNA, PLACIDIA Φ U7

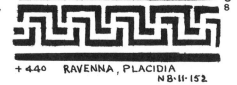
+440 RAVENNA, PLACIDIA NB·II·152 U8

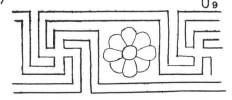
+101 IS·SANAMEN BSA·5·XIX U9

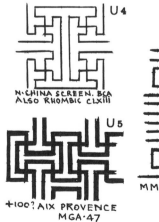

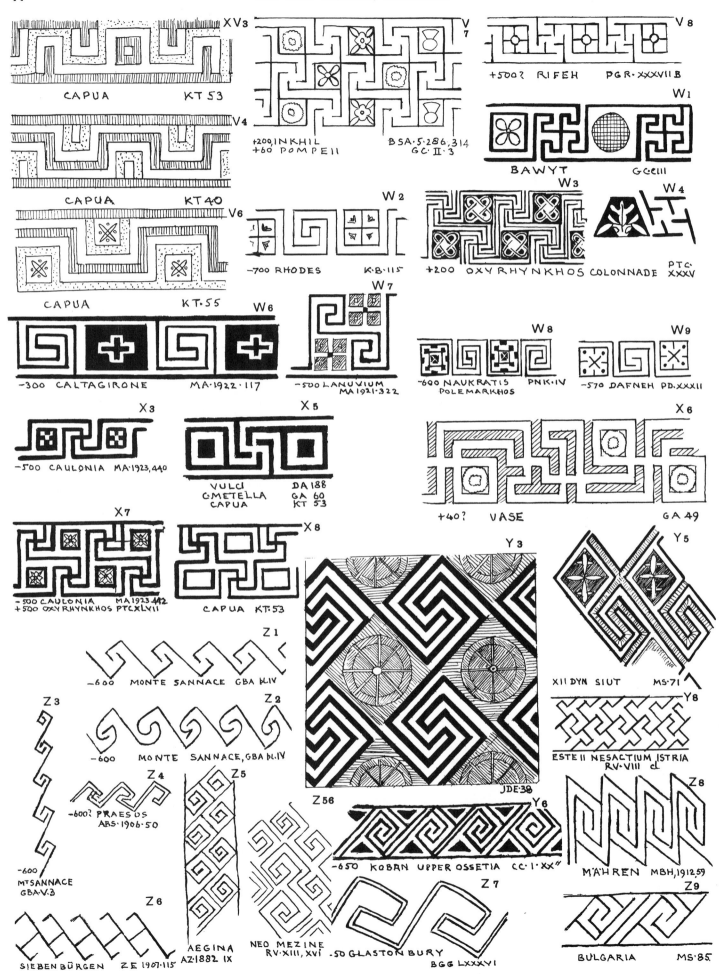

XV3

CAPUA KT 53

V4

CAPUA KT 40

V6

CAPUA KT·55

W6

−300 CALTAGIRONE MA·1922·117

V7

+200, INKHIL
+60 POMPEII

BSA·5·286,314
GC·II·3

W2

−700 RHODES K·B·115

W7

−500 LANUVIUM
MA1921·322

V8

+500? RIFEH PGR·XXXVII B

W1

BAWYT G·CCIII

W3

+200 OXYRHYNKHOS COLONNADE

W4

PTC·XXXV

W8

−600 NAUKRATIS PNK·IV
POLEMARKHOS

W9

−570 DAFNEH PD·XXXII

X3

−500 CAULONIA MA·1923,440

X5

VULCI DA 188
C.METELLA GA 60
CAPUA KT 53

X6

+40? VASE GA 49

X7

−500 CAULONIA MA1923.442
+500 OXYRHYNKHOS PTCXLVII

X8

CAPUA KT·53

Z1

−600 MONTE SANNACE GBA bl·IV

Z3

Z2

−600 MONTE SANNACE, GBA bl·IV

Z4

−600? PRAESOS
ABS·1906·50

Z5

Z56

−650 KOBAN UPPER OSSETIA CC·I·XX''

Y3

JDE·38

Y5

XII DYN SIUT MS·71

Y8

ESTE II NESACTIUM ISTRIA
RV·VIII cL

Y6

Z8

MÄHREN MBH,1912,59

−600
MtSANNACE
GBA·V.3

Z6

SIEBENBÜRGEN ZE 1907·115

AEGINA
AZ·1882 IX

NEO MEZINE
RV·XIII, XVI −50 GLASTONBURY
BGG LXXXVI

Z7

Z9

BULGARIA MS·85

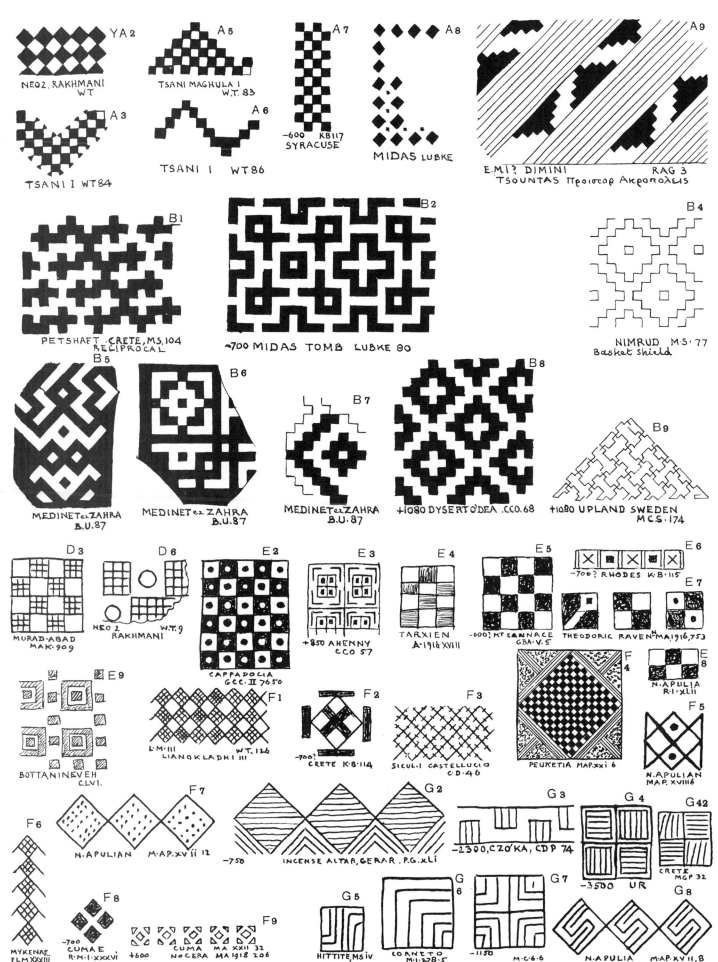

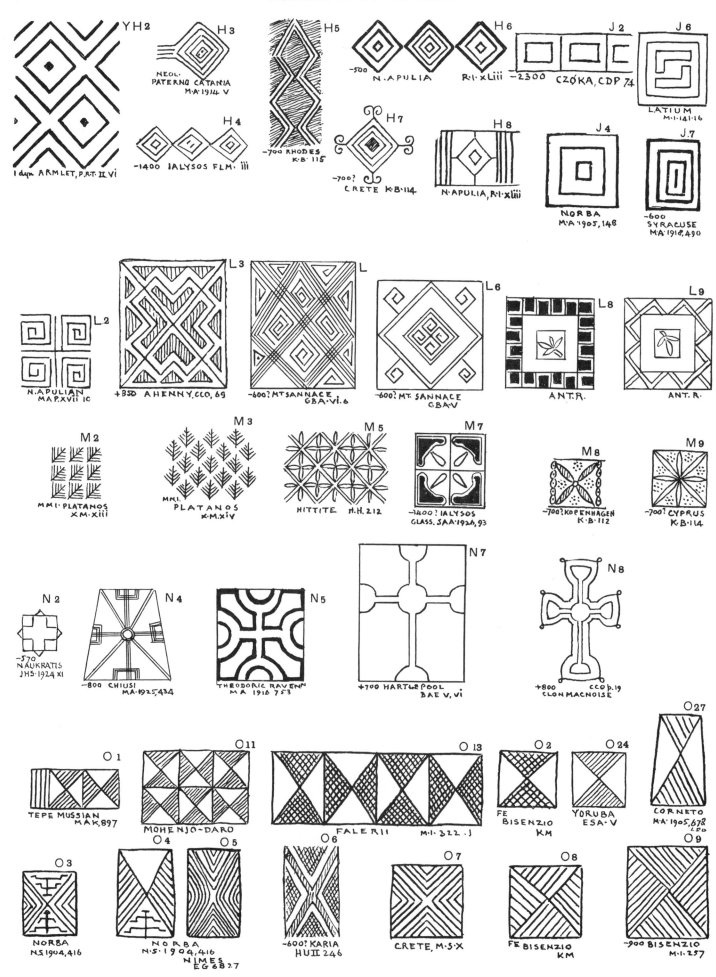

Y H 2
1 dyn ARMLET. P.R.T. II Vi

H 3
NEOL.
PATERNO CATANIA
M·A·1914 V

H 4
-1400 IALYSOS F.L.M. iii

H 5
-700 RHODES
K·B· 115

H 7
-700? CRETE K·B·114

H 6
-500 N. APULIA R·I· xLiii

H 8
N·APULIA, R·I· xLiii

J 2
-2300 CZÓKA, CDP 74

J 6
LATIUM
M·I·141·16

J 4
NORBA
M·A·1905, 148

J 7
-600 SYRACUSE
M·A·1918, 490

L.2
N. APULIAN
MA P. XVII 10

L 3
+350 A HENNY, CCO, 69

L
-600? MT SANNACE
GBA·VI·6

L 6
-600? MT. SANNACE
GBA·V

L 8
ANT. R.

L 9
ANT. R.

M 2
MM I. PLATANOS
X·M·xiii

M 3
MM I.
PLATANOS
X·M·xiv

M 5
HITTITE M.H. 212

M 7
-1400? IALYSOS
GLASS. SAA·1926, 93

M 8
-700? KOPENHAGEN
K·B·112

M 9
-700? CYPRUS
K·B·114

N 2
-570 NAUKRATIS
JHS·1924 XI

N 4
-800 CHIUSI
MA·1925, 434

N 5
THEODORIC RAVENN
MA 1918 753

N 7
+700 HARTLEPOOL
BAE V, Vi

N 8
+800 CCO p.19
CLONMACNOISE

O 1
TEPE MUSSIAN
MAK 897

O 11
MOHENJO-DARO

O 13
FALERII M·I·322·J

O 2
FE
BISENZIO
KM

O 24
YORUBA
ESA·V

O 27
CORNETO
M·A·1905, 678

O 3
NORBA
N.S 1904, 416

O 4
NORBA
N·S·1904, 416

O 5
NIMES
EG 682·7

O 6
-600? KARIA
HU II 246

O 7
CRETE, M·S·X

O 8
FE BISENZIO
KM

O 9
-900 BISENZIO
M·I·257

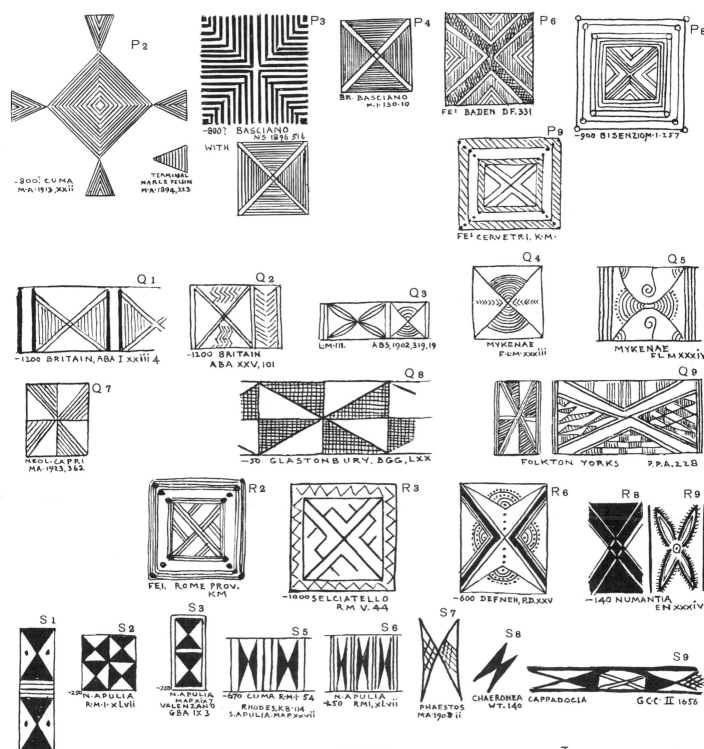

P 2

-800? CUMA
M·A·1913,XXii

TERMINAL
NARCE FELSIN
M·A·1894,223

P3

-800? BASCIANO
NS 1896 516

WITH

BR. BASCIANO
M·I·130·10

P4

FE¹ BADEN D.F.331

P6

P8

-900 BISENZIOM·I·257

P9

FE¹ CERVETRI. K·M·

Q1

-1200 BRITAIN, ABA I xxiii 4

Q2

-1200 BRITAIN
ABA XXV, 101

Q3

L·M·III. ABS,1902,319,19

Q4

MYKENAE
F·L·M·xxxiii

Q5

MYKENAE
F·L·M·XXXiv

Q7

NEOL. CAPRI
MA·1923,362

Q8

-50 GLASTONBURY, BGG, LXX

Q9

FOLKTON YORKS P.P.A.228

R2

FE¹. ROME PROV.
K·M·

R3

-1000 SELCIATELLO
RM V. 44

R6

-600 DEFNEH, P.D.XXV

R8

R9

-140 NUMANTIA
EN.xxxiv

S1

M·APULIA
M·AR·XXi 6

S2

-250 N.APULIA
R·M·I·xLVii

S3

-250 N.APULIA
VALENZANO
GBA IX 3

S5

-670 CUMA R·M·I· 54
RHODES,KB·114
S.APULIA·MAP·xxvii

S6

N.APULIA
-250 RMI,xLvii

S7

PHAESTOS
MA·1908 ii

S8

CHAERONEA
WT. 140 CAPPADOCIA

S9

G·C·C· II 1656

T1

N. APULIAN
M·AP·xviii·11

T2

MYKENAE
F·L·M·xxviii

T3

ARCH⁵ SUSA DCLXVI·11

T4

-780 CUMA MA1913,xxxi

T5

CORNETO
M·I· 283,6

T6

-140 NUMANTIA
EN.xxxiv

T7

TEPE MUSSIAN
MAK 899
IV MILL⁵ SUSA

T9

DAUNIA
M·A·P·XV,17

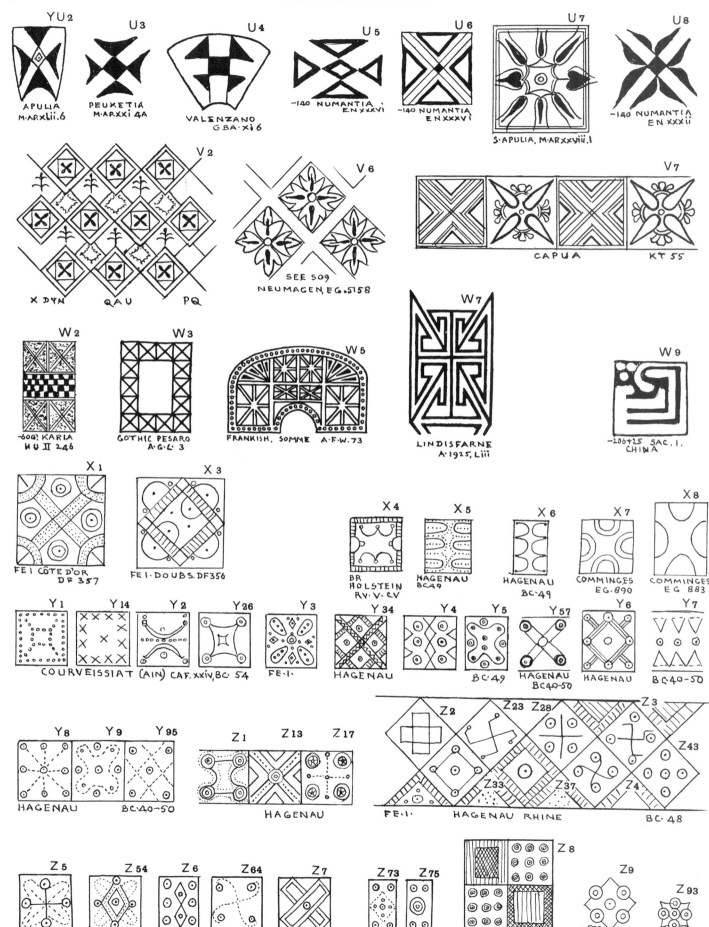

YU2 APULIA M·AR·xlii.6

U3 PEUKETIA M·AR·xxi 4A

U4 VALENZANO G·BA·xi 6

U5 -140 NUMANTIA EN·xxxvi

U6 -140 NUMANTIA EN·xxxvi

U7 S·APULIA, M·AR·xxxviii.1

U8 -140 NUMANTIA EN·xxxii

V2 X DYN QAU PQ

V6 SEE 509 NEUMAGEN·EG.5158

V7 CAPUA KT 55

W2 -600? KARIA HU·II·246

W3 GOTHIC PESARO A·G·L·3

W5 FRANKISH, SOMME A·F·W·73

W7 LINDISFARNE A·1925,Liii

W9 -206+25 SAC·I· CHINA

X1 FE·I·CÔTE D'OR DF·357

X3 FE·I·DOUBS.DF356

X4 BR HOLSTEIN RV·V·CV

X5 HAGENAU BC·49

X6 HAGENAU BC·49

X7 COMMINGES EG·890

X8 COMMINGES EG·883

Y1 Y14 Y2 Y26 Y3 COURVEISSIAT (AIN) CAF·xxiv, BC·54 FE·I·

Y34 Y4 Y5 Y57 Y6 Y7 HAGENAU BC·49 HAGENAU BC40-50 HAGENAU BC·40-50

Y8 Y9 Y95 HAGENAU BC·40-50

Z1 Z13 Z17 HAGENAU

Z2 Z23 Z28 Z3 Z33 Z37 Z4 Z43 FE·I· HAGENAU RHINE BC·48

Z5 Z54 Z6 Z64 Z7 HAGENAU BC 40-50

Z73 Z75 HAGENAU, BC·

Z8 FE I BADEN DF 331

Z9 -570 NAUKRATIS JHS·1924·XI

Z93 -570 NAUKRATIS JHS·1924·XI

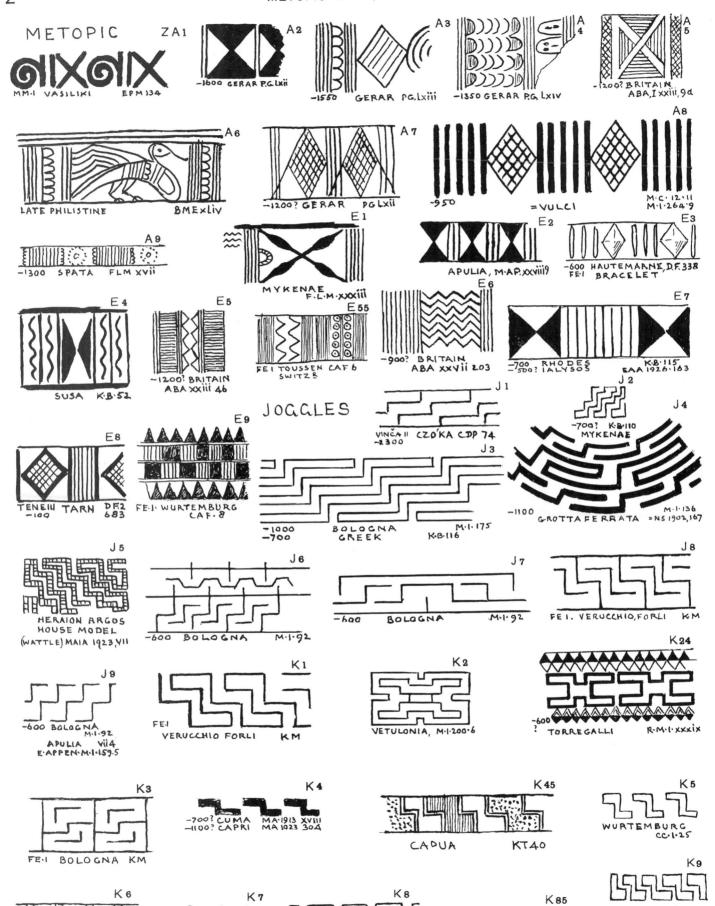

METOPIC ZA1

MM·I VASILIKI EPM 134

A2 —1600 GERAR P.G.LXii

A3 —1550 GERAR P.G.LXiii

A4 —1350 GERAR P.G. LXiv

A5 —1200? BRITAIN ABA,I xxiii,9d

A6 LATE PHILISTINE BMExliv

A7 —1200? GERAR PG.LXii

A8 —950 =VULCI M·C·12·11 M·I·264·9

A9 —1300 SPATA FLM XVII

E1 MYKENAE F.L.M·xxxiii

E2 APULIA, M·A·P.xxviii9

E3 —600 HAUTEMARNE D.F.338 FE·I BRACELET

E4 SUSA K.B.52

E5 —1200? BRITAIN ABA xxiii 4b

E55 FE·I TOUSSEN CAF6 SWITZ·R

E6 —900? BRITAIN ABA XXVII 203

E7 —700 RHODES —500? IALYSOS K·B·115 EAA 1926·163

E8 TENEIII TARN DF2 —100 683

E9 FE·I· WURTEMBURG CAF·8

JOGGLES

J1 VINČA II CZÓKA CDP 74 —2300

J2 —700? K·B·110 MYKENAE

J3 —1000 BOLOGNA —700 GREEK M·I·175 K·B·116

J4 —1100 GROTTA FERRATA M·I·136 =NS 1902,167

J5 HERAION ARGOS HOUSE MODEL (WATTLE) MAIA 1923,VII

J6 —600 BOLOGNA M·I·92

J7 —600 BOLOGNA M·I·92

J8 FE·I. VERUCCHIO,FORLI KM

J9 —600 BOLOGNA M·I·92 APULIA vii4 E·APPEN·M·I·159·5

K1 FE·I VERUCCHIO FORLI KM

K2 VETULONIA, M·I·200·6

K24 —600 ? TORREGALLI R·M·I·xxxix

K3 FE·I BOLOGNA KM

K4 —700? CUMA MA 1913 XVIII —1100? CAPRI MA 1923 304

K45 CADUA KT40

K5 WURTEMBURG CC·I·25

K6 STYRIA BC·53

K7 —140 NUMANTIA EN·XXXIII

K8 ARDANE CCO·7D

K85 CLONMACNOISE CCO·66

K9 BR. BEIESK MM·XXX

-550? IALYSOS SAA·1926.161 P 1

APULIA MAP.I.2 P 2

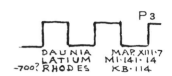
P 3
DAUNIA MAP XIII·7
LATIUM MI·141·14
-700? RHODES KB·114

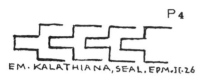
P 4
EM. KALATHIANA, SEAL. EPM. II·26

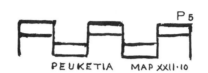
P 5
PEUKETIA MAP XXII·10

P 6
HAGENAU BC·48

P 7
VINČA II CZOKA
-2300 CDP·74

P 8
PRE-INCA BOWL
CHIMU PERU

P 9
-700? CRETE KB·114

V 3
N. APULIA
MAP. XVII. 8

V 4
GOTHIC, SWEDEN
AFW 16

V 7
-700? THERA
KB·114

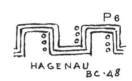
V 8
+500 RAVENNA
MA·1916 753

MODERN V 9
FENCE
SZECHUAN
BCA·CXI

P 92
ANDRONOVO ORAK SIBERIA
STYLE RV. XIII XCII B

W 1
-1300
IALYSOS
SAA·1926 f80

W 2
-700 CRETE
ABS VIII

W 3
BR.
E·APENNINE
MI·130·5

W 4
MID. APULIA
M·AP·XX·8

W 5
-800? CUMA
MA 1913 XII
W 6
-800? CUMA
MA·1913 XVIII

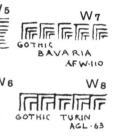
W 7
GOTHIC
BAVARIA
AFW·110
W 8
GOTHIC TURIN
AGL·63

W 9

BARBERINI
MAA 1925 p.62

X 2 X 3
-3500 UR -3500 UR

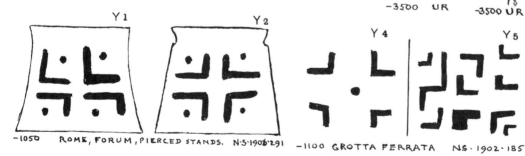
Y 1 Y 2 Y 4 Y 5
-1050 ROME, FORUM, PIERCED STANDS. N·S·1906·291
-1100 GROTTA FERRATA NS·1902·185

Y 8
CORNETO MI·290·2

Y 9
FALERII MI·320·13

Z 1
HAGUEAU
+REINDEER
BC·48

Z 2
LM·III WT·125
LIANOKLADHI·III

Z 3
NEO.
CAPRI
MA·1923.i

Z 4 Z 5
NEO
PATERNO M·A· UBAID
CATANIA 1914·V HWU,XUX
Z 6
EARLY HELLAD BK·I

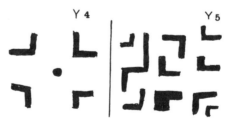
Z 7
BR·AGE RAN98
ROMSDAL
Z 8
-1050
MC 6·6
HUT URN
Z 9
-1050
HUT URN
MC·XXVI 15

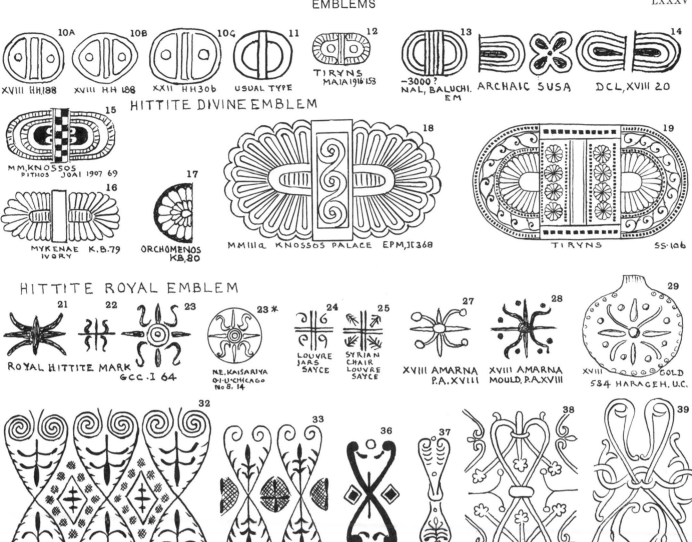

10A XVIII HH.188 10B XVIII H.H 188 10C XXII HH30b 11 USUAL TYPE 12 TIRYNS MAIA 1916·153 13 –3000? NAL, BALUCHI. EM ARCHAIC SUSA 14 DCL, XVIII 20

HITTITE DIVINE EMBLEM

15 MM. KNOSSOS PITHOS JOAI 1907 69

16 MYKENAE IVORY K.B.79 17 ORCHOMENOS K.B.80

18 MM III a KNOSSOS PALACE EPM, II 368

19 TIRYNS SS·106

HITTITE ROYAL EMBLEM

21 ROYAL HITTITE MARK 22 23 GCC.I 64 23* NE. KAISARIYA O·I·U·CHICAGO No 8, 14 24 LOUVRE JARS SAYCE 25 SYRIAN CHAIR LOUVRE SAYCE 27 XVIII AMARNA P.A. XVIII 28 XVIII AMARNA MOULD, P.A.XVIII 29 XVIII 584 HARAGEH. U.C. GOLD

32 X DYN. QAU P.Q. i

33 MEIR BLM

36 LM·I·DRESS OF KEFTIU EPM II 480

37 500? KASHGAR POT. S.P.19

38 +800 SWISS BAS·XXV* (PERSIAN?)

39 +1000? LETTLAND LODDIGER-TREYDEN N50 104

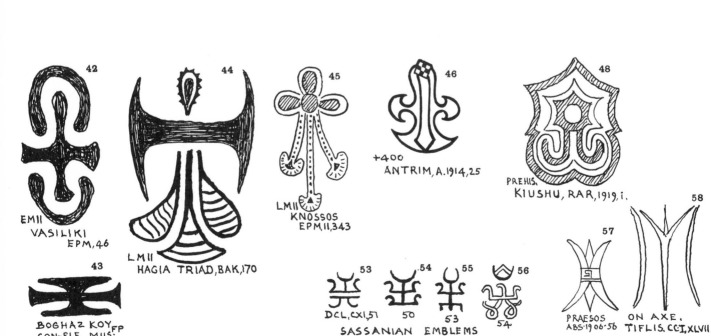

42 EMII VASILIKI EPM, 46

43 BOGHAZ KOY CON-PLE MUS. FP

44 LMII HAGIA TRIAD, BAK, 170

45 LMII KNOSSOS EPM, II, 343

46 +400 ANTRIM, A.1914, 25

48 PREHIS. KIUSHU, RAR, 1919, i.

53 DCL, CXI, 57 54 55 56 50 53 54 SASSANIAN EMBLEMS

57 PRAESOS ABS·19 06·56

58 ON AXE, TIFLIS. CCI, XLVII

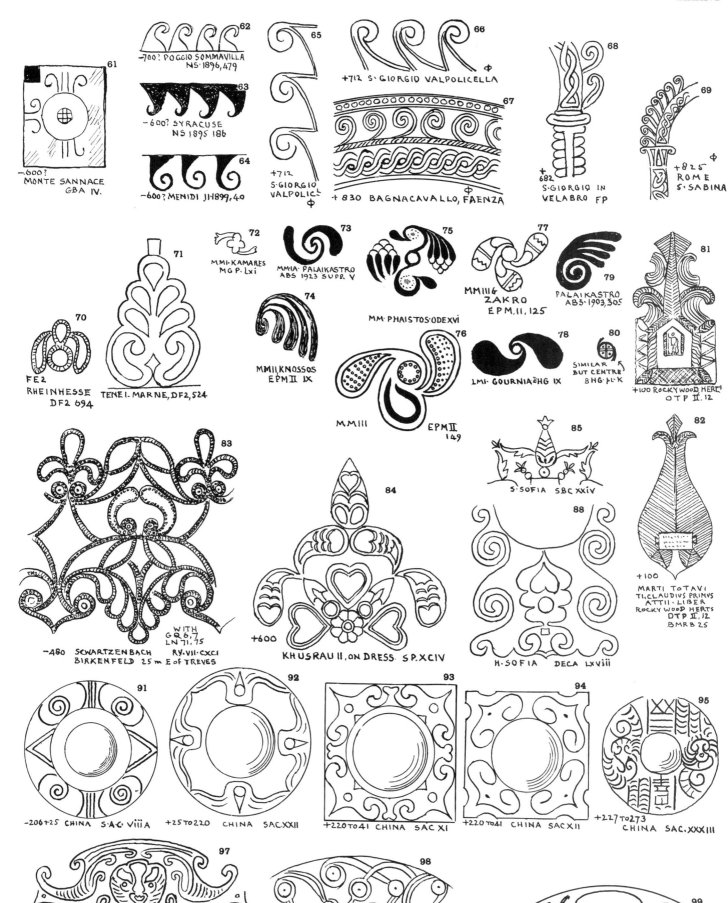

61 −600?
MONTE SANNACE
GBA IV.

62 −700? POGGIO SOMMAVILLA
NS.1896,479

63 −600? SYRACUSE
NS 1895 186

64 −600? MENIDI JI·1899,40

65 +712
S·GIORGIO
VALPOLIC⌖

66 +712 S·GIORGIO VALPOLICELLA

67 +830 BAGNACAVALLO, FAENZA ⌖

68 +682
S·GIORGIO IN
VELABRO FP

69 +825 ⌖
ROME
S·SABINA

70 FE2
RHEINHESSE
DF2 694

TENE I. MARNE, DF2, 524

71

72 MMI·KAMARES
MG P. Lxi

73 MMIA· PALAIKASTRO
ABS 1923 SUPR V

74 MMII, KNOSSOS
EPM II IX

75 MM· PHAISTOS·ODEXVi

76 MMIII

EPM II
149

77 MMIIIG
ZAKRO
EPM.II,125

78 LMI· GOURNIA BHG IX

79 PALAIKASTRO
ABS·1903,305

80 SIMILAR
BUT CENTRE
BHG·II·K

81 +100 ROCKYWOOD HERTS
OTP II.12

82 +100
MARTI TOTAVI
TI.CLAUDIUS PRIMUS
ATTII·LIBER
ROCKYWOOD HERTS
OTP II,12
BMRB 25

83 −480 SCWARTZENBACH
BIRKENFELD 25 m E of TREVES

WITH
GQ 6,7
LN 71,75
RV·VII·CXCI

84 +600
KHUSRAU II, ON DRESS. SP.XCIV

85 S·SOFIA SBC XXiv

88 H·SOFIA DECA LXViii

91 −206+25 CHINA S·A·C·Viiia

92 +25TO220 CHINA SAC.XXII

93 +220TO41 CHINA SAC XI

94 +220TO41 CHINA SAC XII

95 +227TO273 CHINA SAC.XXXIII

97 +25TO220 CHINA SAC·XXIII

98 −206+220 CHINA·HSM·9

99 +265TO589 CHINA S.A.C. XLIII

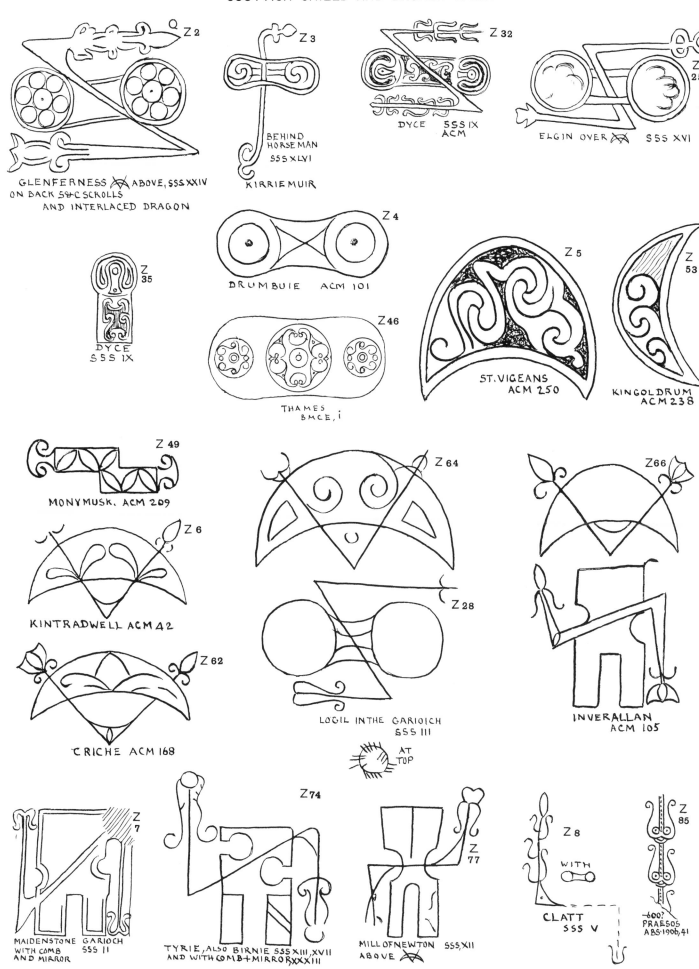

Z2
GLENFERNESS ⋈ ABOVE, SSS XXIV
ON BACK S&C SCROLLS
AND INTERLACED DRAGON

Z3
BEHIND
HORSEMAN
SSS XLVI
KIRRIEMUIR

Z32
DYCE SSS IX
ACM

Z25
ELGIN OVER ⋈ SSS XVI

Z35
DYCE
SSS IX

Z4
DRUMBUIE ACM 101

Z46
THAMES
BMCE, i

Z5
ST. VIGEANS
ACM 250

Z53
KINGOLDRUM
ACM 238

Z49
MONYMUSK, ACM 209

Z6
KINTRADWELL ACM 42

Z62
C RICHE ACM 168

Z64

Z28
LOGIL IN THE GARIOCH
SSS III

AT
TOP

Z66

INVERALLAN
ACM 105

Z7
MAIDENSTONE GARIOCH
WITH COMB SSS II
AND MIRROR

Z74
TYRIE, ALSO BIRNIE SSS XIII, XVII
AND WITH COMB+MIRROR XXXIII

Z77
MILL OF NEWTON SSS, XII
ABOVE ⋈

Z8
WITH
CLATT
SSS V

Z85
-600?
PRAESOS
ABS 1906, 41

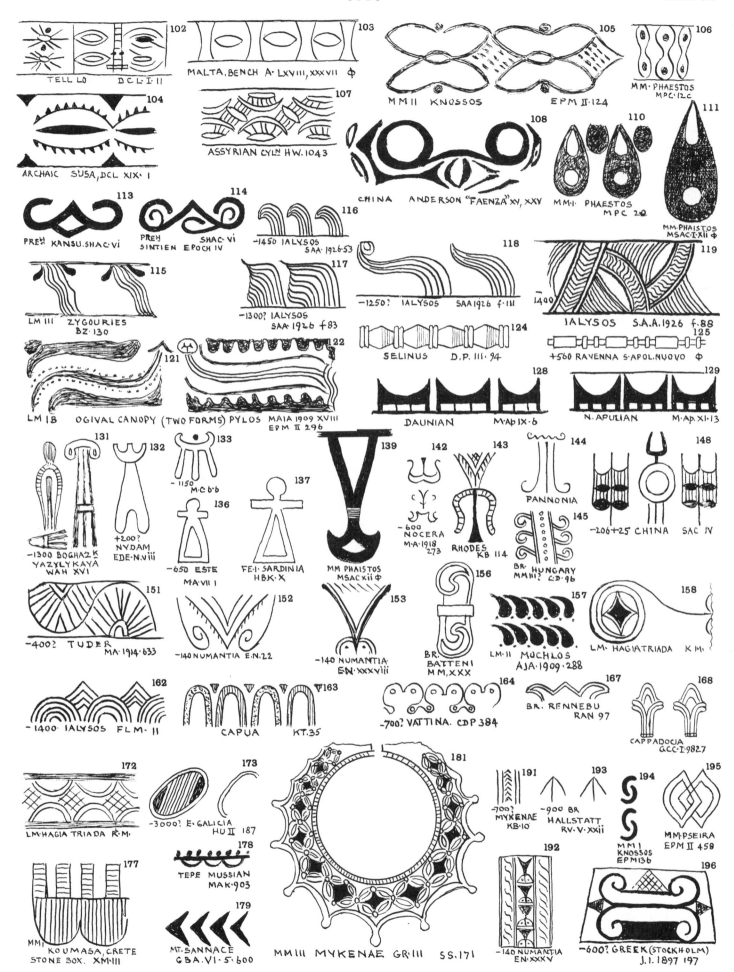

102 TELL LO DCL·I·II

103 MALTA, BENCH A·LXVIII, XXXVII Φ

105 MM II KNOSSOS EPM II·124

106 MM·PHAESTOS MPC·I2C

104 ARCHAIC SUSA, DCL XIX·I

107 ASSYRIAN CYLN H.W.1043

108 CHINA ANDERSON "FAENZA" XV, XXV

110 MM·I· PHAESTOS MPC 20

111 MM·PHAESTOS MSAC·I·XII Φ

113 PREH KANSU·SHAC·VI

114 PREH SINTIEN SHAC·VI EPOCH IV

116 -1450 IALYSOS SAA·1926·53

118 -1250? IALYSOS SAA1926 f·III

119 IALYSOS S.A.A.1926 f·88

115 LM III ZYGOURIES BZ·130

117 -1300? IALYSOS SAA 1926 f83

-1400

121 LM IB OGIVAL CANOPY (TWO FORMS) PYLOS

122 MAIA 1909 XVIII EPM II 296

124 SELINUS D.P.III·94

125 +560 RAVENNA S·APOL·NUOVO Φ

128 DAUNIAN M·Ap IX·6

129 N. APULIAN M·Ap XI·13

131 -1300 BOGHAZ K YAZYLYKAYA WAH XVI

132 +200? NYDAM EDE·N·VIII

133 -1150 M·C 6·6

136 -650 ESTE MA·VII I

137 FE·I· SARDINIA H·BK·X

139 MM PHAISTOS MSAC XII Φ

142 -600 NOCERA M·A·1918 273

143 RHODES KB 114

144 PANNONIA

145 BR· HUNGARY MM III? C·D·96

148 -206+25 CHINA SAC IV

151 -400? TUDER MA·1914·633

152 -140 NUMANTIA E·N·22

153 -140 NUMANTIA EN·xxxviii

156 BR· BATTENI MM·XXX

157 LM·II MOCHLOS AJA·1909·288

158 LM· HAGIATRIADA K·M·

162 -1400· IALYSOS FLM·II

163 CAPUA KT·35

164 -700? VATTINA· CDP 384

167 BR· RENNEBU RAN 97

168 CAPPADOCIA GCC·I·9827

172 LM·HAGIA TRIADA K·M·

173 -3000? E·GALICIA HU II 187

177 MM·I KOUMASA, CRETE STONE BOX· XM·III

178 TEPE MUSSIAN MAK·903

179 MT·SANNACE GBA·VI·5·600

181 MM III MYKENAE GR·III SS·171

191 -700? MYKENAE KB·10

192 -140 NUMANTIA EN·XXXV

193 -900 BR HALLSTATT RV·V·xxii

194 MM I KNOSSOS EPM136

195 MM·PSEIRA EPM II 458

196 -600? GREEK (STOCKHOLM) J.I. 1897 197